THE
BUSH
FAMILY

Julia: Her Life

John and Caroline: Their Lives in Pictures

Ronald Reagan: His Life in Pictures

Black and White Men (as photographer)

Jackie: Her Life in Pictures

Streisand: Her Life

More Than a Woman: A Biography of Bette Davis

Peter Lawford: The Man Who Kept the Secrets

Grace: The Secret Lives of a Princess

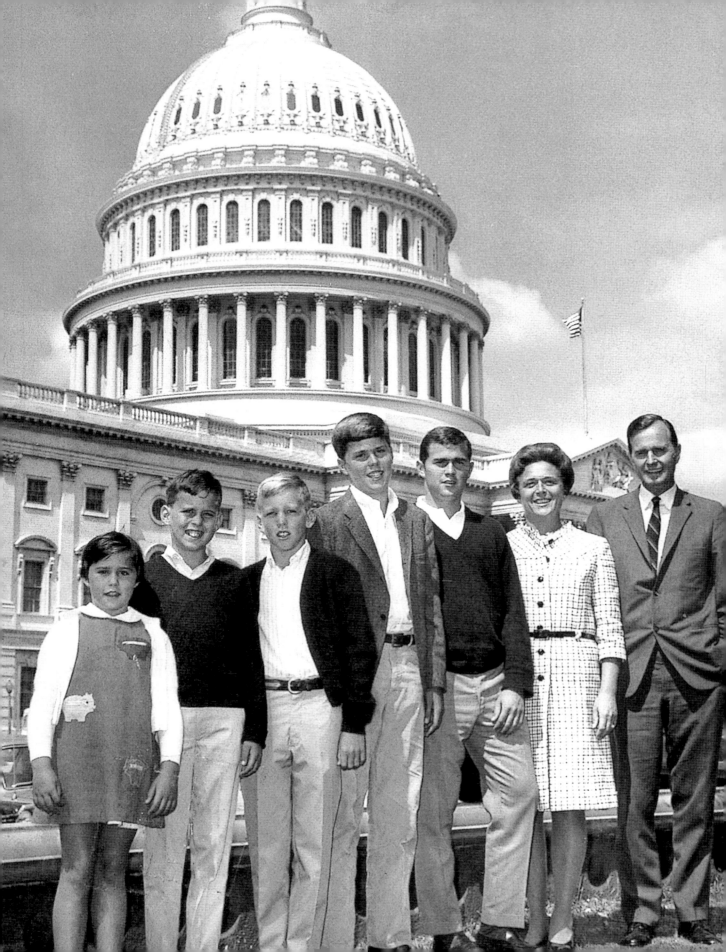

THE BUSH FAMILY

FOUR GENERATIONS OF HISTORY IN PHOTOGRAPHS

JAMES SPADA

ST. MARTIN'S PRESS ❧ NEW YORK

FRONTISPIECE: The George H. W. Bush family in front of
the Capitol in Washington, D.C., 1967.

www.stmartins.com

Design by Joseph Rutt

ISBN 0-312-33514-8
EAN 978-0312-33514-4

First Edition: August 2004

10 9 8 7 6 5 4 3 2 1

CONTENTS

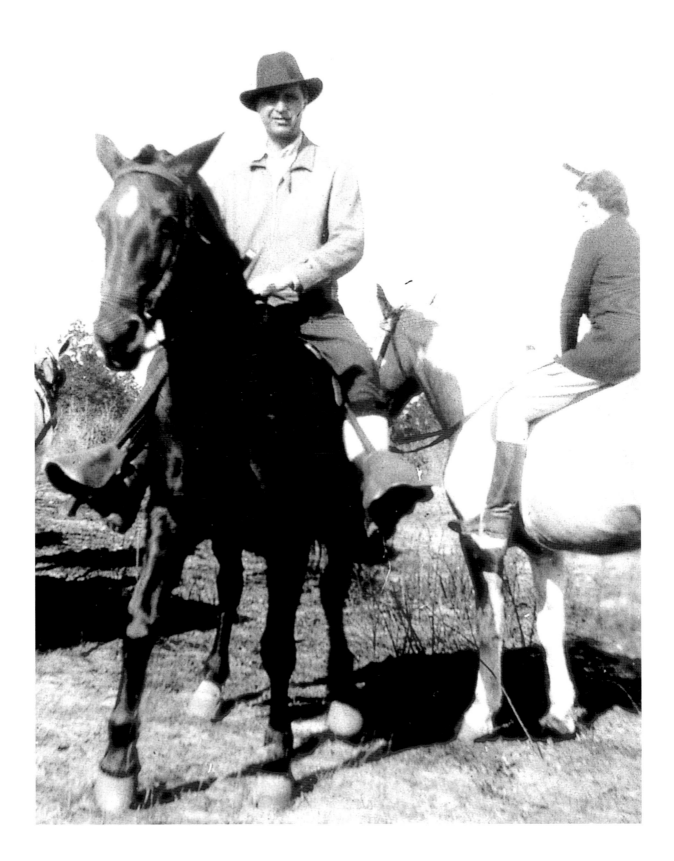

LONE STAR YANKEES

OPPOSITE: New Englander Prescott Bush takes on the
aura of a cowboy as he rides with friends in 1938.

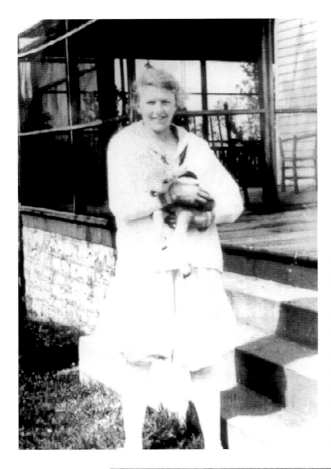

LEFT: Fourteen-year-old Dorothy Walker, the woman who would become the mother of George Herbert Walker Bush, with a pet lamb, circa 1915. Her father, the investment banker and golf enthusiast George Herbert Walker, had provided her with a *Mayflower* pedigree, an opulent lifestyle, a finishing-school education, and a love of sports. She excelled at golf, softball, horseback riding, and tennis and finished as runner-up in a 1918 Girls' National Tennis Tournament.

BELOW: Prescott Sheldon Bush, George H. W. Bush's father, with his Yale varsity baseball teammates in 1916. (He is third from the right in the middle row.) Handsome, wealthy, and athletic, he boasted a pedigree even more impressive than his future bride's—his lineage could be traced back to the fifteenth-century English nobleman Henry Spencer, whose descendants included Sir Winston Churchill and Princess Diana. His father, Samuel, a Democrat in Columbus, Ohio, rose to the presidency of the Buckeye Steel Castings Company, a position he held for twenty-two years.

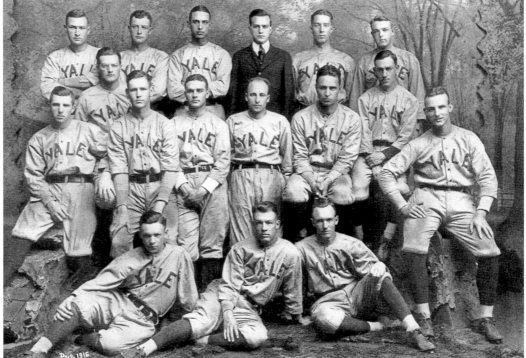

RIGHT: Prescott Bush's Yale University graduation portrait, 1917. He received a bachelor of arts degree, then served as a captain of field artillery in the American Expeditionary Forces until 1919. He served on the front for just ten weeks but came under fire during the Meuse-Argonne offensive. "It was quite exciting," he recalled, "and of course a wonderful experience." He did not, however, particularly distinguish himself during his military career.

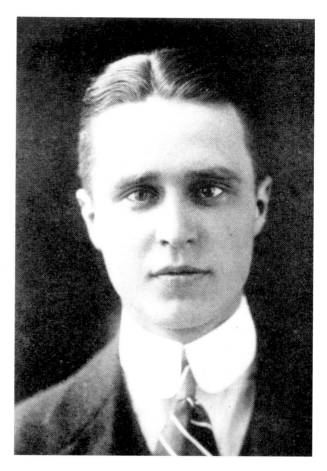

BELOW: Prescott and Dorothy Bush in an undated photo taken at her family's retreat on the 10,000-acre Duncannon Plantation near Snelling, South Carolina, where the Walkers, and later the Prescott Bushes, spent nearly every Thanksgiving and Christmas holiday. They had been married on August 16, 1921, at the St. Ann's Episcopal Church in Kennebunkport, Maine, where the Walkers had a lavish summer home overlooking the Atlantic Ocean at Walker's Point. Prescott, who worked for his father at Buckeye, was twenty-six, Dorothy twenty.

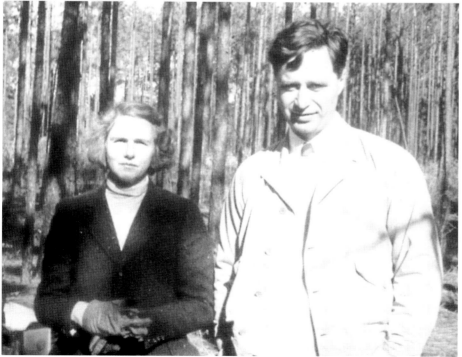

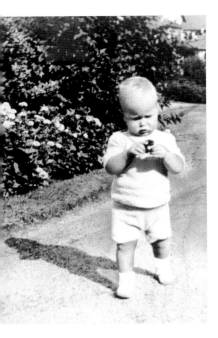

Prescott and Dorothy's second child, George Herbert Walker Bush, at the age of one and a half in the fall of 1925. He was born on June 12, 1924, in Milton, Massachusetts, where his parents had moved to be near the headquarters of the Stedman Company, a rubber manufacturer for which Prescott then worked. Prescott Bush Jr. (Pressy) had been born in 1922, and the parents agreed to name their second son after Dorothy's father. Since *he* had been named after the seventeenth-century English poet George Herbert, both names were important, so baby George got saddled with two middle names. Because Grandfather Walker's nickname was Pop, family members called little George "Poppy," and it stuck—much to his chagrin as he entered his teens.

Five-year-old Poppy with his three-year-old sister, Nancy, in 1929. The Bushes would have two more sons, Jonathan, born in 1931, and William (Bucky), born in 1938. The family now lived in Greenwich, Connecticut, and Prescott commuted to his job at the Wall Street banking house of W. A. Harriman and Company, where his father-in-law was president.

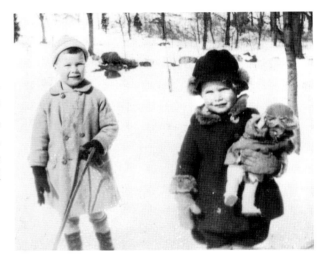

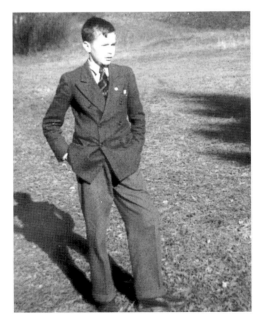

Thirteen-year-old Poppy Bush surveys the grounds of Phillips Andover Academy in 1937, the year he enrolled in the exclusive Massachusetts prep school that boasted its "business was making the leaders of tomorrow." Tall for his age, handsome, and athletic, he might have become arrogant, but his mother saw to it that he didn't. Dorothy disdained self-importance and nipped it in her children before it could blossom. "You talk about yourself too much," she frequently told Poppy—and once, when he told her he'd lost a tennis match because his game was off, she replied, "You don't have a game." Still, he said, his mother's criticism, "like Dad's, was always constructive, not negative."

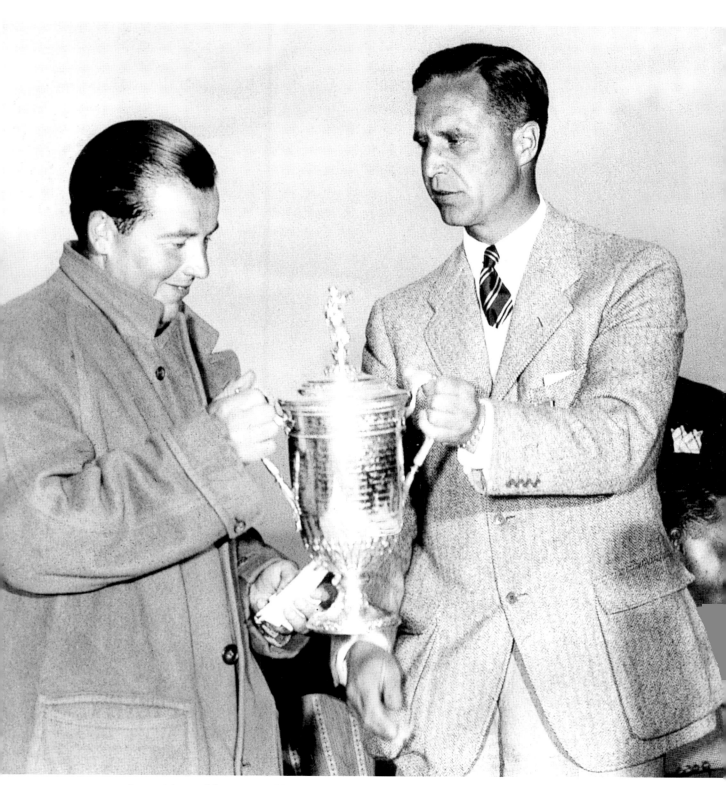

As president of the U.S. Golf Association, Prescott Bush presents Sam Parks Jr. with the organization's trophy cup after Parks won the U.S. Open Golf Championship at the Oakmont Country Club in Oakmont, Pennsylvania, on June 8, 1935.

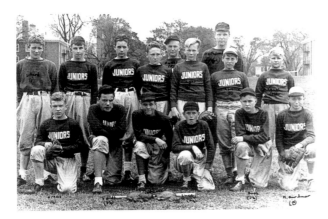

Andover's junior varsity baseball team, circa 1939. Poppy, the team's captain, is second from the right in the first row. During the spring of his junior year, he developed a staph infection under his right arm, a serious affliction in the days before sulfa treatments. He spent two weeks in the Massachusetts General Hospital, his brother Pressy recalled, and "came close to losing his life before they were able to get it under control." The illness negatively affected his grades and forced him to take an extra term of instruction.

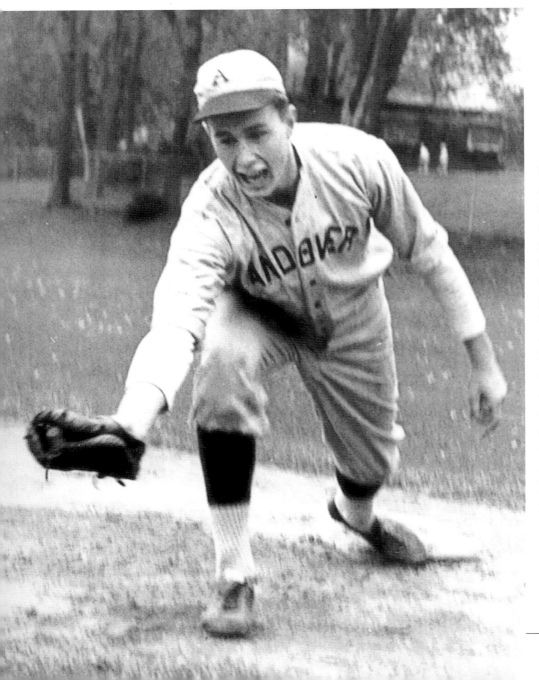

In his senior year, fully recovered, Poppy was chosen captain of the baseball and soccer teams. He had a natural athleticism inherited from both his parents and, his classmates felt, the personality of a leader. One friend called him "a cheerleader with a small *c.*" He supervised the church collections, ran a charity event one year, and was elected president of the school's Greek Club. He wasn't the brightest student Andover had ever had, but he was one of its most popular.

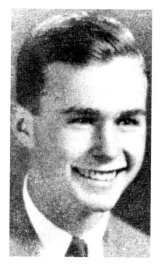

Bush's graduation portrait at Andover shows a good-looking youth with a crooked grin and bright eyes. His classmates voted him third "best all-around fellow," third most respected, third most popular, third handsomest, and second most influential with the faculty. He did *not* place in the "most likely to succeed" category.

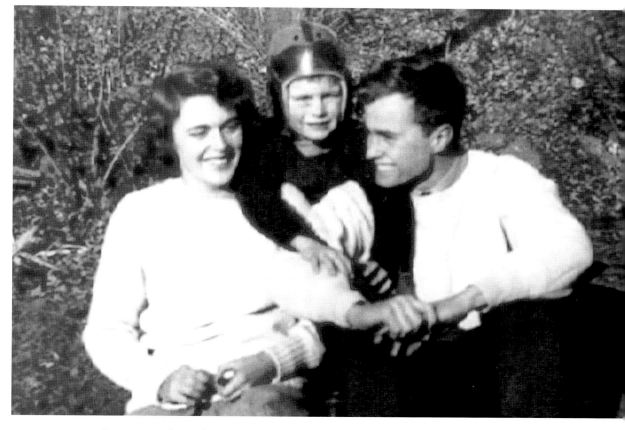

Poppy, nearly eighteen, with his nearly seventeen-year-old girlfriend, Barbara Pierce, and his baby brother Bucky, circa 1942. He had met Barbara at a dance at the Round Hill Country Club in Greenwich six months earlier and found himself attracted to her vitality and earthiness. The daughter of an executive of the McCall Publishing Company, Pierce was a student at Ashley Hall in Charleston, South Carolina, and she returned Poppy's interest in full. "I could hardly breathe when he was in the room," she recalled.

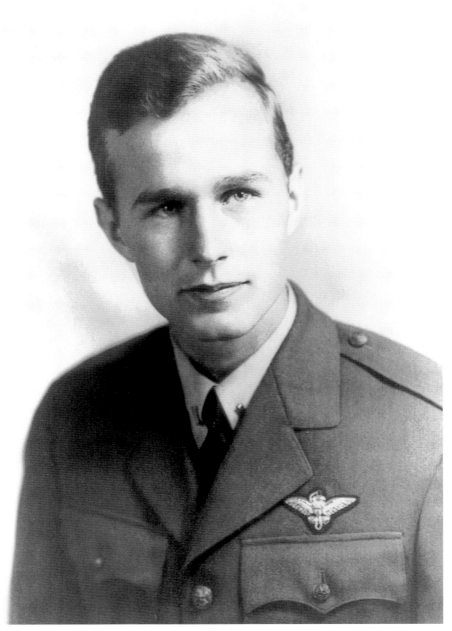

Their romance would have to wait. On his eighteenth birthday in June 1942, six months after America's entry into World War II, George Bush enlisted in the U.S. Navy and was sworn in as a seaman second class. He then traveled to North Carolina by rail for training as an airman. He became the youngest commissioned navy aviator (not yet nineteen) when he got his wings in June 1943, and he became part of a three-man TBF Avenger aircraft team in the South Pacific assigned to the aircraft carrier *San Jacinto*.

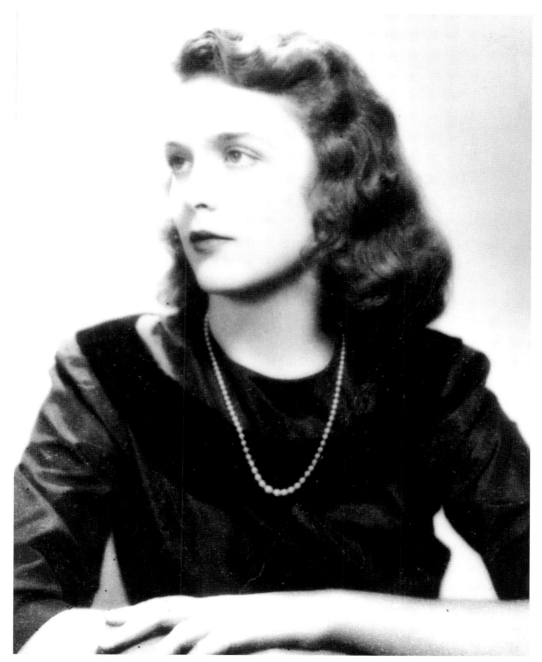

In 1943 Barbara graduated from Ashley Hall. She and George had seen little of each other before he enlisted, but afterward they corresponded regularly, exchanging photographs as keepsakes. Before George's deployment, he and Barbara became "secretly" engaged. (It was, George said, "secret to the extent that the German and Japanese high commands weren't aware of it.") On December 12, 1944, the announcement appeared in the *New York Herald Tribune:* MISS BARBARA PIERCE AND ENSIGN BUSH, NAVY FLYER, TO WED.

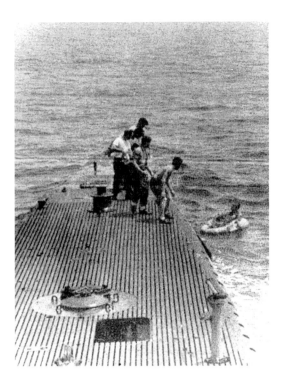

George Bush's aircraft, nicknamed *Barbara,* was hit by Japanese fire above the island of Chichi Jima on September 2, 1944. "Suddenly," he later wrote, "there was a jolt, as if a massive fist had crunched into the belly of the plane. Smoke poured into the cockpit, and I could see flames ripping across the crease of the wing, edging toward the fuel tanks." He continued to fly and dropped his load of 500-pound bombs on the Japanese military listening post on the island below. He shouted to his two crew members to bail out, then did so himself. He hit his head on the plane's rear horizontal stabilizer as he jumped, tearing a gash in his forehead and a hole in his parachute. He hit the water hard, then "swam like hell" to avoid Japanese boats eager to pick up a prisoner of war. He inflated a life raft among his gear and then, bleeding and stung by jellyfish, waited to be rescued.

Crew members of the submarine USS *Finback* threw him a line and pulled him out of the water. He immediately asked about the fate of his fellow pilots. "Later I learned that neither Jack Delaney nor Ted White had survived."

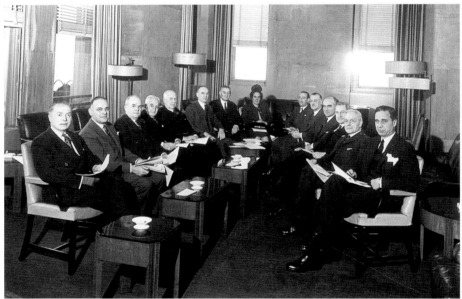

The executive committee of the National War Fund, established in 1943 to coordinate more than six hundred war-relief groups, shown here in the spring of 1945. Its chairman, Prescott Bush, is at the far right. Next to him is John D. Rockefeller Jr. Prescott's talent for fund-raising was duly noted by Connecticut's Republican Party, which the following year named him chair of its finance committee. At home, Dorothy did her part for the war effort with a "victory garden."

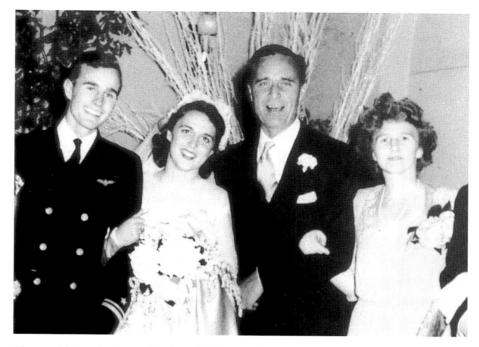

The wedding of George Herbert Walker Bush and Barbara Pierce took place at the First Presbyterian Church in Rye, New York, on January 6, 1945. Barbara had left Smith College, where she admittedly studied little and fared poorly academically, to marry her dashing six-foot-two flyboy. "One might well ask why our parents would sign permission slips for us to marry at the ages of nineteen and twenty," she later wrote. "The answer: In wartime, the rules change. You don't wait until tomorrow to do anything."

Yalie George H. W. Bush with future Yalie George W. Bush in late 1946. The boy, born on July 6 of that year in New Haven, had seemed so reluctant to leave his mother's womb that Barbara's mother, Pauline, gave her a large dose of castor oil in hopes of ex- pediting labor. It apparently worked: The child was born shortly af- terward. "The baby was a lovely boy," Barbara said, "but sad to say, he didn't weigh sixty pounds. That was what I had gained and that was what I had to lose."

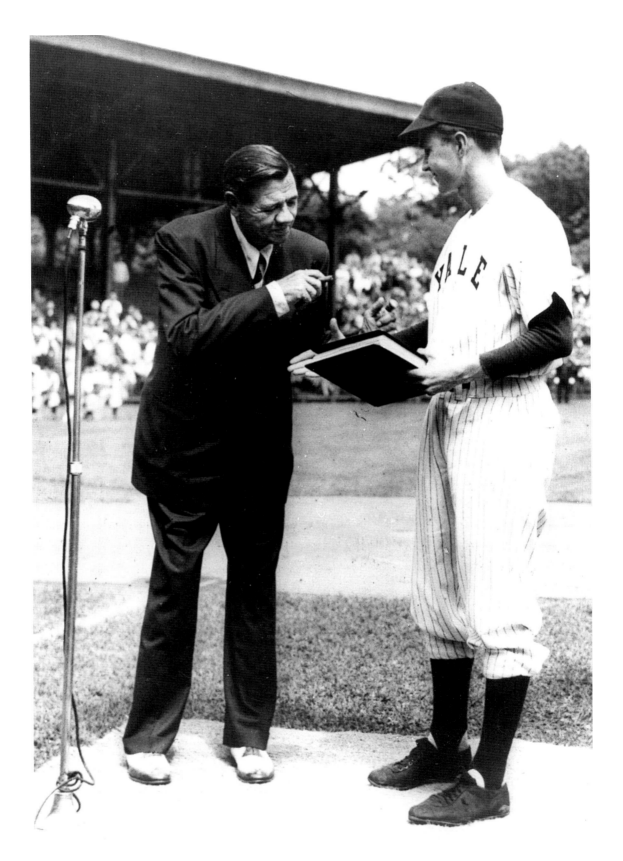

Barbara shows off the nearly two-year-old "Georgie," Easter 1948. The family took pains to tell people he wasn't George Jr., although it proved largely ineffective. His grandmother Pauline said she disliked being alone with the baby because if she didn't give him her full, undivided attention, his face would take on a hurt expression.

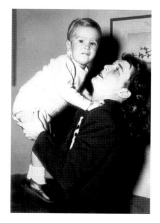

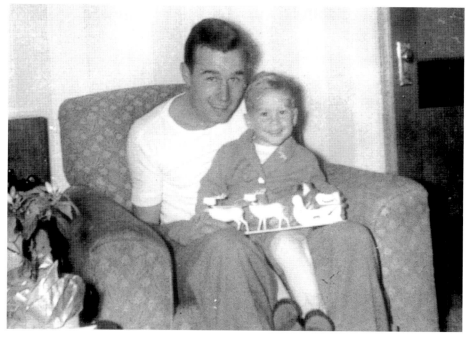

The two Georges, Christmas 1948. The young Bush family had resettled that spring in Odessa, Texas, where George and Barbara felt they could escape certain family pressures. "George's mother was a formidable and strong woman," Barbara recalled, "and so was my mother, and we wanted to get out from under the parental gaze, be on our own!" Also attractive to a young man eager to forge his own way in life: the burgeoning oil industry in Texas. With the help of a family friend, George became a salesman for Ideco, a supplier of drilling rigs, traveling around the Southwest up to a thousand miles a week.

OPPOSITE: "One of the biggest moments" of George Bush's senior year: As captain of the Yale baseball team, he accepts the original manuscript of Babe Ruth's autobiography, presented by the Bambino himself on June 5, 1948. Ruth made the gift to the Yale Library. Ten weeks later, Ruth died of cancer.

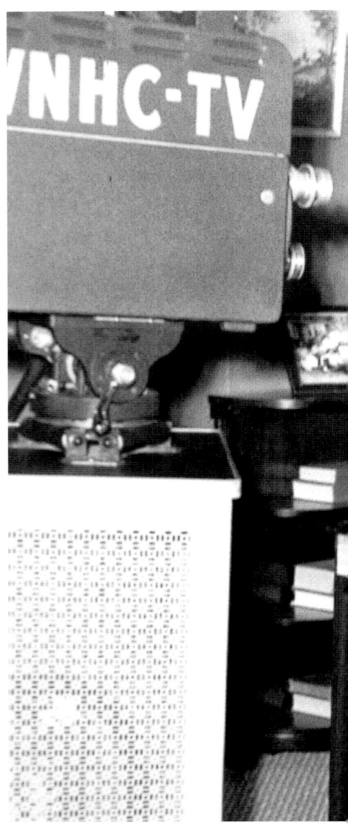

RIGHT: In 1950 Prescott Bush ran as a Republican in Connecticut in a special election for a seat in the U.S. Senate against the interim incumbent Democrat, William Benton, appointed to fill the seat left vacant after the resignation of Republican Senator Raymond Baldwin. Here, he makes a campaign appearance on the local New Haven television station.

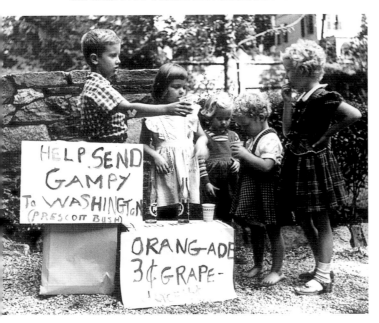

ABOVE: Despite the campaign efforts of his grandchildren, Prescott Bush lost the election by 1,102 votes. The family blamed a radio broadcast by Walter Winchell the Sunday before the election that criticized Prescott's supposed involvement in the Planned Parenthood movement, since there wasn't enough time for him to effectively deny it. His son George recalled, "My own first awareness of birth control as a public policy issue came with a jolt in 1950. . . . Many political observers felt a sufficient number of voters were swayed by [Prescott Bush's] alleged contacts with the birth controllers to cost him the election."

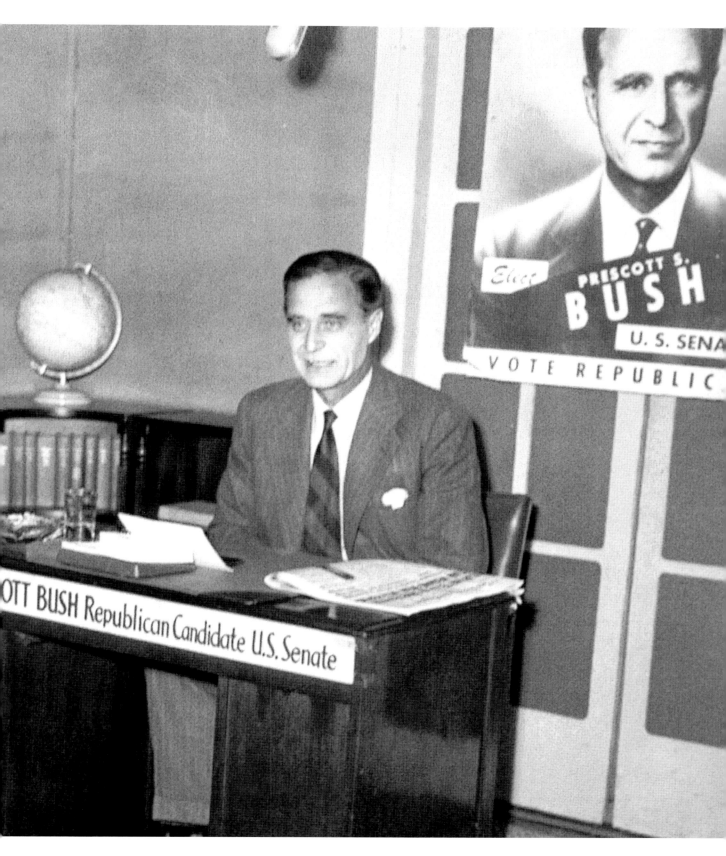

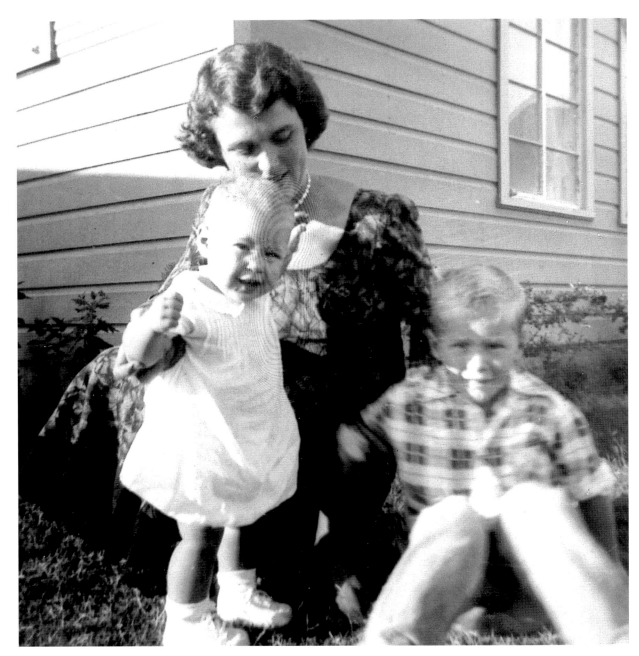

Barbara with her ten-month-old daughter, Pauline Robinson (Robin), and four-year-old son, Georgie, outside their Midland, Texas, home in October 1950. Robin had been born the previous December 20. "George brought Robin and me home Christmas Day," Barbara later wrote. "You can't ask for more than that."

Eight-year-old Georgie and his two-year-old brother, Jeb (John Ellis Bush), circa 1955. Their sister Robin had died of leukemia two years earlier, not yet four years of age. His parents didn't tell little George his sister was dying; he saw her only when she was allowed to leave Sloan-Kettering Institute in New York City for vacation trips to Kennebunkport or home to Midland, Texas. The girl had photos of her brothers next to her hospital bed. Her father, Barbara said, couldn't stand to see his daughter get blood transfusions: "He would say he had to go to the men's room." But when Robin died, her husband proved to be "the rock of our family."

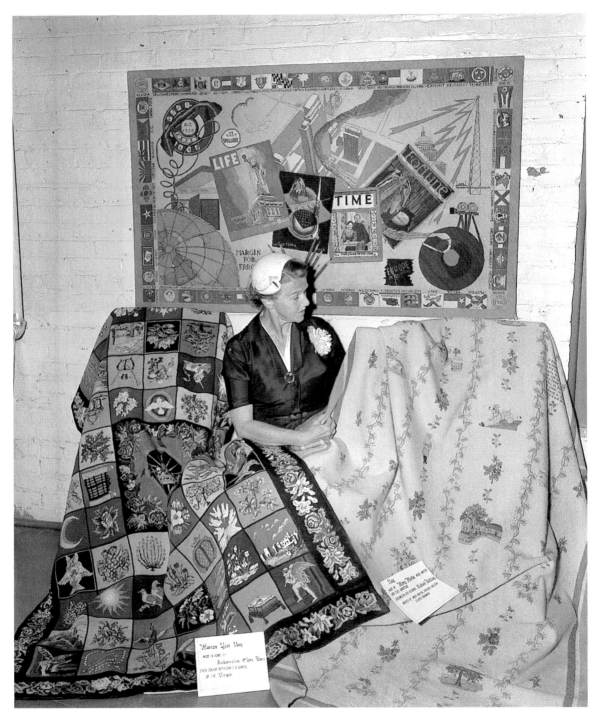

At a needlepoint exhibition in Washington's National Cathedral on April 29, 1955, Mrs. Prescott Bush admires a rug that was made by the actress Mary Martin. The other two pieces were created by Clare Booth Luce, the U.S. ambassador to Italy. Prescott Bush had been elected a Senator from Connecticut in 1952 after winning a special election held following the death of the Democratic incumbent, Brien McMahon.

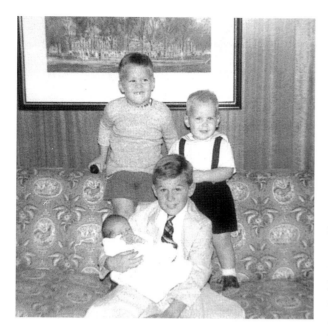

LEFT: Thanksgiving 1956: Little George holds the new-born Marvin as his brothers Jeb and Neil (born in 1955) pose for the camera. Georgie had had night-mares following the death of his sister; it was, a friend said, a "profound and formative" experience for him. His mother's reaction to the tragedy, George W. later said, "was to envelop herself totally around me. She kind of smothered me and then recognized that it was the wrong thing to do."

BELOW: Christmas 1956: Georgie provides musical ac-companiment as Jeb and Neil head for the presents and their mother watches with delight. Three years after Robin's death, life was going well for the Bush family. George had begun his own business, the Bush-Overbey Oil Development Company, in 1950; in 1953 he joined forces with two other men to create a new company, Zapata, named after the Marlon Brando film *Viva Zapata!*, which was playing in Midland at the time. Oil wells gushed. The company, and the George Bushes, flourished.

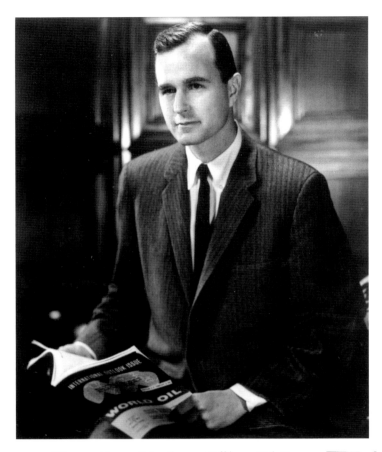

OPPOSITE: President John F. Kennedy receives an honorary doctorate from Yale University on June 11, 1962, accompanied by Senator Prescott Bush and former Secretary of State Dean Acheson (middle). Two and a half years later, Bush retired from the Senate at the age of sixty-nine.

ABOVE: The president of the Zapata Offshore Oil Company holds a copy of *World Oil* in this corporate portrait from the late 1950s.

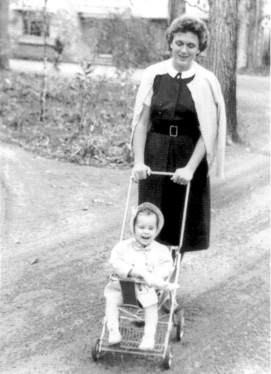

RIGHT: Barbara pushes baby Dorothy in her stroller, late 1960. The Bushes were delighted to have another girl to join their four boys. Barbara's aunt Charlotte told her that she had seen the baby's father just after Dorothy's birth with his head against the nursery window, "tears of joy running down his face."

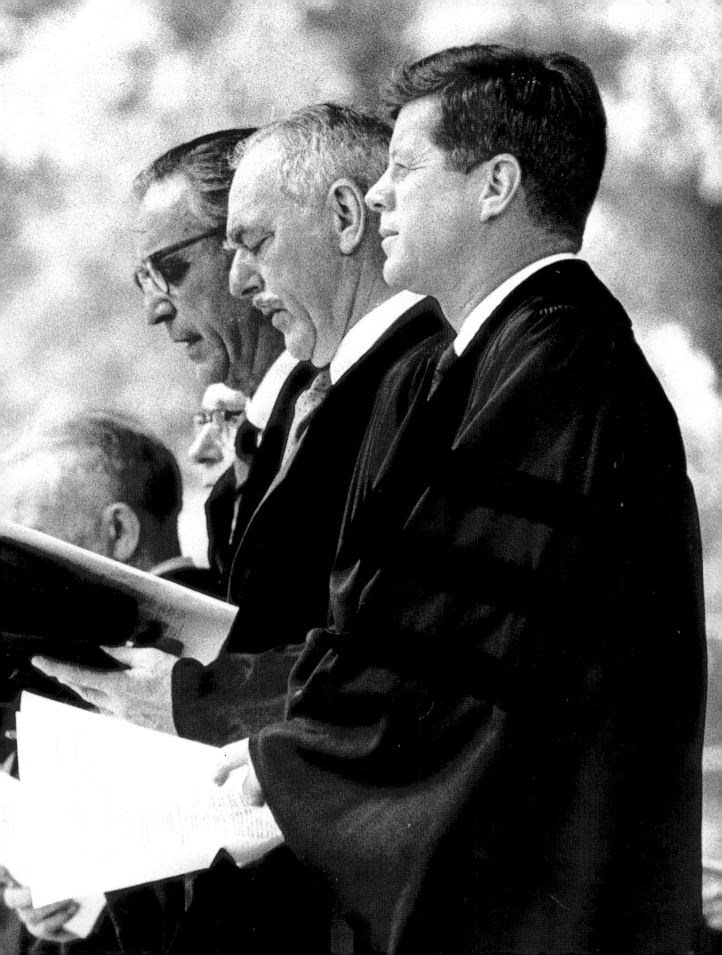

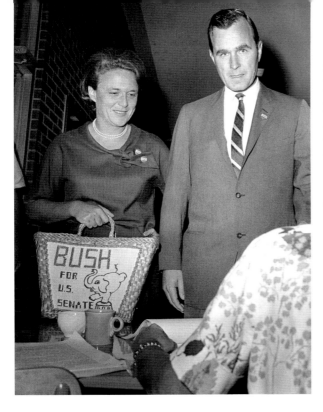

LEFT: Barbara carries a homespun advertisement for her husband as the Bushes vote in the Republican Senate primary in Texas on June 6, 1964. George, thirty-nine, had been chosen chairman of the Harris County, Texas, Republican Party in February 1963 and—like his father—made his first run for elective office at an unusually high level. He ran against a former colleague, Jack Cox, and won the nomination to challenge incumbent Senator Ralph Yarborough.

BELOW: The candidate plays football with his daughter, Doro. In order not to be perceived as a Yankee carpetbagger, George Bush went to great lengths to take on the trappings of a good ol' boy. He dressed the part (after once leaving his home wearing shorts and a flowered shirt and finding out how well *that* went over), dropped his *g*'s, started saying *'em* instead of *them,* and developed a fondness for football and barbecued spareribs.

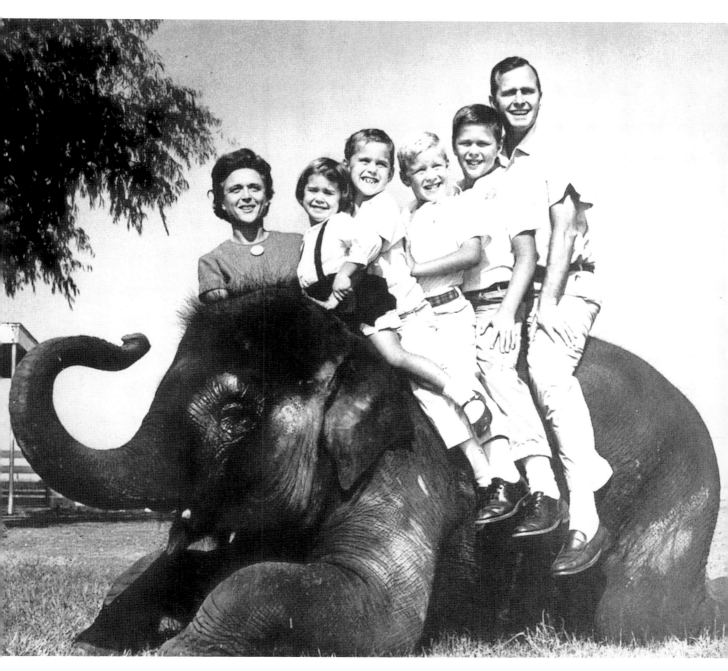

Leaving no doubt which party George Bush represented, the candidate poses with his wife and children (except for Georgie, who was away at Phillips Andover Academy).

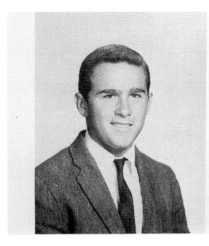

GEORGE WALKER BUSH
"Tweeds" *"Lip"*
5525 BRIAN DRIVE, HOUSTON, TEXAS

YALE
JULY 6, 1946

LOWER
AMERICA

JV Baseball 2,3; Varsity Baseball 4; JV Basketball 2,3; Varsity Basket-
ball 4; JV Football 3,4; Head Cheerleader 4; Athletic Advisory Board
4; Student Congress 4; Spanish Club 2,3,4; Phillips Society 2,3,4; Stick-
ball Commission 3,4; High Commissioner of Stickball 4; Proctor, Amer-
ica House.

Roommate: John Kidde

George W.'s 1964 senior yearbook entry at Phillips Andover revealed that his nick-
names at the school were "Tweeds" and "Lip." He was known there as a handsome,
cocky kid with brilliant blue eyes and a remarkable ability to remember names, a
fun-loving cutup. He didn't excel at academics but made his mark as a cheerleader,
a mimic of the Beatles, and as the "High Commissioner of Stickball."

The Lip and his fellow cheerleaders do the old telephone-booth stunt . . . then
climb a tree to show their support for the school's football team.

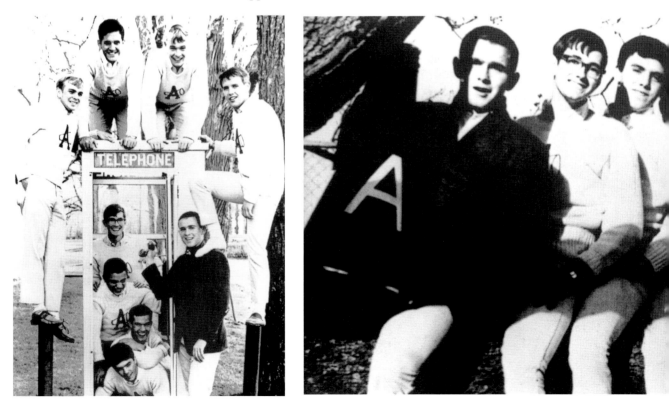

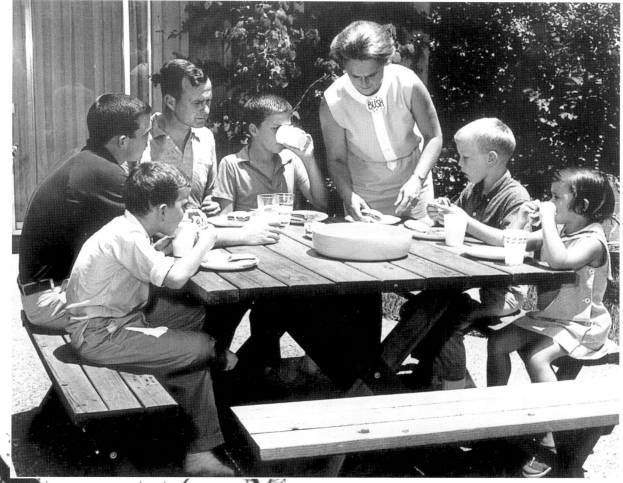

All seven Bushes enjoy a Southern-style cookout during a break in the campaign in the summer of 1964. George W. accompanied his father that July on the "Bandwagon for Bush," a bus caravan that carried them to forty towns throughout Texas.

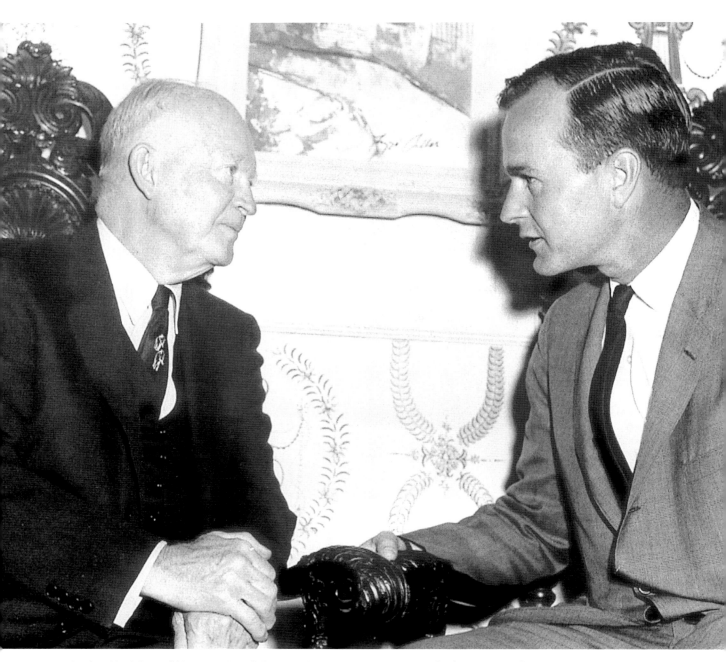

At the 1964 Republican National Convention in San Francisco, which nominated Barry Goldwater for President, George Bush meets with former President Dwight D. Eisenhower. In his campaign, Bush staked out conservative positions to counter Senator Yarborough's liberalism: He opposed President Lyndon Johnson's civil rights bill, the Limited Nuclear Test Ban Treaty, increases in foreign aid, and domestic antipoverty programs. George W. sat in awe while the cheers of his father's supporters washed over him as his father hammered home these positions in speech after speech.

George flashes a victory sign after he and Barbara voted on November 3, but victory was not in the cards. Nineteen sixty-four proved a bad year for Republicans as President Johnson, riding a crest of goodwill after the assassination of John F. Kennedy, buried Goldwater, winning 486 electoral votes to his opponent's 52.

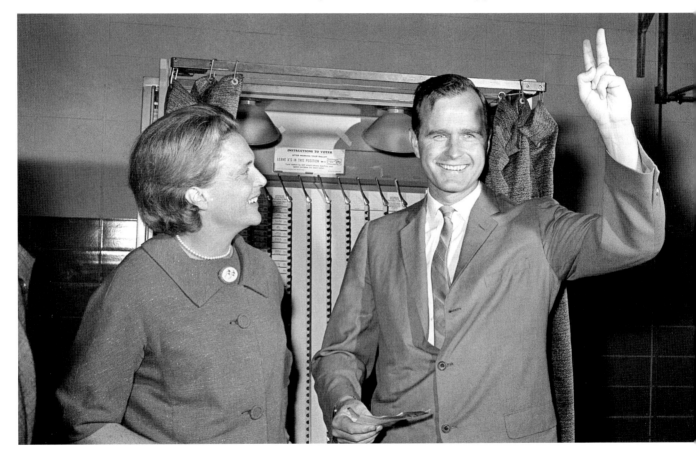

Texas was still a solidly Democratic state in the sixties, and George Bush realized that he had a better chance of winning election locally than statewide. In 1966 he resigned as chairman and CEO of Zapata, sold his stock in the company (which reaped him over a million dollars), and ran for a congressional seat from Houston's Seventh District. He campaigned tirelessly, his eldest son again at his side, and this time the effort proved successful. Here, he and Barbara celebrate on Election Night. "Barbara shared my concern with the way things were going in the country," he later said, "and my feeling that we had an obligation to give something back to a society that had given us so much."

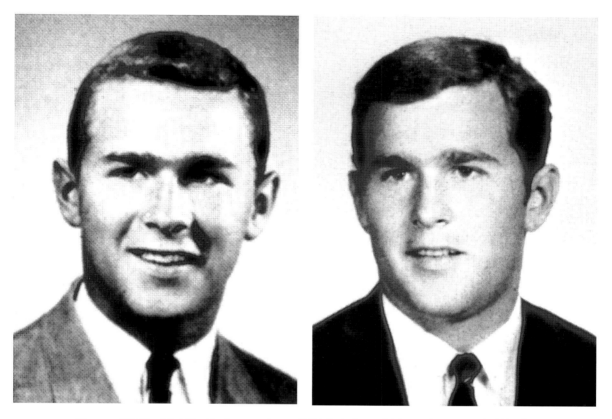

George W. Bush's Yale freshman photo (1964), left, and his senior portrait (1968), right. Just as the Yale sweater he wore as a toddler predicted, Little George had followed his father, grandfather, and assorted uncles to the august Ivy League college in New Haven. As he had in Andover, George impressed his classmates more with his gregarious nature than with his intellectual acumen. His fraternity, Delta Kappa Epsilon, was known for throwing the best parties on campus. In December 1967 he was arrested and charged with disorderly conduct after a beer-soaked night out during which he snatched a Christmas wreath off a storefront. The charges were dismissed. A friend remembered him as "quite outrageous," someone who would "pop off . . . imitate people . . . He got away with it because he was so funny." He graduated from the school in May 1968 with a bachelor of science degree. He had majored in history.

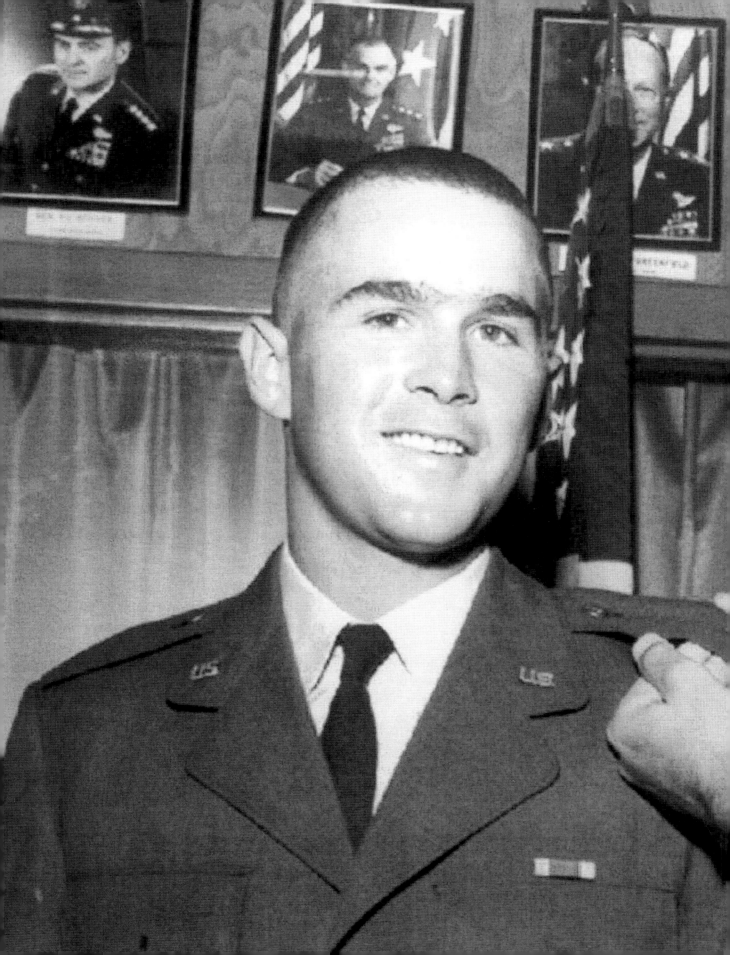

Not long after his graduation, George W. joined the Texas Air National Guard rather than serve in Vietnam. Here, his father pins a lieutenant's bar on his uniform after George was made an officer. Later that year, George H. W. was re-elected to Congress.

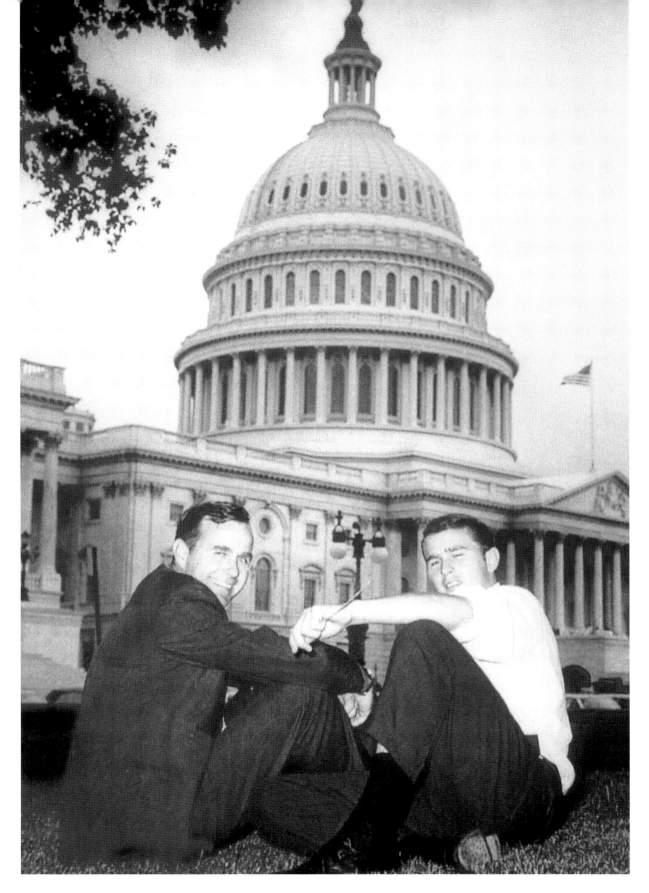

OPPOSITE: Congressman George H. W. Bush and his namesake in front of the U.S. Capitol shortly after George W.'s graduation. One of his fraternity brothers had been amazed to hear good-time George talk seriously one night about his admiration for his father. It was an era in which young people rebelled against their parents, protested the Vietnam War, warned that no one over thirty could be trusted, and felt that most politicians were phonies at best. To hear the son of a Republican congressman openly profess admiration for his father was something the man never forgot.

Barbara, George, and George W. celebrate another Republican Senate nomination for Bush, this time in May 1970. He had expected to have a rematch with Ralph Yarborough, but Lloyd Bentsen defeated the senator in the Democratic primary.

The nominee and his sons during the campaign. With him, left to right, are Neil, fifteen; Jeb, seventeen; George W., twenty-four; and Marvin, fourteen.

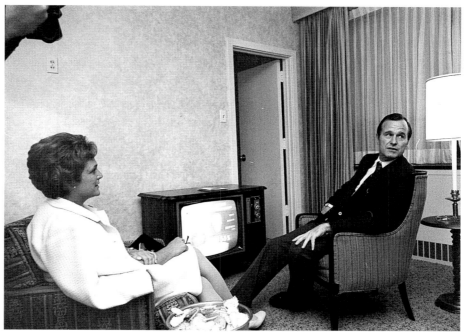

In a Houston hotel suite on November 3, George and Barbara learn from television news that George's second campaign for the Senate has failed. Barbara blamed her husband's defeat on the fact that the Democrats had put a "liquor by the drink" bill on the ballot and "Democrats who otherwise might not have voted turned out in record numbers." More likely, the voters of Texas had not been able to embrace as one of their own a man many still saw as a Connecticut Yankee. George Bush had batted just .500 in general elections, losing twice statewide, and as his wife later said, "Losing isn't much fun." He clearly harbored bigger dreams for his career than representing a small Texas congressional district, and whether George Bush planned it that way or not, his path to the White House would be paved with appointments rather than electoral victories.

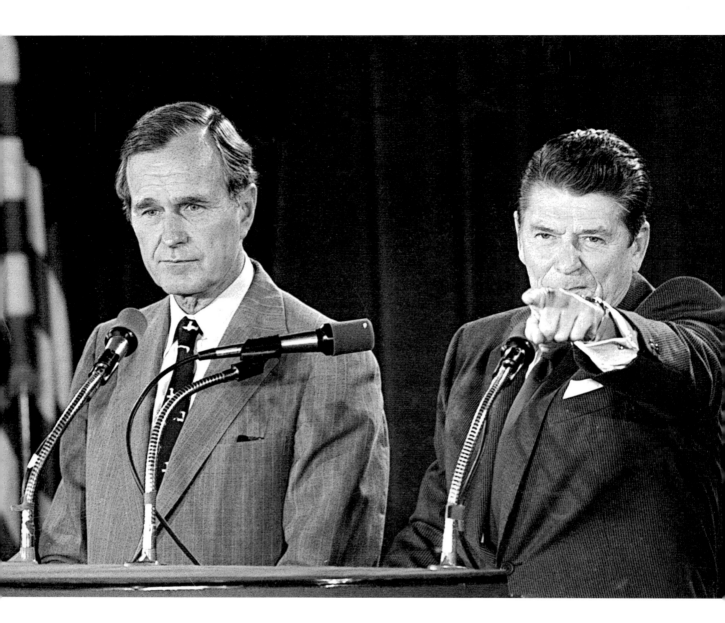

George Bush and Ronald Reagan take questions from reporters
after Reagan announced that Bush would be his running mate, July 17, 1980.

BUILDING
THE RÉSUMÉ

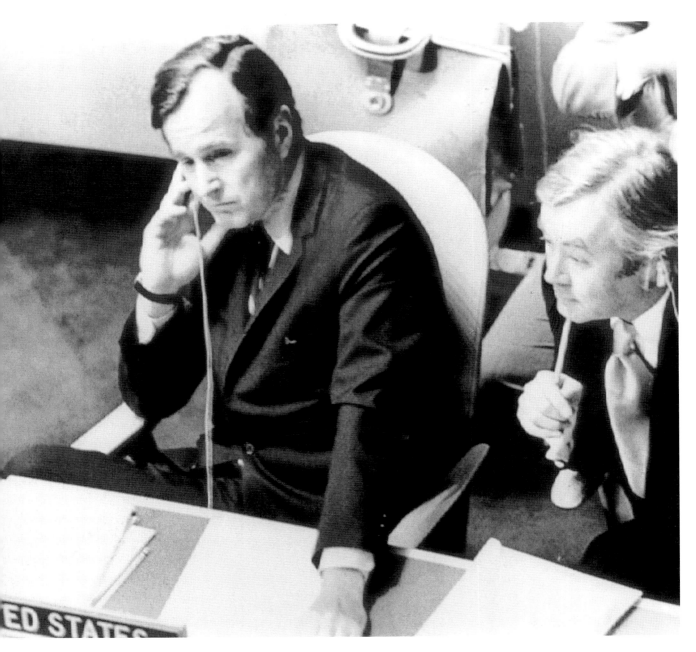

ED STATES

The résumé gets stronger. Little more than a month after the Senate defeat, President Nixon appointed Bush as the U.S. ambassador to the United Nations. (With him here is Daniel Patrick Moynihan, the American ambassador to India at the time.) Nixon selected Bush, he said, "not only [because he] had the diplomatic skills to be an effective ambassador, but also because it would be helpful to him in the future to have this significant foreign policy experience." During his job interview with Nixon, Bush argued that he could be a strong proponent for the administration's policies at a time when the Vietnam War provoked protests at home and abroad. "I was there as an advocate," Bush wrote, "not as an apologist." He held the position for two years.

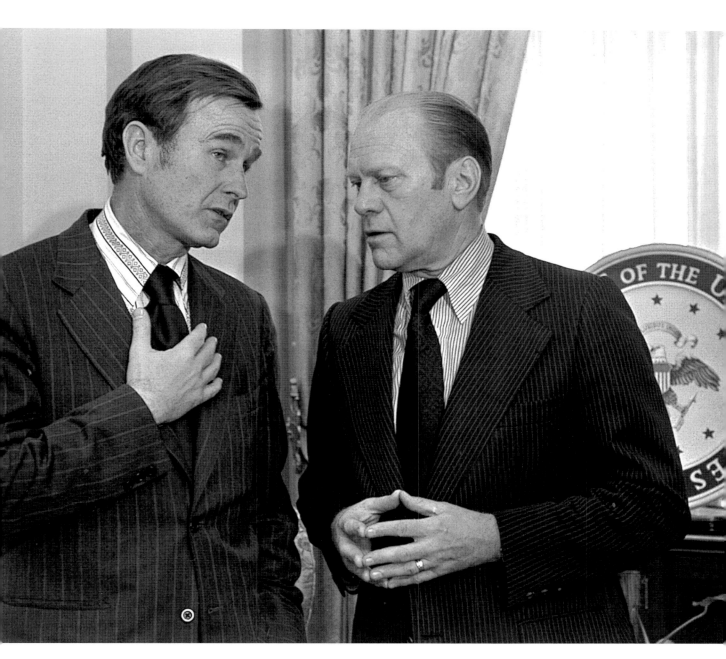

Bush meets with Vice President Gerald Ford in Washington on December 18, 1973. A year earlier President Nixon had offered Bush the job of chairman of the Republican National Committee, and although Barbara told him, "Anything but that," he accepted. "How can you turn down a President?" Bush asked her. Less than eighteen months later, Gerald Ford became President after Nixon's resignation in the wake of the Watergate scandal. It was not a good time to be the head of the Republican Party. "George always said dealing with Watergate was like dealing with a stampede," Barbara wrote. "The other shoe kept dropping."

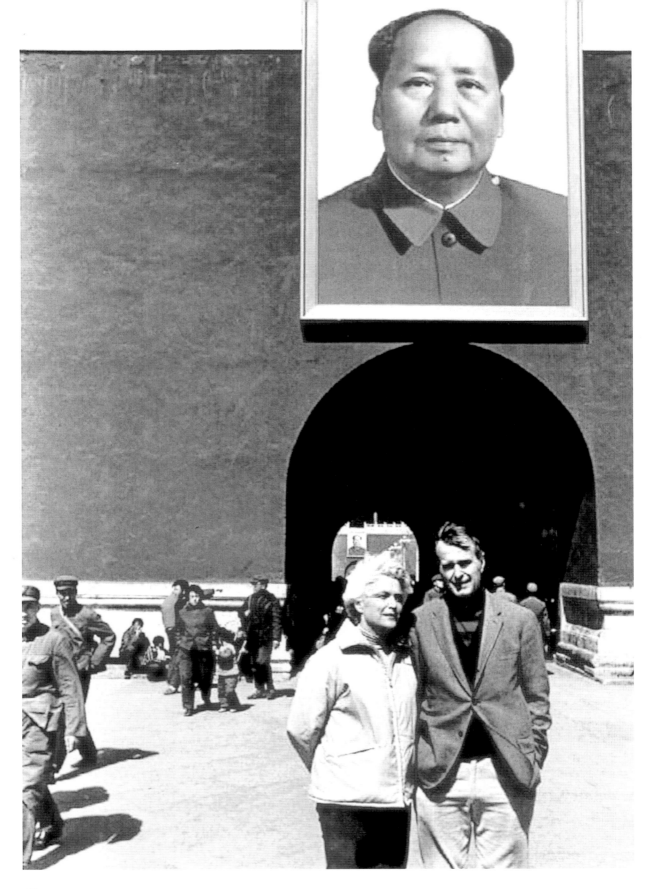

OPPOSITE: In 1974, after he passed over Bush in favor of Nelson Rockefeller as his Vice President, Gerald Ford appointed him ambassador to China. Bush could have had plusher postings in London or Paris, but he preferred Beijing because he felt "that was where the action was"—and, a friend said, because he "wanted to get as far away as possible from the stench of Watergate." Here, he and Barbara sightsee in a Beijing square as Chairman Mao keeps an eye out. Their children visited several times, Barbara recalled, and George W. "ran for miles every day" in Beijing.

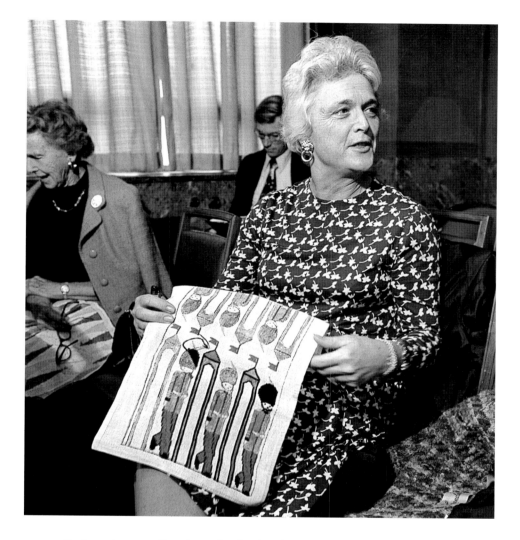

ABOVE: Barbara does needlepoint as her husband testifies before the Senate Armed Services Committee, which was considering his nomination to head the Central Intelligence Agency, December 16, 1975. President Ford had asked him to return from China to take over the controversial agency, which was seen by many as abusive of its power. He hesitated at first, worried that the job was "a graveyard for politics" and concerned that his children, nieces, and nephews would disapprove. His son George urged him to take the job, and he did—mainly because, he wrote to his siblings, "it's a tough, mean world and we must stay strong."

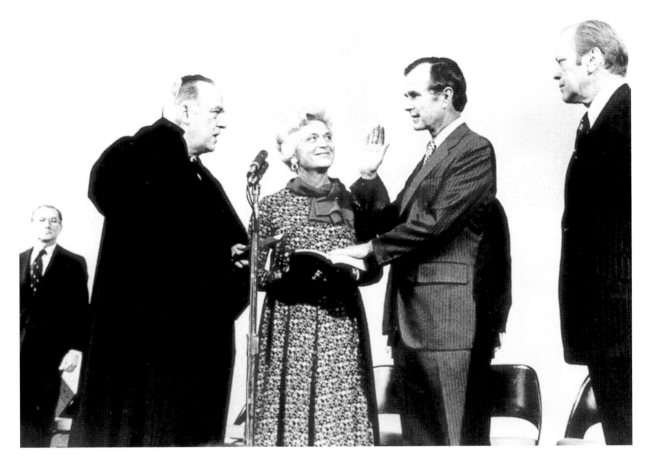

Despite some opposition to his appointment among the committee members—
mostly because of their worry that he would leave the post before long to become
Gerald Ford's running mate—Bush's nomination was approved by the Senate. On
January 30, 1976, Barbara holds the family Bible as Supreme Court Justice Potter
Stewart swears her husband in as CIA director. President Ford looks on at right.
Bush remained head of the CIA only until January 1977, when Jimmy Carter re-
placed Gerald Ford as President. George and Barbara returned to Houston, where
Ross Perot offered Bush a position with his company, Electronic Data Services.
Bush turned him down, instead becoming a consultant to First International Bank-
shares of Dallas and a director of its London affiliate. Directorships on the boards of
other companies, such as Eli Lilly and Texas Gulf, Inc., would eventually earn him
more than a quarter million dollars a year.

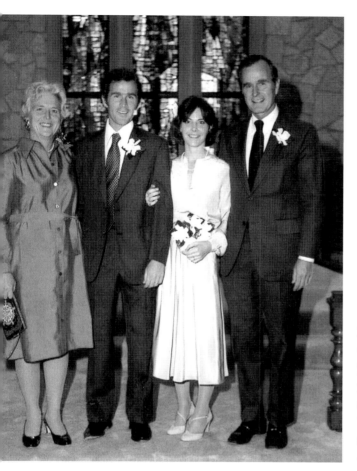

LEFT: Mr. and Mrs. George W. Bush pose with his parents after their wedding in Midland, Texas, on November 5, 1977. George met the former Laura Welch, a pretty, serene school librarian, the previous August, and both had immediately been smitten. "He's so cute," Laura told friends. George's friends and family felt she "took the rough edges off him." George felt "the best decision I ever made was asking Laura to marry me. I'm not sure the best decision she ever made was saying yes. But I'm glad she did."

BELOW: After following in his father's footsteps as a Texas oil entrepreneur, George W. decided to follow him into politics as well. Here, George and Laura campaign for a congressional seat from Midland during the summer of 1978. As in his father's first Senate campaign, his opponents called George W. a Yankee carpetbagger (even though he had grown up in Midland) and questioned how he had managed to be worth "half a million dollars," as he told a reporter, when he seemed not to have much of a business track record. George won the Republican nomination but lost the election. He blamed the defeat on the voters' "provincialism" and said his biggest regret was not having been born in Texas. Still, he later said, "getting whipped was probably a pretty good thing for me."

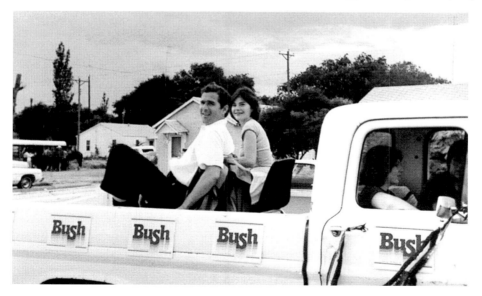

May 1, 1979: George H. W. Bush announces his candidacy for the presidency of the United States. Cheering him on at the National Press Club in Washington, D.C., are (left to right) Jeb; his wife, Columba; Marvin; Doro; Barbara; Neil; Dorothy Bush; as well as Laura and George W.

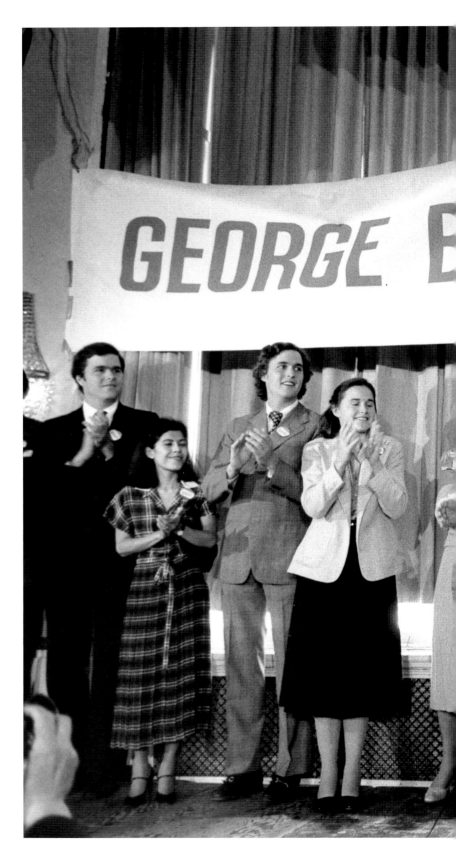

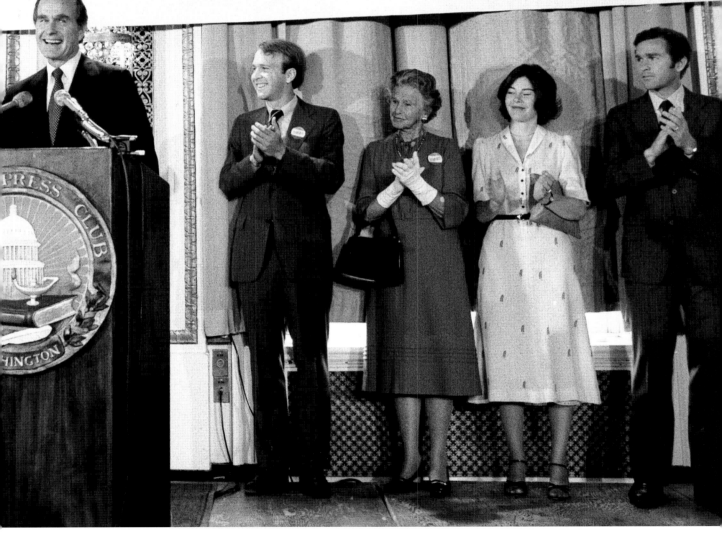

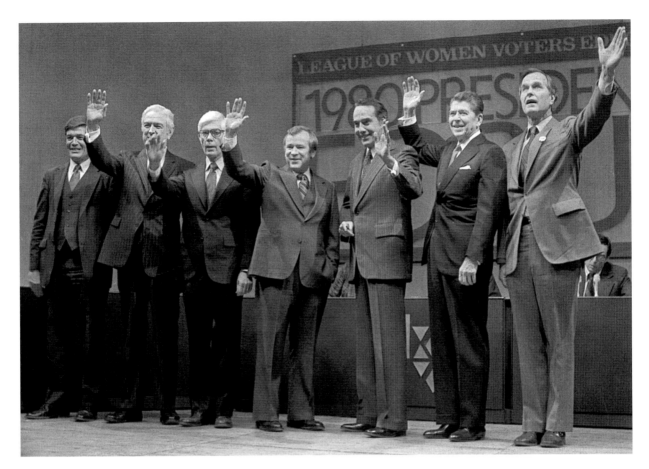

ABOVE: Prior to a debate at Central High School in Manchester, New Hampshire, on February 20, 1980, the Republican presidential hopefuls wave to the audience. With Bush, left to right, are Philip Crane, John Connally, John Anderson, Howard Baker, Robert Dole, and Ronald Reagan. One-third of viewers felt Reagan won this debate, while only 17 percent thought Bush had. Three nights later Reagan stood up strongly to a debate moderator who attempted to cut off his microphone, providing a pivotal moment in the primary campaign. Reagan beat Bush in New Hampshire by 26 percentage points, a devastating setback.

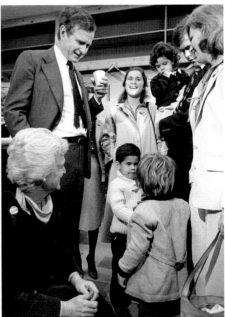

RIGHT: At Bush for President headquarters in Hartford, Connecticut, on March 24, 1980, George and Barbara watch as their four-year-old grandson, George Prescott, greets another child. George's father, Jeb Bush, holds his two-year-old daughter, Noelle. After Ronald Reagan went on to win twenty-eight of the next thirty-two Republican primaries, his nomination was ensured.

LEFT: But the campaign wasn't over for George Bush. Although a *Chicago Sun-Times* headline shouted IT'S REAGAN AND FORD!, Reagan offered the VP spot to Bush—despite his having called the former California governor's fiscal plans "voodoo economics." Bush balanced the ticket well, bringing to Reagan two important things he lacked: foreign policy experience and strong Washington connections. For Bush, a man whose career had consisted of incremental steps upward, the decision to accept the assignment wasn't difficult. The rigors of the campaign were, however, as this photograph of Bush in Cleveland on September 17 clearly shows.

BELOW: Gerald Ford lends his support to the Reagan-Bush ticket during a joint appearance in Peoria, Illinois, on November 3, the day before the election. Finals polls showed Reagan and President Jimmy Carter in a tight race.

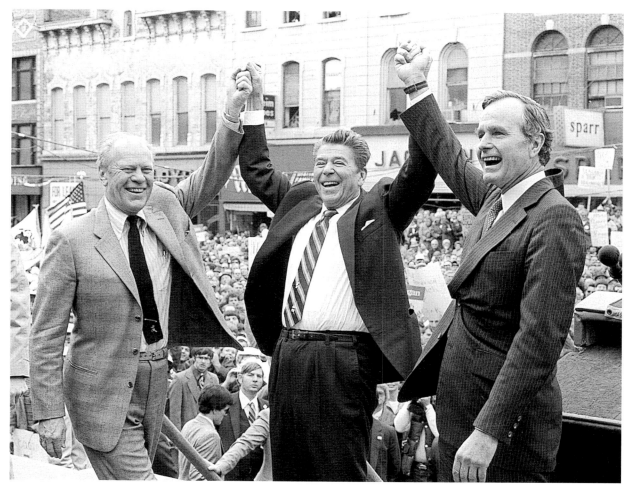

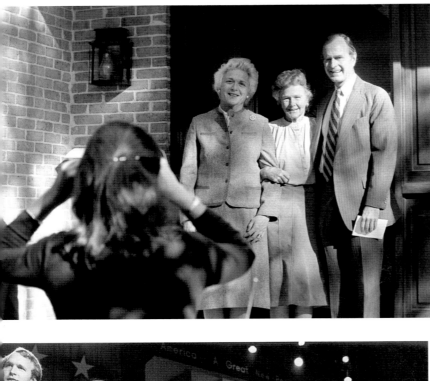

Daughter Doro photographs Vice President-elect and Mrs. Bush as they pose with his mother, Dorothy, on the steps of the Bush home in Houston on Wednesday, November 5. The day before, the Reagan-Bush ticket had won a surprisingly broad victory over Jimmy Carter and Walter Mondale, winning forty-six states for an electoral-vote margin of 489 to 49.

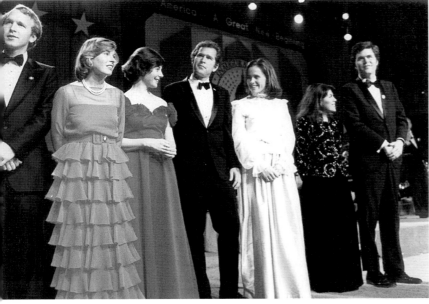

At the inaugural ball on January 20, 1981: Neil; his wife of six months, Sharon; Laura and George; Dorothy; and Columba and Jeb are dressed to the nines as they celebrate their father's swearing-in. "They looked beautiful," Barbara gushed. The day proved even more special than usual, as fifty-four American hostages held by Iran for more than a year were released during Reagan's inaugural address.

The Bushes spend an evening with the Reagans at Blair House, the Vice President's residence, on February 12, 1981. There were rumors of coolness between the First and Second Families, born not only of differences in political temperament but of personality as well. Bush denied this. He said his political rivalry with Reagan was over (and in fact his politics had become more conservative) and professed a deep fondness for his boss, whom he found easy to get close to in one-on-one situations—unlike Nixon, whom he found kept "pulling back."

LEFT: March 30, 1981: The Vice President flies back to Washington from Texas after learning that President Reagan had been shot by would-be assassin John Hinckley. Information was spotty, and often erroneous first reports indicated that presidential press secretary Jim Brady had died from his gunshot wound and that the president was uninjured. The House majority leader, Texas Democrat Jim Wright, traveling with Bush, recalled that the vice president "demonstrated a complete command of his emotions" in the face of what could have been a cataclysmic event in American history. On the plane Bush prayed for the President's recovery.

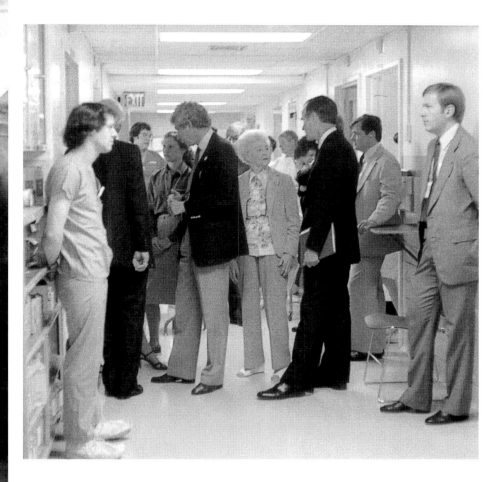

ABOVE: Four days later, Bush waits outside the President's room at George Washington University Hospital. Upon his return to Washington, Bush met with top administration officials in the White House Situation Room and told them, "The more normal things are, the better. If reports about the President's condition are encouraging, we want to make the government function as normally as possible. Everybody has to do his job." The American government continued to run smoothly, and on April 11 Bush helped welcome Reagan back to the White House. His graceful handling of the crisis won him admiration even from Reagan loyalists who had distrusted him.

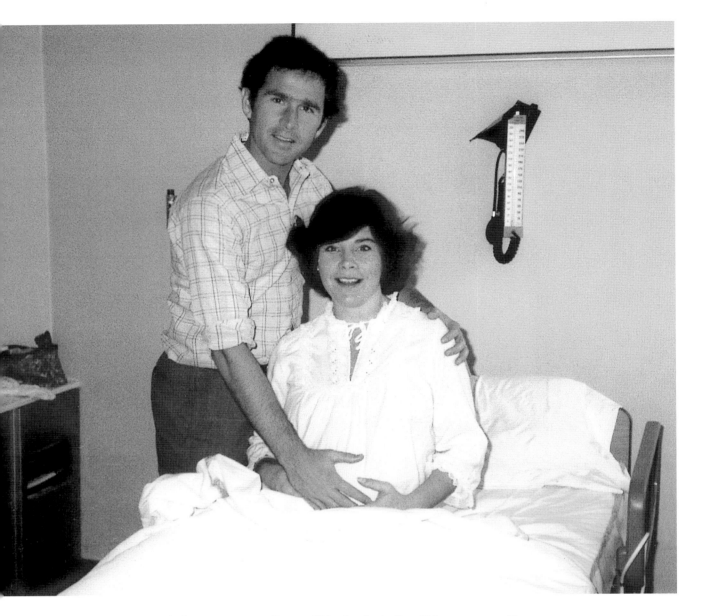

A hospital scene of a happier nature: George W. rubs the belly of his pregnant wife as they await the birth of twins in November 1981. They had tried unsuccessfully to have a baby for three years, and Laura blamed herself. "Look at the size of George's family, and then look at mine," she said to friends. (She was an only child; her mother had miscarried a number of times.) Doctors told them that Laura could not conceive, and she fell into a depression. They were about to finalize an adoption when Laura's doctors told her she was pregnant. She and George both sobbed at the news. "It was like a miracle," she said.

A delighted George holds his healthy daughters Jenna and Barbara, born November 25, 1981. The pregnancy had been difficult and dangerous for Laura and the fraternal twins; Laura developed toxemia, a condition that threatened her life and the lives of the babies. "That was a very emotional time for George," a friend said. "He was very worried about Laura." Doctors induced labor five weeks early, when Laura's kidneys threatened to fail. "I witnessed it all" in a Dallas, Texas, hospital, George said of the delivery. "It was beautiful—the most thrilling moment of my life."

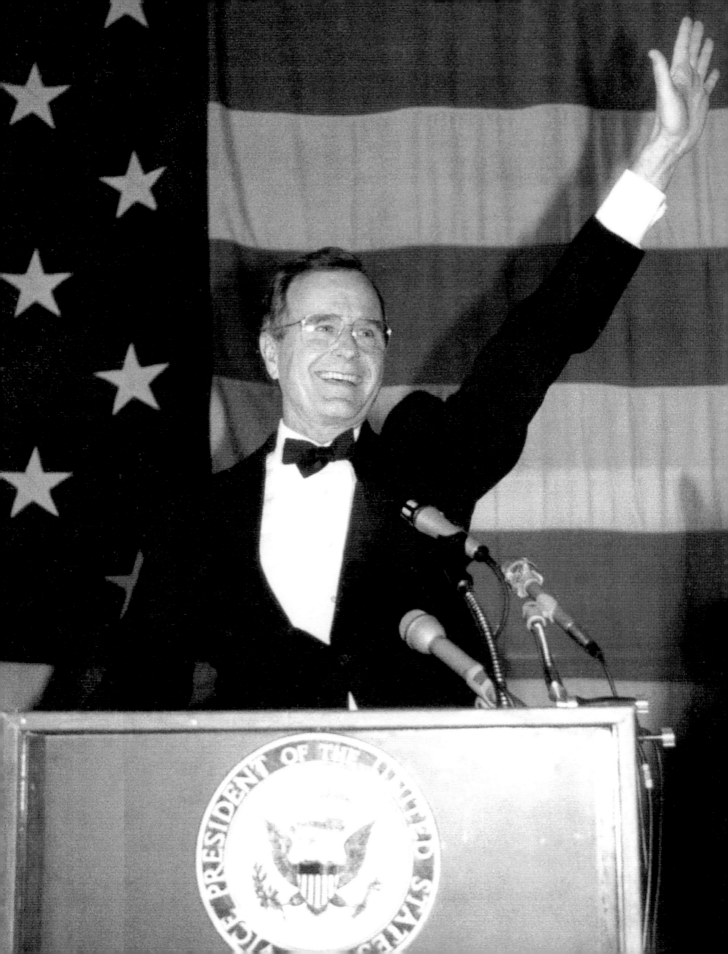

BELOW: George and Laura hold their girls and watch along with his mother as the Vice President addresses a crowd at a Reagan-Bush rally in Midland, Texas, on May 31, 1984.

OPPOSITE: Vice President Bush responds to cheers at a Young Republicans dinner on March 17, 1984. He had been a loyal lieutenant in the Reagan army, had traveled 1.3 million miles in the United States and abroad, and was increasingly seen as Reagan's heir apparent to the presidency. But first the Reagan-Bush team would have to win re-election, and in the spring of 1984 that was hardly a foregone conclusion.

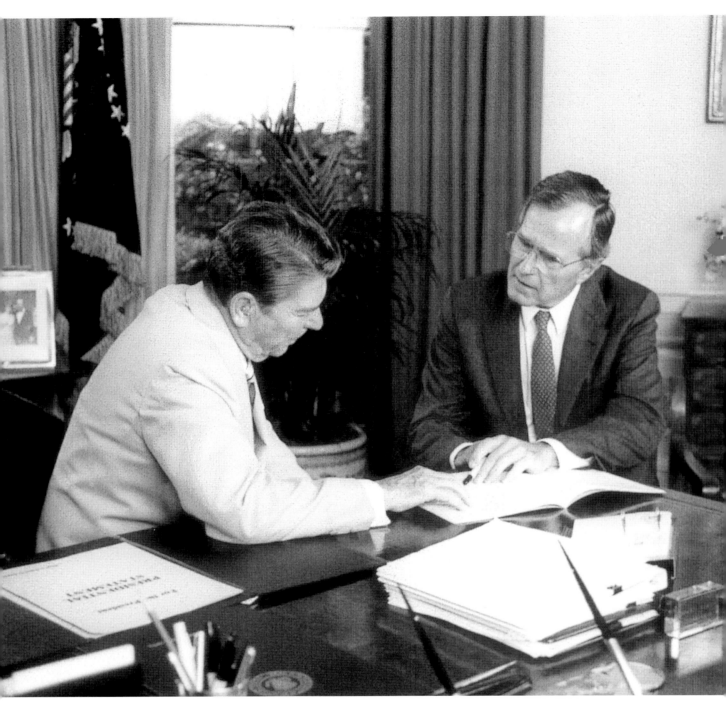

In the Oval Office on July 20, 1984, Reagan and Bush go over plans for the Republican National Convention in Dallas the following month. The economy, weak at the end of 1983, had begun a recovery, and America's stature in the world had improved as a result of Reagan's tough stance against communism. The Reagan-Bush re-election theme would be "It's morning in America."

With the nomination of New York Congresswoman Geraldine Ferraro as Walter Mondale's running mate, George Bush found himself in the unprecedented position of running against a woman for national office. Ferraro neatly summed up Bush's dilemma: "[He] had to stand up to me and yet not be so aggressive he'd end up looking like a bully." In their one debate, on October 11, Ferraro responded to the Vice President's comment "Let me help you with the difference, Mrs. Ferraro, between Iran and the embassy in Lebanon" with this biting riposte: "Let me just say, first of all, that I almost resent, Vice President Bush, your patronizing attitude that you have to teach me about foreign policy." Most viewers judged Bush as the debate victor; the conservative *New York Post* ran a blazing headline the next day: GEORGE WINS ONE FOR THE GIPPER!

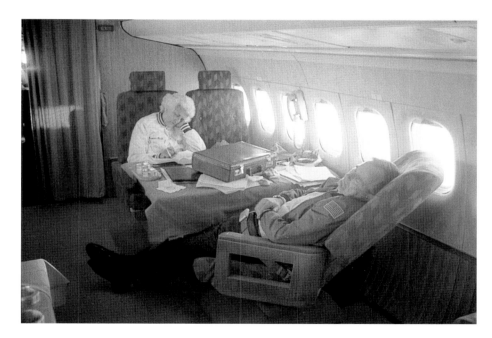

Two weeks later, George and Barbara catch a few winks on *Air Force Two* as they travel from one campaign stop to another. On November 4 the Reagan-Bush ticket captured forty-nine states to win the most lopsided electoral college majority in history, 525 to 13.

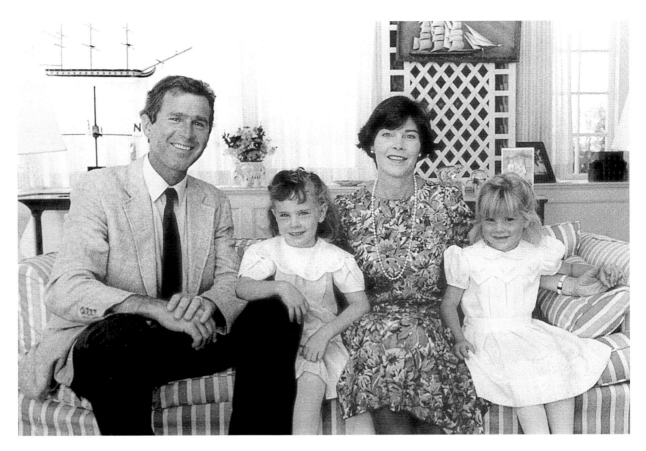

At the Bush family's summer retreat in Kennebunkport, Maine, on August 24, 1986, the George W. Bushes pose for a family portrait. Less than two months earlier, W. (as he was most often called now) had given up drinking. His drunken diatribes against journalists whose stories he didn't like and his sometimes obnoxious party-boy behavior had put such a strain on his marriage that Laura reportedly told him she would take the girls and leave if he didn't stop. She was skeptical when he announced, after a drunken birthday party in June, that he was quitting. But he kept his pledge. "Alcohol was beginning to compete for my affections with my wife and my family," he explained. "It was beginning to crowd out my energy and I decided to quit."

The Vice President on a fishing trip in June of 1987.

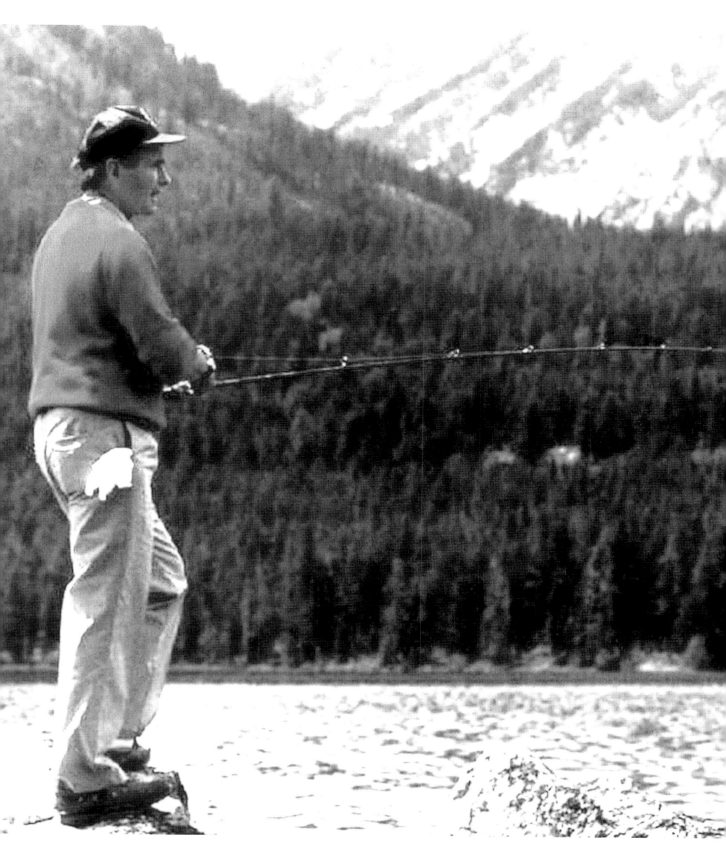

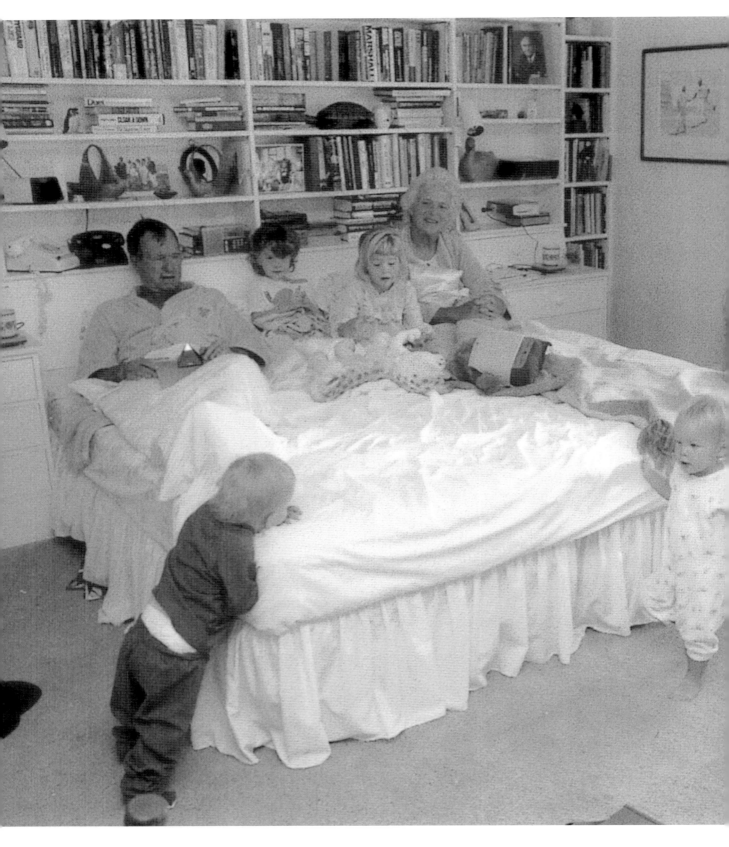

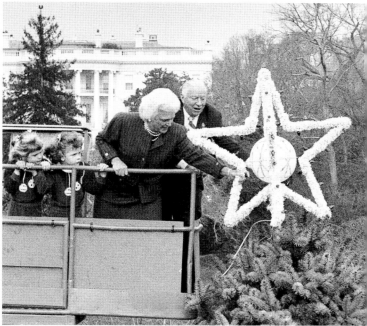

LEFT: George and Barbara in their bedroom with assorted grandchildren during their annual summer vacation in Kennebunkport, 1987. Daughter-in-law Margaret, Marvin's wife, looks on.

ABOVE: The Second Lady places the main ornament on top of the national Christmas tree near the White House, November 25, 1987. Watching her are Jenna and Barbara and Joseph H. Riley, president of the Christmas Pageant of Peace, Inc.

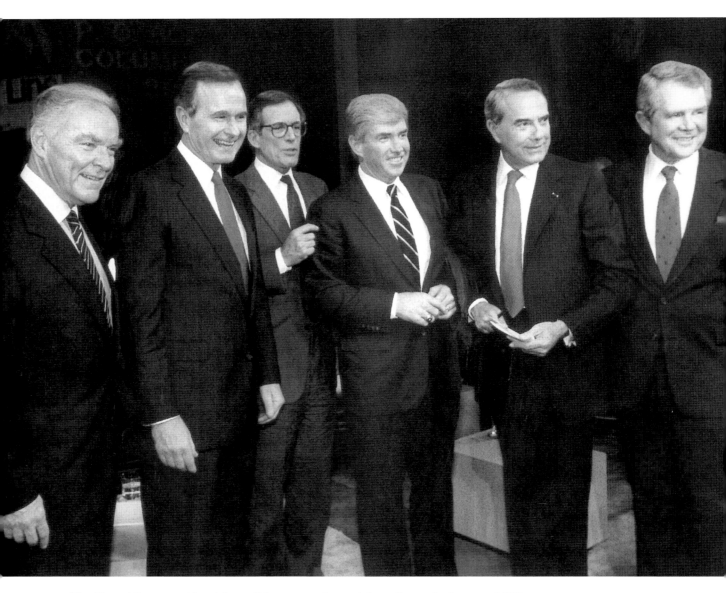

The Republican presidential candidates at an Iowa debate forum in January 1988. With the Vice President, left to right, are former Secretary of State Alexander Haig, former Delaware Governor Pierre "Pete" du Pont, Congressman Jack Kemp, Senator Bob Dole, and the televangelist Pat Robertson. If Bush expected a coronation as a sitting Vice President, he was in for a rude surprise. His opponents hit him hard on the Iran-Contra scandal, in which representatives of the administration sold arms to Iran in exchange for the release of hostages and then funneled the money to resistance forces (*Contras*) in Nicaragua. The illegal operation led to criminal actions against several White House officials. Two convictions were reversed on appeal and Bush (just before he left office as President in 1992) pardoned several others, some prior to trial or even indictment. Both Reagan and Bush were cleared of any direct involvement, and the Vice President said he resented being asked questions about it, "as if I hadn't answered them."

More questions came Bush's way on January 25, 1988—three weeks before the New Hampshire primary—during an interview by Dan Rather on the *CBS Evening News*. Bush deflected repeated queries about Iran-Contra and turned the tables on Rather by asking, "How would you like it if I judged your whole career by those seven minutes when you walked off the set in New York?" Although many viewed Bush's counteroffensive as a triumph, it didn't help him win the Iowa caucuses. Shockingly, he came in third behind Dole and Robertson. Winning the New Hampshire primary became vital; if Bush lost that one too, his campaign would likely be over. On February 16, he beat Dole in New Hampshire by nine points. In his victory speech, he paraphrased Mark Twain: "Reports of my death have been greatly exaggerated." He went on to sweep the Super Tuesday primaries and clinched the nomination with a victory in Pennsylvania on April 26.

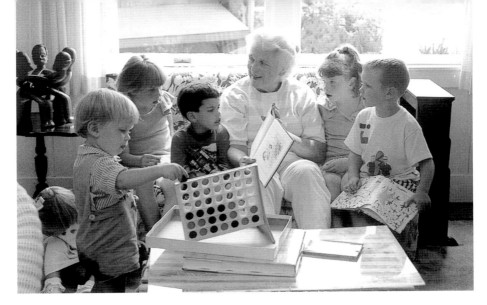

Barbara reads to several of her grandchildren in Kennebunkport on August 7, 1988, as her husband prepares his acceptance speech for delivery at the Republican convention in New Orleans less than two weeks later.

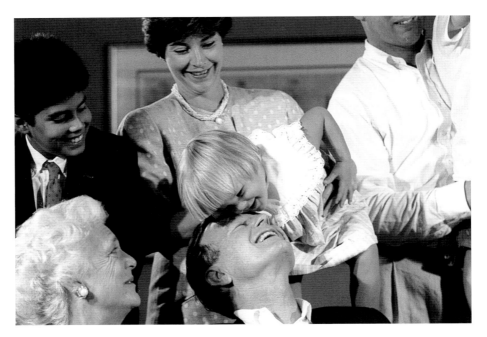

Laura Bush holds her two-year-old niece, Marshall, as Gampy nuzzles her during the nomination roll call in New Orleans, August 17, 1988. In a memorable acceptance speech the next day, Bush spoke of his vision for a "kinder, gentler" America than Ronald Reagan had presided over. The strongest reaction from the delegates, however, came in response to his pledge not to raise taxes. "My opponent won't rule out raising taxes," he said. "But I will. The Congress will push me to raise taxes, and I'll say no, and they'll push, and I'll say no, and they'll push again." Then, in a departure from his prepared text, he thundered, "And all I can say to them is, 'Read my lips, no new taxes!' "

The nominee embraces his wife at a reception in her honor at the convention, August 18.

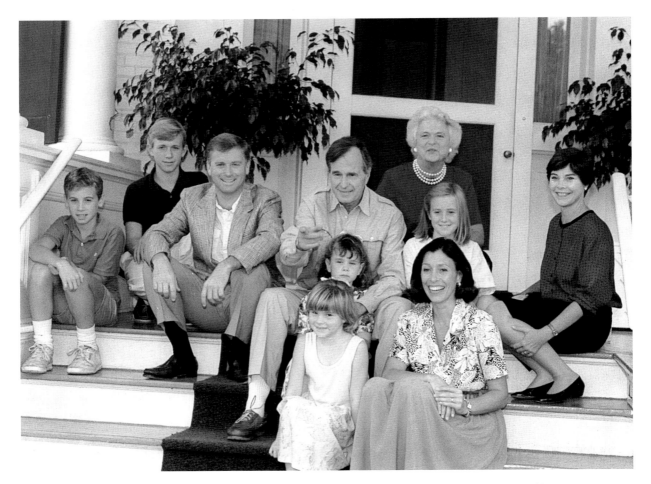

ABOVE: George and Barbara pose with vice presidential nominee Dan Quayle and his wife, Marilyn, during a Sunday lunch at Blair House on September 11. With them, left to right, are Quayle's sons, Ben and Tucker, Bush granddaughters Barbara and Jenna, and Quayle's daughter Corinne. Bush's selection of Quayle, a relatively young (forty-one), virtually unknown senator from a small state (Indiana), surprised many. Bush considered Quayle's youth a plus: He wanted to appeal to younger voters, and the Hoosier's strong conservatism would placate the Republican right wing, many of whom still didn't adore George Bush the way they had Ronald Reagan.

OPPOSITE: October 13, 1988: Democratic nominee Michael Dukakis acknowledges the cheers of his partisans after his second debate with George Bush, at UCLA's Pauley Pavilion. Dukakis had been perceived by most as the winner of the first debate sixteen days earlier, but during this one, moderator Bernard Kalb issued a knockout punch to Dukakis early by asking the death-penalty opponent how he would react if his wife, Kitty, was raped and murdered. The governor's cool, measured response was viewed by many as unfeeling, and Dukakis's campaign never recovered.

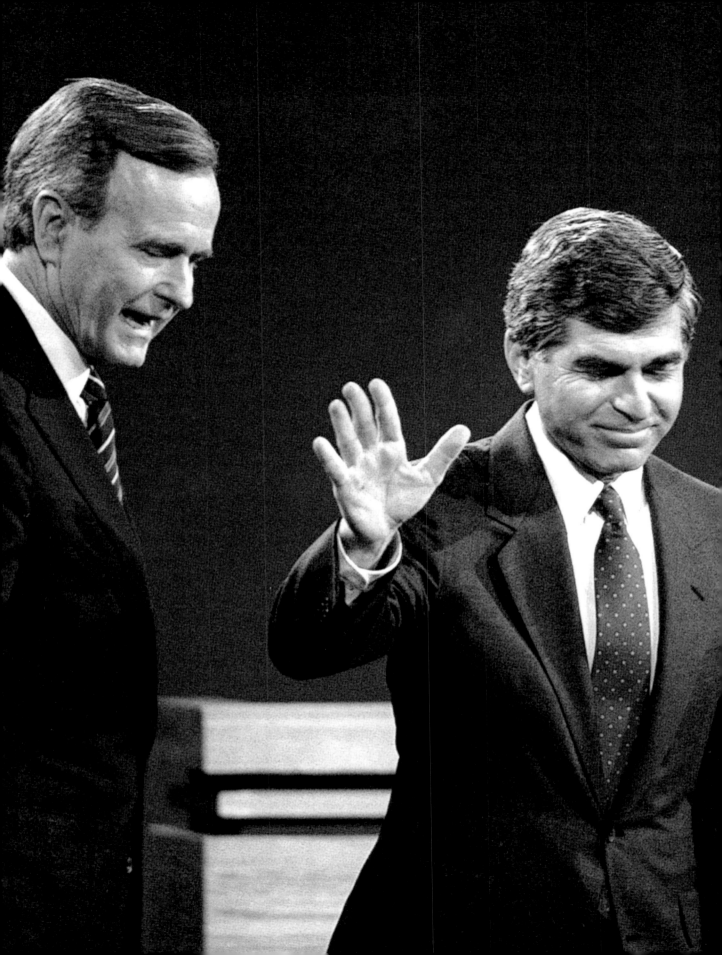

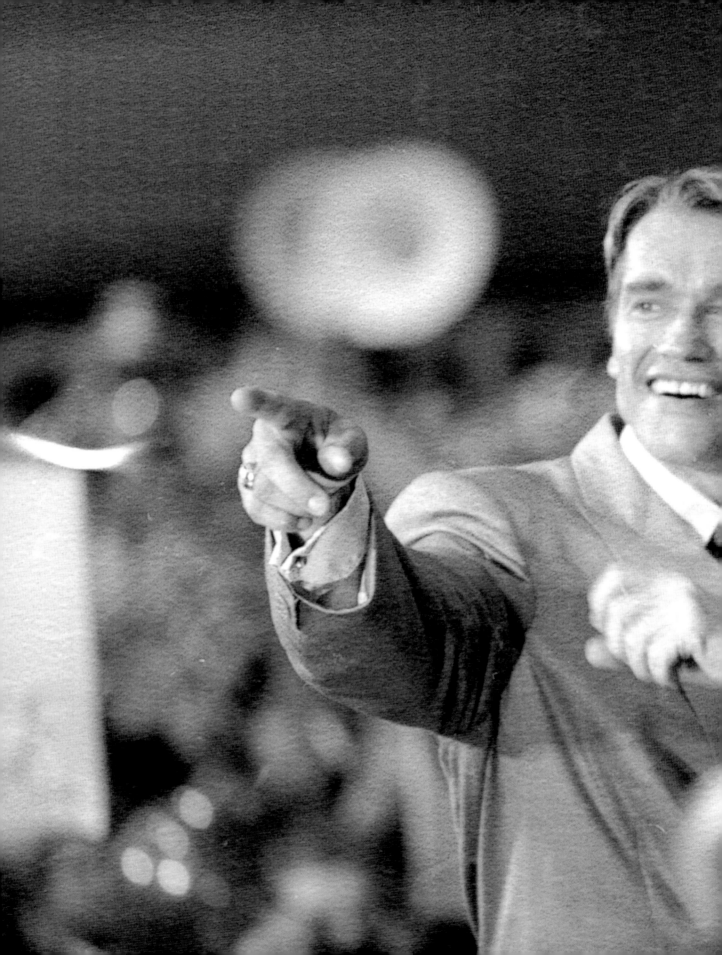

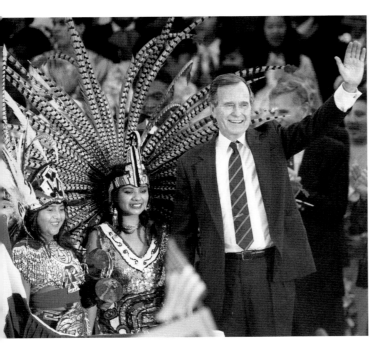

LEFT: The Sunday before Election Day, candidate Bush waves to supporters as he stands next to two young Indian girls in full costume in Covina, California.

BELOW: George and Barbara watch election returns on television in Houston on November 8. The Bush victory margin—426 electoral votes to 111—wasn't as big as either of Ronald Reagan's, but it was nonetheless substantial. "All five of our children's states went for George," Barbara said. "We were so happy for them as they worked so hard. . . . How do we thank our brothers, sisters, and cousins by the dozens? And, especially, how do we thank our children and grandchildren for putting their own lives on the back burner for us?"

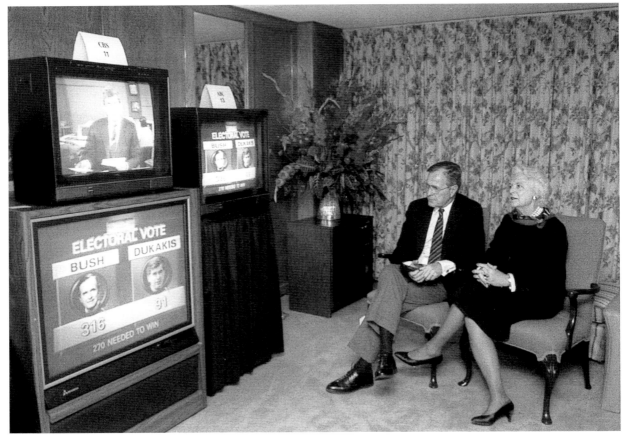

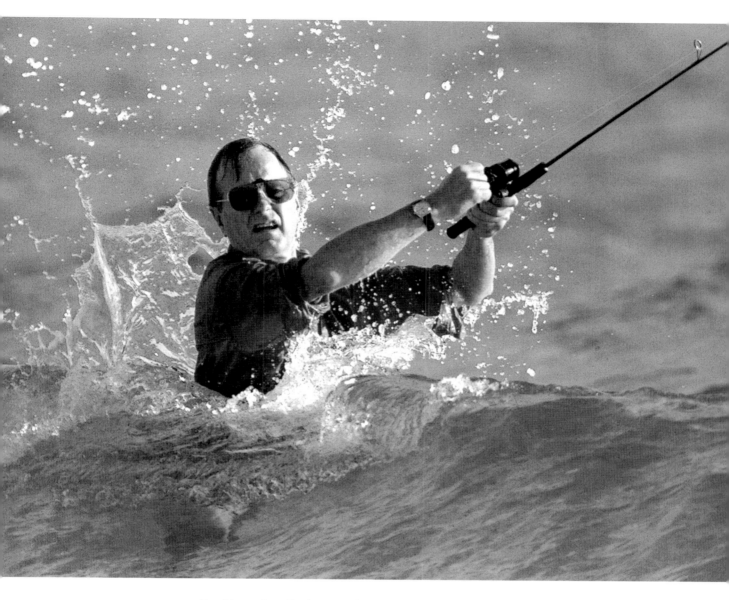

President-elect Bush casts a line while surf fishing at Gulf Stream, Florida, on November 12, 1988. This vacation, Barbara said, gave her the first indication of how different their lives would be. "The press was everywhere, and even walking on the beach was impossible."

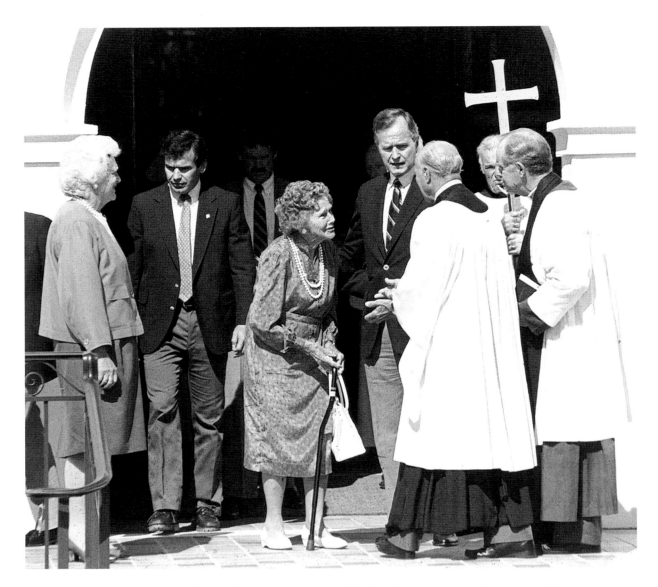

In Jupiter Island, Florida, on November 13, the President-elect introduces his eighty-seven-year-old mother to clergy of the Christ Memorial Church after attending services.

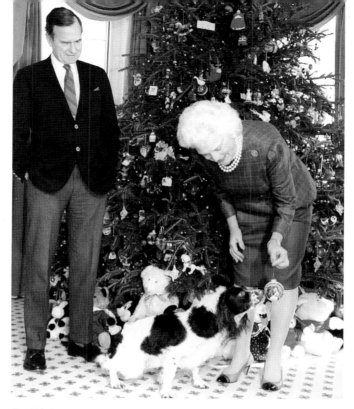

At Blair House on December 11, the Bushes' Springer spaniel Millie sniffs an ornament as they unveil their Christmas tree.

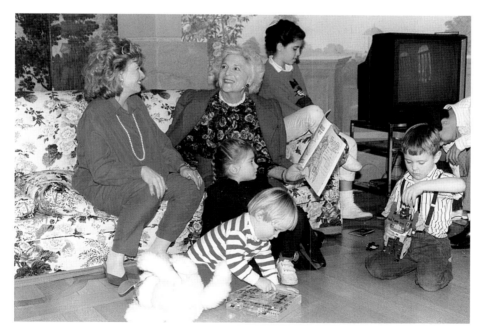

The day before her husband's swearing-in as the forty-first President of the United States on January 20, Barbara Bush hosts some of her relatives at Blair House. Left to right, Sharon Bush; Pierce Bush, two; Lauren Bush, four; Noelle Bush, eleven; Sam LeBlond, four; and George P. Bush, twelve.

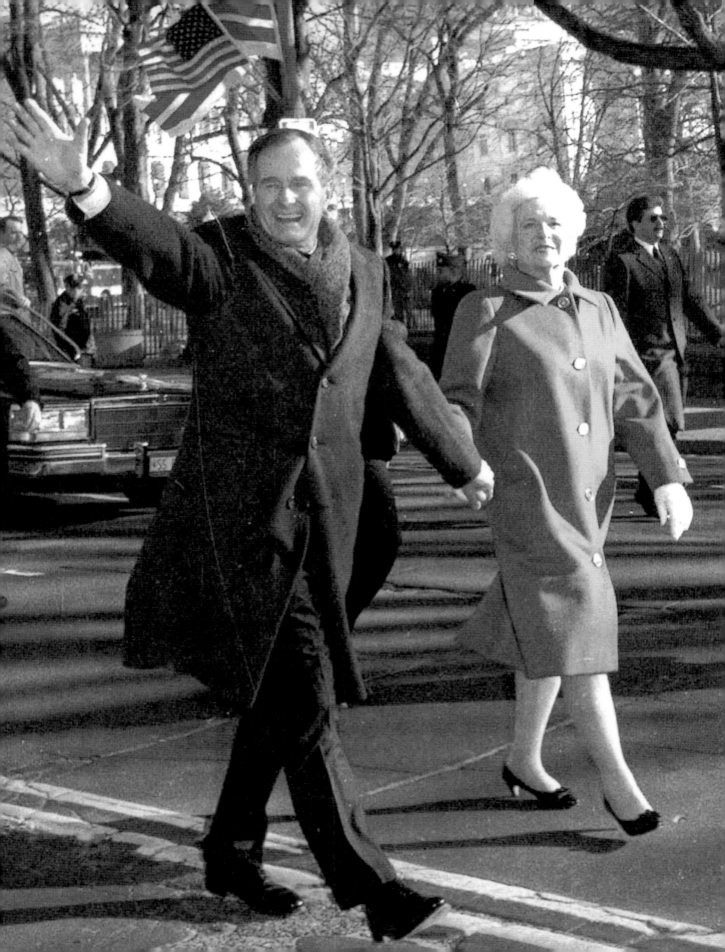

"41"

The forty-first President and First Lady walk in
the inaugural parade, January 20, 1989.

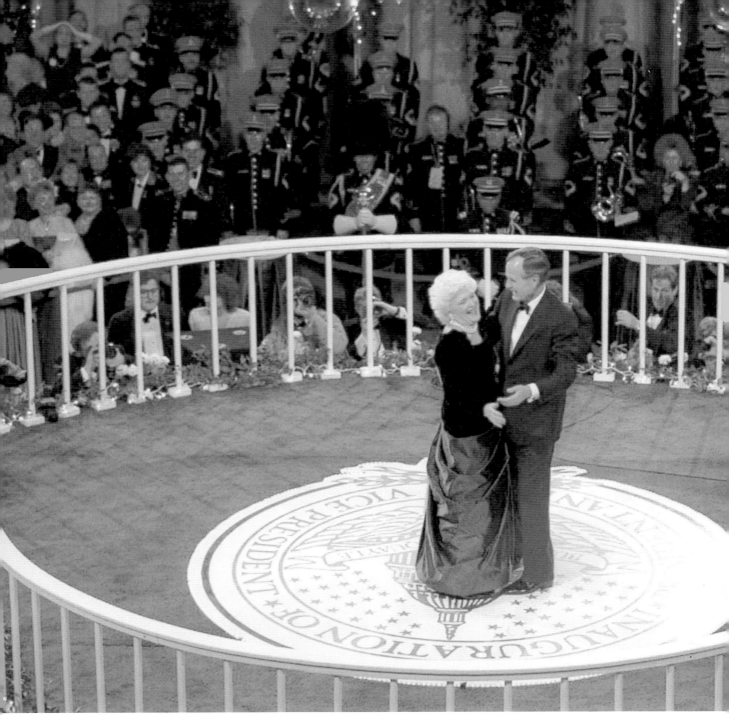

On January 20, 1989, the President and First Lady share a dance at his inaugural ball in Washington, D.C. The new President's conciliatory inaugural address, which called for volunteerism equaling "a thousand points of light," pleased Democrats more than Republicans. "It was nice to the Democrats, nice to the Russians, nice to the homeless, nice to kids and old folks," mockingly wrote the conservative commentator TRB in *The New Republic*. "It was just incredibly nice. The new President's new breeze blew in off the West Front of the Capitol in the form of a great howling gale of niceness."

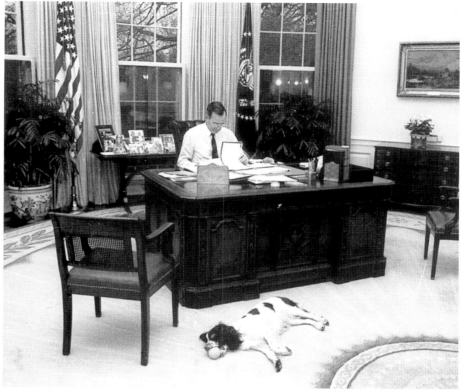

February 16: A pregnant first dog Millie relaxes with a tennis ball in the Oval Office as her master prepares for his first trip abroad as President at the end of the month.

ABOVE: In China on February 26, Barbara tours the rock garden at Gong Wang Fu in "my beloved" Forbidden City. With her is Mrs. Bety Lord, wife of the American ambassador. The trip, a "sentimental journey" for the Bushes, included a Southern-style barbecue reception that featured country music, a big Texas flag, Lone Star beer, bandanna-wearing waiters, and checkered tablecloths. The trip, President Bush hoped, would further relations between the United States and China, still under Communist rule but tentatively reaching out to the West.

RIGHT: On Friday, March 24, the First Lady watches over Millie and her six-day-old puppies before departing for a weekend at Camp David. The puppies included Ranger and Spot, who became beloved White House pets.

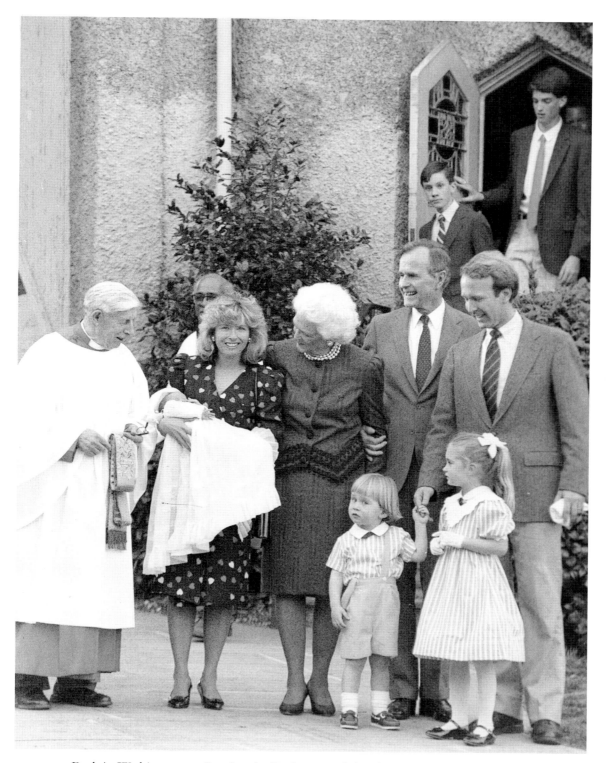

Back in Washington on Sunday, the Bushes attend the christening of their eleventh grandchild, Neil's daughter, Ashley, at St. Alban's Sanctuary. With them, from left, are Canon Charles Martin, Neil's wife, Sharon (holding Ashley), Pierce, Lauren, and Neil. "She is a beauty," her grandmother said of the baby.

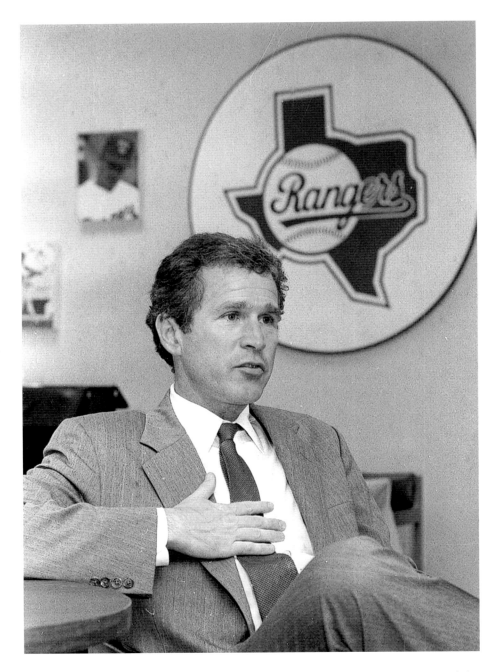

W. speaks to reporters after the American and National League owners approved the sale of the Texas Rangers baseball team to a group headed by him and Edward M. Rose III. The boy who had collected thousands of baseball cards had grown up to own a team, and he made the most of it. He printed his picture on baseball cards and gave them out; he hobnobbed with the legendary pitcher Nolan Ryan and slapped backs in the locker room. W. looked on his ownership as having "solved my biggest political problem in Texas—'What's the boy ever done?' " Still, he told reporters he never harbored a childhood ambition to follow in his father's footsteps as President. "I grew up wanting to be Willie Mays," he said. "But I couldn't hit the curveball."

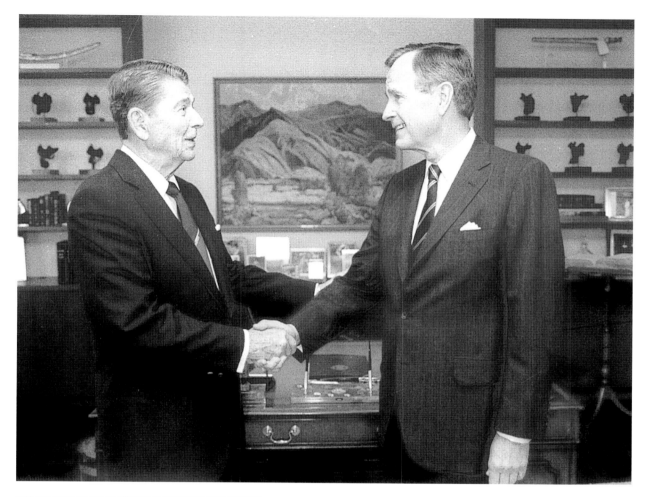

ABOVE: On April 26 the President pays a visit to his predecessor's office in California. The Bush presidency had begun as a bit of a tap dance: He wanted to continue those Reagan policies that had strengthened America militarily and economically while softening the harsher aspects of Reagan's budget cutting and hard-line social values. He hoped to harness the special magic Reagan wielded on the country without having his own personality subsumed by it. In one respect he succeeded in distinguishing himself from Reagan: As the *Economist* in London observed, "The contrast with Mr. Reagan, whose days were planned in advance, whose speeches and even small talk were scripted on three-by-five cards, and who knew where to stand because there was a white cross on the ground, could not be more marked."

LEFT: At the invitation of her son, the First Lady throws out the first ball at the start of a Texas Rangers home game against the New York Yankees on May 5.

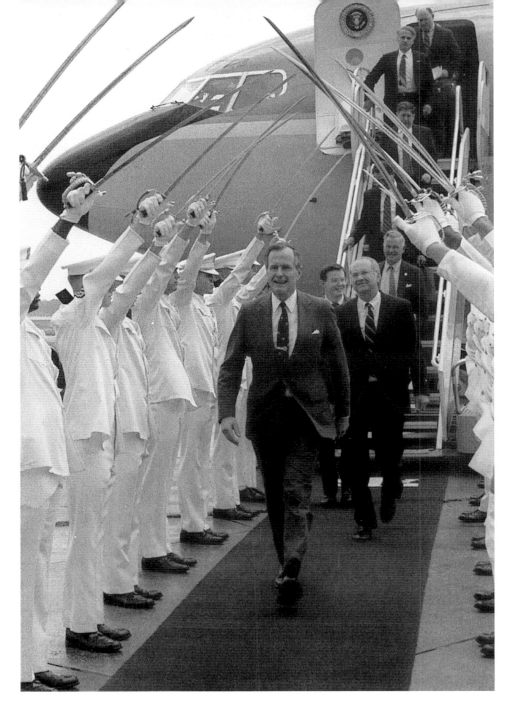

The Ross Volunteers from Texas A&M University salute the President as he arrives at College Station, Texas, on May 12. Bush delivered the school's commencement address, as he had as Vice President in 1984. He used the occasion to make a major policy stand in regard to the Soviet Union, drafted by National Security Council staff member Condoleezza Rice. In his journal he noted that the speech engendered "great enthusiasm! I have my Soviet speech talking about reintegrating Soviets into the world order and an open-sky proposal, as well, and it was pretty good. It got fairly good reviews except from those who want us to match [Soviet premier] Gorbachev, proposal for proposal, though it's not that dramatic."

On May 17 Coretta Scott King beams as President Bush signs into law the Martin Luther King Jr. Federal Holiday Commission Extension Act.

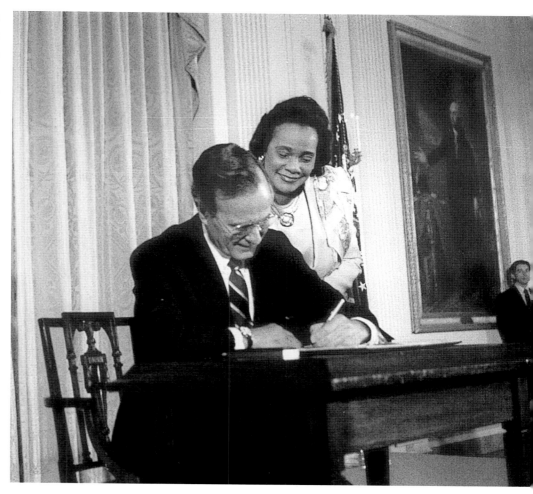

The next day, in Kennebunkport, the President leans over the side of his boat *Fidelity* to tend to a cranky engine. Mrs. Bush and a Secret Service agent look on.

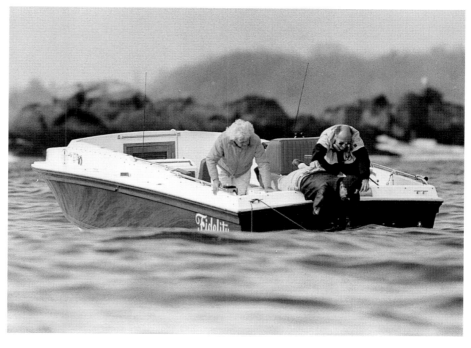

RIGHT: Pope John Paul II listens as President Bush reads a statement in the pope's library in the Vatican on May 27. During this trip, the Bushes also attended a NATO summit meeting in Brussels, lunched with Queen Elizabeth in Buckingham Palace, and met with British Prime Minister Margaret Thatcher and West German Chancellor Helmut Kohl.

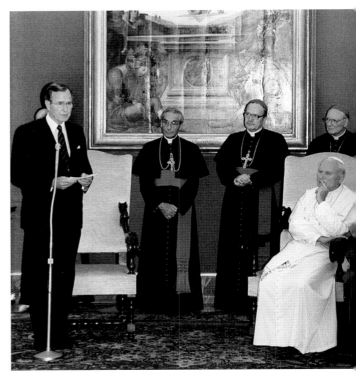

BELOW: Barbara Bush wriggles the loose tooth of five-year-old March of Dimes ambassador Kyle O'Brien during a Reading Champions program on June 7, held to raise money for the fight against birth defects. Kyle was born with a hole in his spine and needed braces and a crutch to walk.

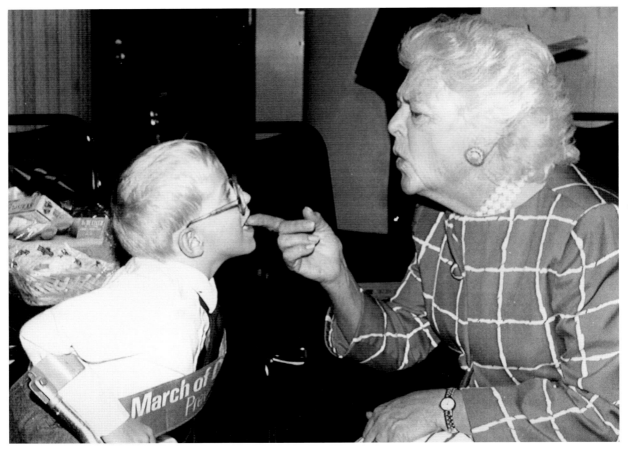

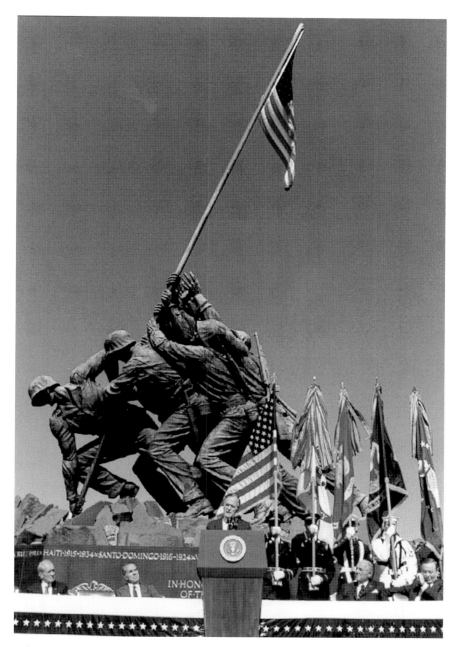

At the U.S. Marine Corps Memorial in Arlington on June 30, President Bush speaks in favor of a constitutional amendment banning flag burning. The Senate had passed, 97–3, a resolution condemning a Supreme Court decision that flag desecration was a form of political protest protected by the First Amendment. The fight for an amendment banning flag burning became a red-meat issue for conservatives; Bush said the proposed amendment would "defend the United States of America . . . for the sake of the fallen, for the men behind the guns, for every American." By October, however, both liberals and conservatives who believed in the right of free speech had raised awareness of the slippery slope such an amendment threatened to create, and it fell fifteen votes short of the required Senate ratification.

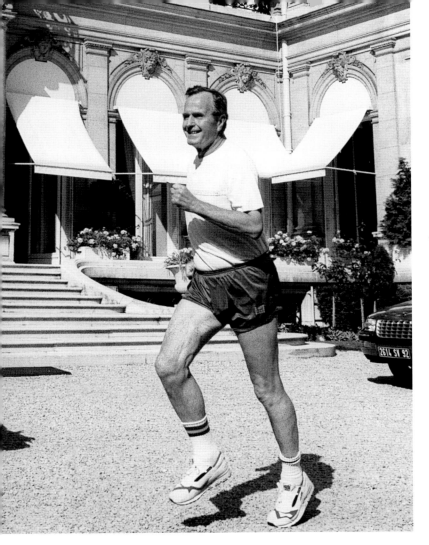

In Paris for the G7 Economic Summit on July 15, the President jogs past the U.S. ambassador's residence.

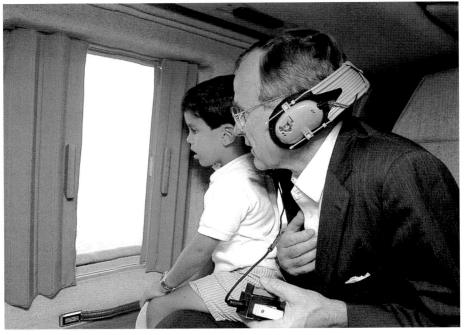

Aboard *Air Force One* on a trip to Kennebunkport on August 16, the President and his six-year-old grandson, Jebbie, peer out the window.

Three days later the President's sons George W. and Jeb join him on the family boat for an expedition on the Atlantic Ocean off the coast of Maine.

In front of the Bush residence at Walker's Point on August 25, the President admires the medal given to Jebbie by the just-departed Danish Prime Minister Poul Schluter. The Band-Aid on the boy's forehead covers a cut he received when he fell on coastline rocks.

August 31: Barbara points out sea life and rocks to Ben Mulroney, the son of Canadian Prime Minister Brian Mulroney, along the Maine coast. Ben's mother, Mila, stands to his left.

The Bushes react after the President stepped on Barbara's toe as they boarded *Air Force One* for a trip to New Jersey on September 22.

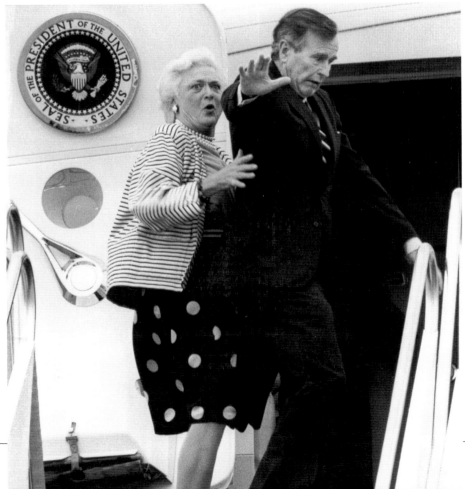

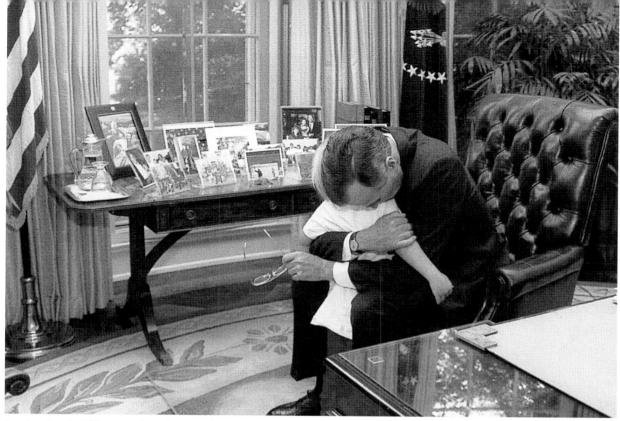

In the Oval Office on October 4, the President gives his three-year-old grand-daughter, Marshall, a big hug. Marshall is the adopted daughter of Marvin and Margaret Bush. She and her younger brother, Walker, also adopted, "have brought such joy into our lives," their grandmother Barbara said.

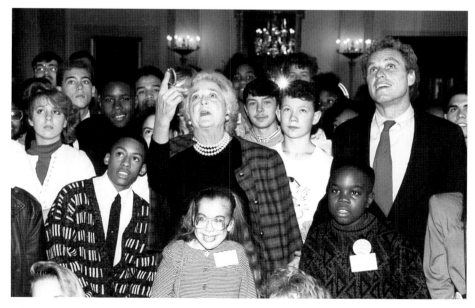

The same day, Mrs. Bush and Congressman Joe Kennedy give a group of children from all fifty states a tour of the White House. The tour was arranged by Kennedy as part of National Children's Day.

BELOW: On December 1, the President says good-bye to crew members of the USS *Forrestal* after a three-hour visit to the famed aircraft carrier, which provided him support during a summit meeting in Malta.

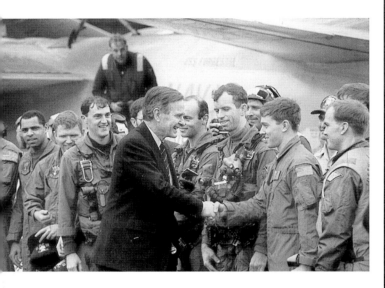

RIGHT: The next day Bush meets Soviet President Mikhail Gorbachev for their first face-to-face diplomatic session aboard the USS *Belknap.* During the meeting Bush expressed his support for the Soviet leader's policy of *perestroika*—an opening up of Soviet society—and offered twenty initiatives to demonstrate that support. Secretary of State James Baker later wrote that the meetings had further melted the Cold War freeze between the two nations. Gorbachev's comments afterward, Baker said, made it clear that "we had moved from conflictual and competitive politics to a more cooperative relationship."

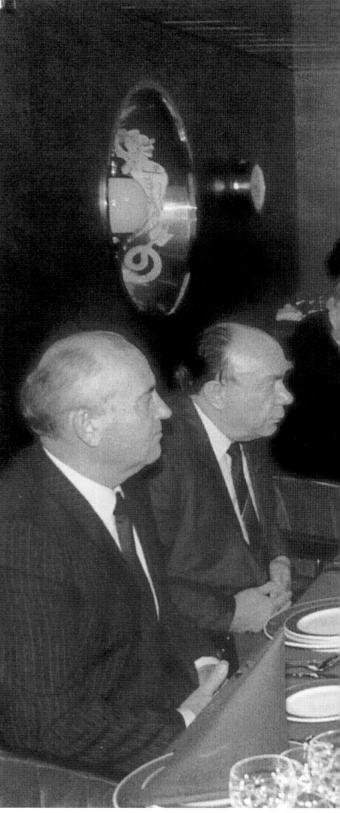

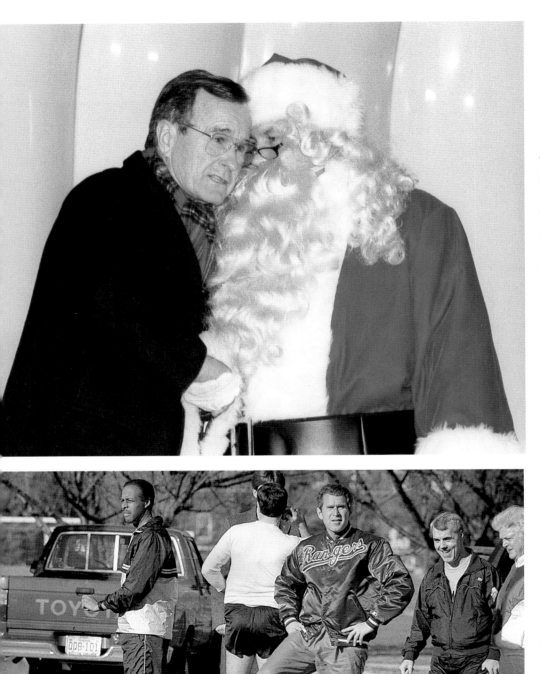

The President welcomes Santa Claus (played by *Today* show weatherman Willard Scott) to the lighting of the national Christmas tree on the ellipse in Washington on December 14.

W. playfully steps on his dad's stomach as the President stretches before a jog at Fort McNair in Washington on January 7, 1990.

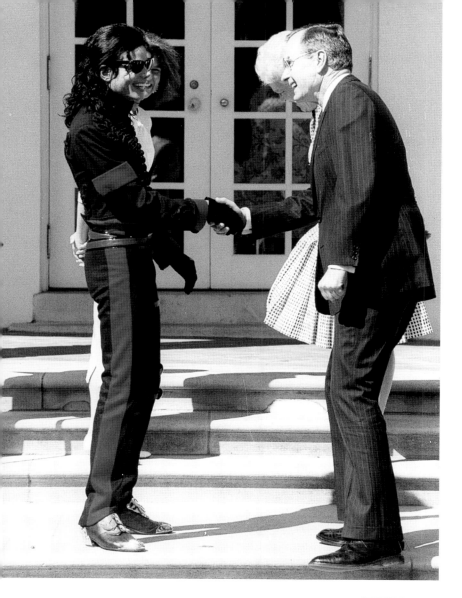

April 5: The President and First Lady welcome Michael Jackson to the White House after the pop singer was named Entertainer of the Decade by the Friends of the Children's Museum in Washington. With the Bushes is their daughter-in-law Margaret.

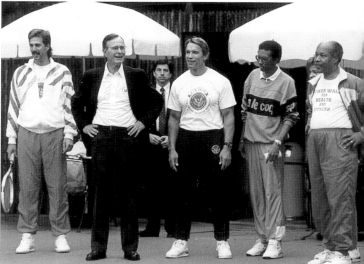

May 1: Arnold Schwarzenegger puts the President through his paces after Bush signed a proclamation naming May the Great American Workout month. In comments after the signing, Bush called Arnold "the man who symbolizes physical fitness" and added: "You know, he's stronger than I thought he was. He bench-pressed the federal budget. This weekend we had our grandson Sam LeBlond [visiting]. I said, 'If Arnold Schwarzenegger can do that, why can't you pick up your socks?' "

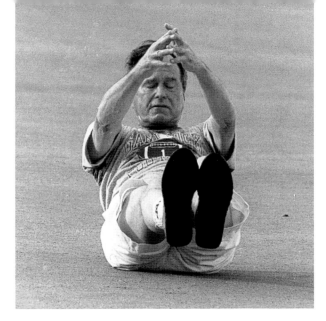

ABOVE: Clearly inspired by Arnold, the President gets in some sit-ups on the football field of the University of South Carolina on May 12. Bush was in Columbia to deliver the commencement address at the university and attend a GOP fund-raiser.

RIGHT: At the dedication of the Richard Nixon Library in Yorba Linda, California, on July 19, Presidents Reagan, Nixon, Bush, and Ford stand amid life-size sculptures commemorating world leaders "who met President Nixon's criterion for great leadership: 'Did they make a difference?' "

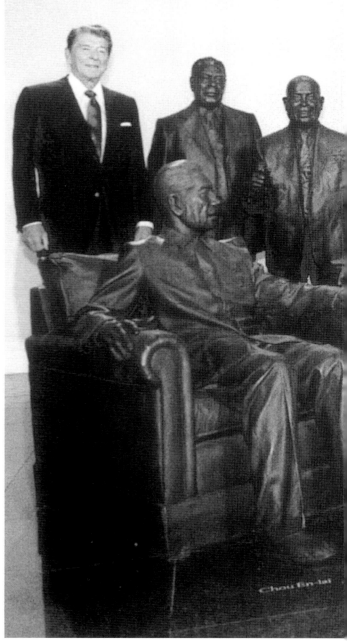

"They are leaders
Not because they wi

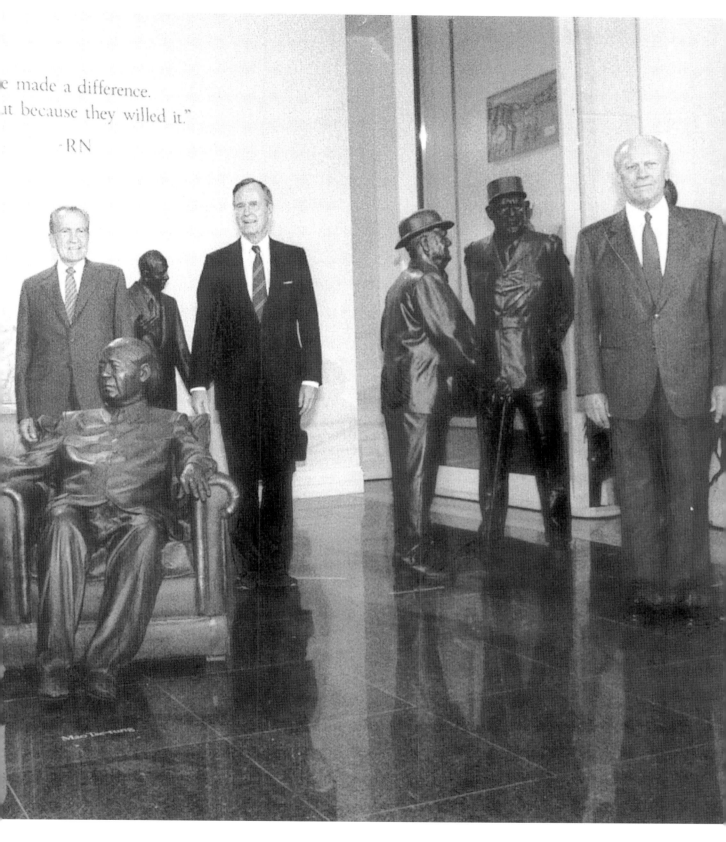

made a difference.

because they willed it."

-RN

Mrs. Bush and a group of youngsters act out the story *Where the Wild Things Are* during the taping of two public service announcements at the Kennedy Center in Washington on July 25. The announcements were created to promote ways in which television and video can be used as a companion to reading. Next to Mrs. Bush (left to right) are James Michak, Sara Jaffa, and Zachary Berhman. During this period both Mrs. Bush and her husband were battling Graves' disease, a condition causing excessive thyroid hormones in the body. Mrs. Bush suffered from double and triple vision, eye popping, and watery eyes.

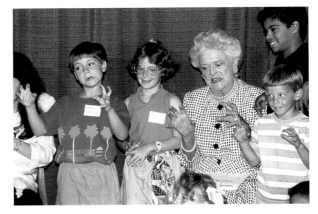

President Bush meets with Secretary of Defense Dick Cheney, Vice President Dan Quayle, Secretary of State James Baker, Joint Chiefs of Staff chairman General Colin Powell, National Security Advisor Brent Scowcroft, CENTCOMM Commander General H. Norman Scwarzkopf, and other senior administration officials at Camp David on August 4 to discuss the United States' response to Iraqi President Saddam Hussein's invasion of neighboring Kuwait on August 2.

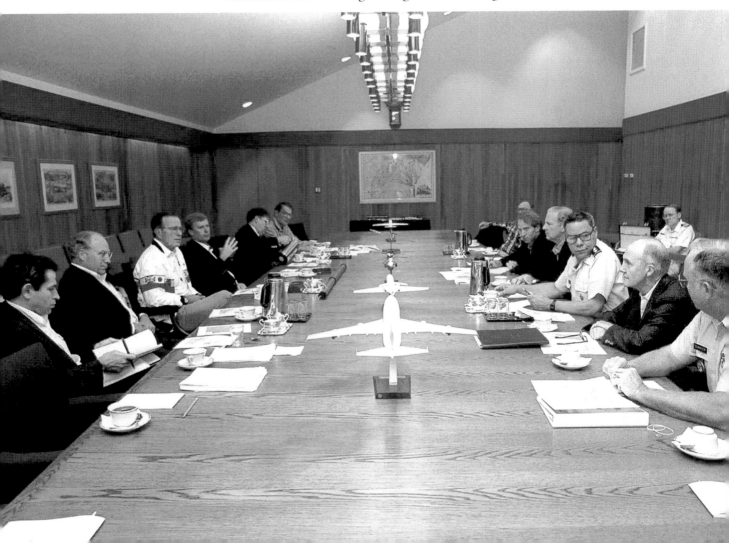

Bush welcomes Canadian Prime Minister Brian Mulroney during another visit to Walker's Point on August 27. The two leaders discussed the President's deployment of American Reserve troops to the Persian Gulf in anticipation of military action to force Iraq out of Kuwait. Mulroney pledged 4,500 troops to assist the United States.

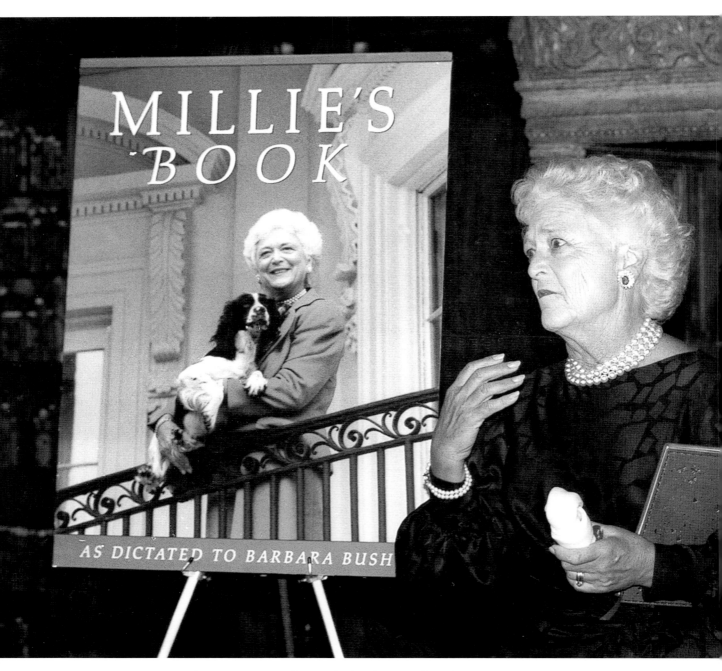

Mrs. Bush at a promotional party for her book with Millie at the Pierpont Morgan Library in New York on September 12. The First Lady holds a rawhide bone given to her as a gift for Millie by the library's director. The book proved a bestseller, and its profits were donated to the cause of literacy. During the publicity blitz that surrounded the book's publication, Barbara recalled seeing two magazine cover photographs of her and Millie and thinking, *It looks as though I had forgotten to iron my face.*

U.S. Open singles tennis champion Pete Sampras teams up with the President for a doubles match at the White House on October 4. They played against Texas Congressman Bill Archer and Matthew Meyer, a friend of Marvin Bush's.

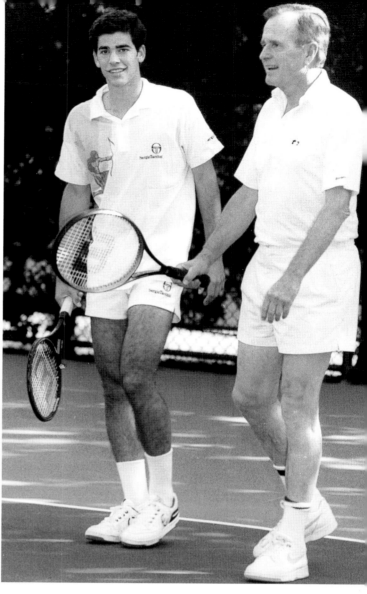

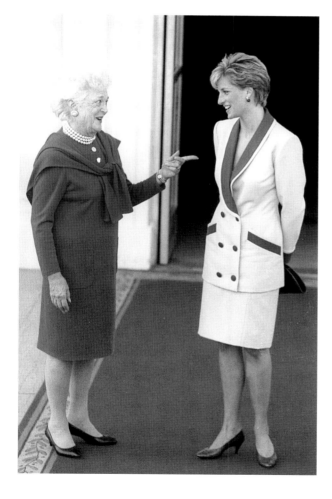

On the North Portico, Mrs. Bush welcomes Britain's Princess Diana to the White House for a coffee party in her honor on October 5.

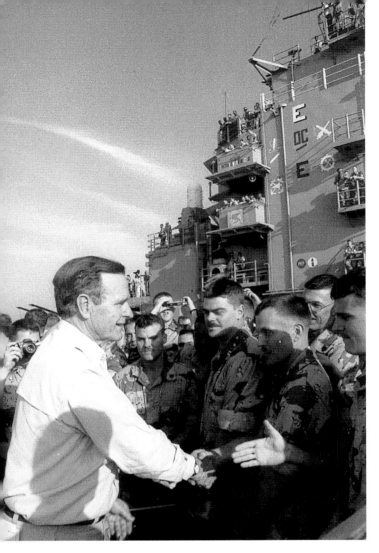

November 22: The President visits with American troops aboard the USS *Nassau* in the Persian Gulf.

In eastern Saudi Arabia the next day, Bush prepares to peer through the sights of a 50-caliber machine gun in a bunker at a forward Marine base. By then more than 500,000 American troops had been joined by over 300,000 from eleven countries, including Saudi Arabia and Kuwait.

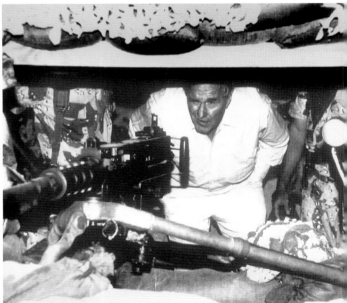

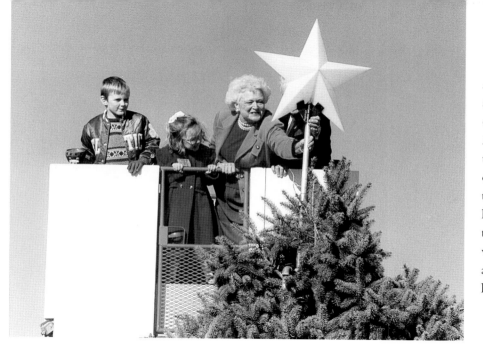

As her grandchildren Sam and Ellie LeBlond look on aboard a hydraulic lift, Mrs. Bush places a star atop the national Christmas tree on the ellipse in Washington, November 30. The lights on the tree, part of the 1989 Pageant of Peace, were lit by the President and First Lady two weeks later.

George W. wears full cowboy regalia as he and his father welcome British Prime Minister John Major and Sir Anthony and Lady Acland to Camp David on December 22.

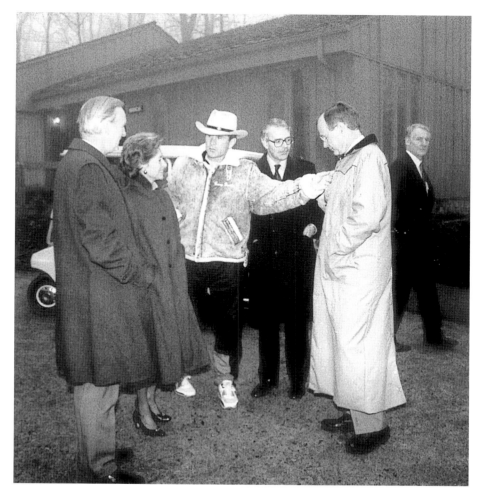

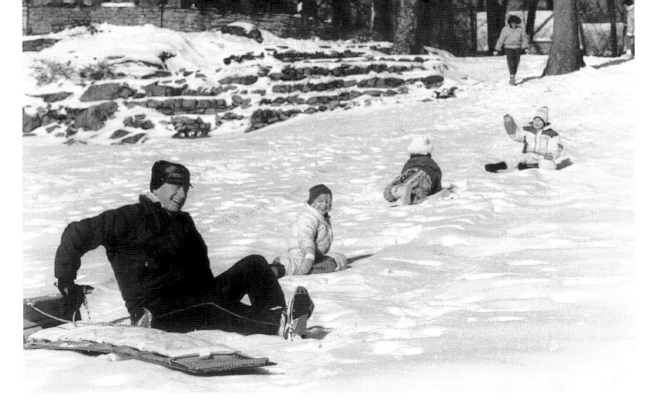

The President and some of his grandchildren go sledding at Camp David on January 13, 1991. Four days earlier Secretary of State Baker and Tariq Aziz, the Iraqi foreign minister, had met for six hours without resolving the Gulf crisis. On January 12 the U.S. Congress had voted to authorize offensive action against Iraq, and January 15 would mark the U.N.'s deadline for Iraq to withdraw from Kuwait.

The President and First Lady return from Camp David on the thirteenth. Mrs. Bush broke a bone in her foot when she hit a tree while sledding earlier that day; the injury did not require a cast, but she was ordered by her doctor to stay off the foot for at least three days.

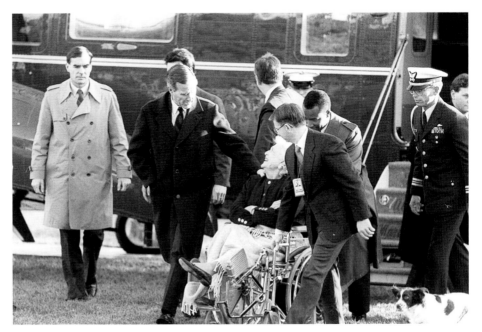

The President works late in the Oval Office on January 17. The day before, the United States had launched Operation Desert Storm, an air war against Iraq, by dropping bombs on Baghdad and other targets in Kuwait and Iraq. "That darn Hussein," Mrs. Bush wrote in her diary. "He is putting all those children at risk. . . . God knows [we] have given Saddam every chance."

With Colin Powell, Dick Cheney, James Baker, and others, President Bush studies an aerial photo of Baghdad on February 13. That day, U.S. bombers destroyed a bunker complex in Baghdad with several hundred citizens inside. Nearly three hundred died.

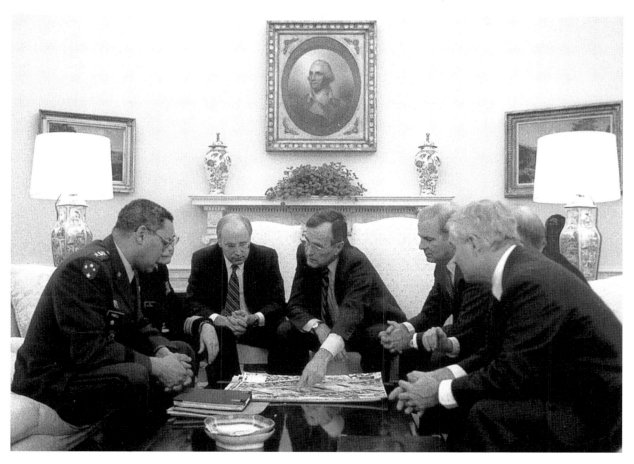

LEFT: Mrs. Bush and their dogs Millie and Ranger greet the President in Washington as he returns from Camp David on February 23. The next day the ground war in Iraq began. Four days later the President ordered a cease-fire; on March 3 Iraq accepted the terms of the cease-fire and agreed to withdraw its troops from Kuwait. American troops began returning home on March 8. The war had been a success, there had been minimal American casualties, and George Bush enjoyed approval ratings in the eighties.

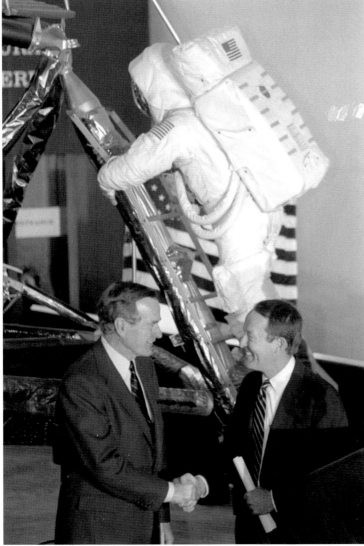

LEFT: The President congratulates the new secretary of education, former Tennessee Governor Lamar Alexander, after his swearing-in at the Smithsonian Institution's National Air and Space Museum in Washington on March 22. In the background is the museum's exhibit of America's 1969 moon landing.

OPPOSITE: Balletically, the President throws out the first ball at the Texas Rangers' home opener versus Milwaukee on April 8 in Arlington.

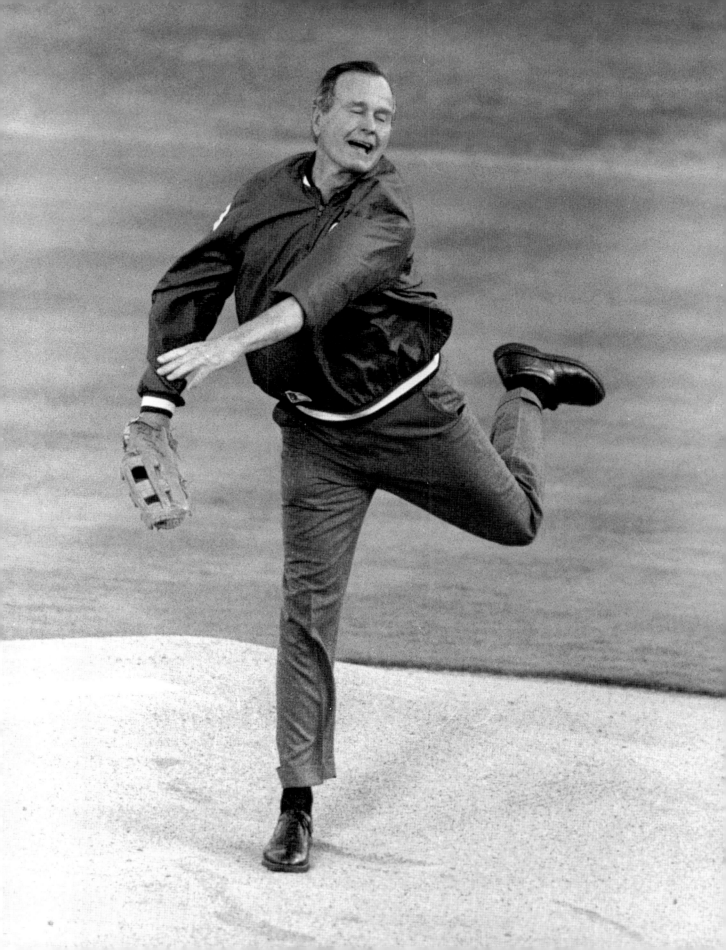

May 5: Hospitalized at the Bethesda Naval Hospital after an atrial fibrillation caused shortness of breath while jogging, the President plays a video game with his grandchildren Sam, seven, and Ellie, five, as Brent Scowcroft and White House Chief of Staff John Sununu wait to get back to their meeting.

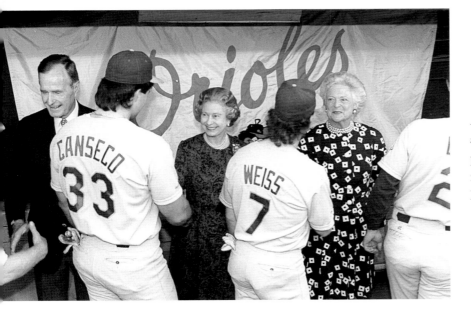

A queen in the dugout: Elizabeth II and the Bushes greet Oakland Athletics players prior to a game with the Baltimore Orioles at Memorial Stadium in Baltimore on May 15.

Millie clearly has a mind of her own despite her owners' orders to get back inside the White House as the Bushes leave to attend graduation ceremonies at West Point on June 1. An aide retrieved Millie and guided her back indoors.

On June 8 the President speaks at a memorial service at Arlington National Cemetery for those Americans—more than two hundred in all—killed in the Gulf War.

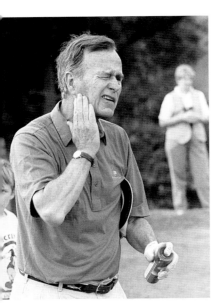

Those mosquitoes can drive a person buggy: Bush slaps on some insect repellent during a golf game at the Cape Arundel Golf Club in Kennebunkport on June 29. With him is Sam LeBlond.

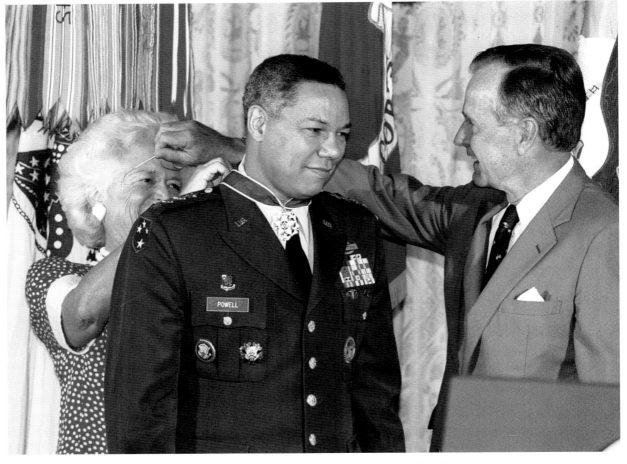

July 3: The President puts her glasses on the First Lady's face to help her see as she pins the Presidential Medal of Freedom on General Colin Powell at an early-morning White House ceremony.

Later that day the First Couple enjoy some quiet time fishing in South Dakota after rededicating Mount Rushmore.

President Bush takes in the beauty of the chandeliers of St. Catherine's Hall in the Kremlin on July 30 as he and the First Lady are greeted by President and Mrs. Gorbachev in Moscow. The two Presidents later took part in three summit meetings.

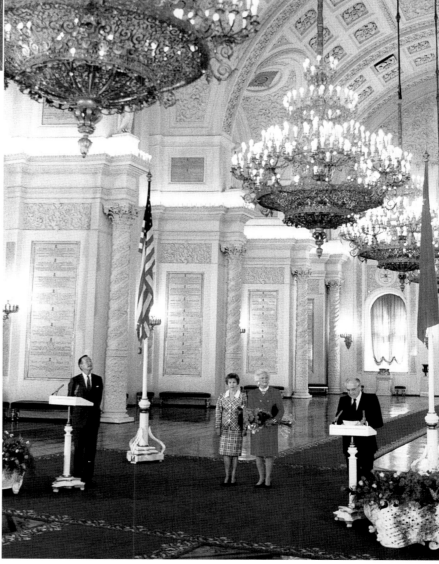

As Hurricane Bob bore down on New England on August 19, a storm of a different kind preoccupied the President: In Russia, a putsch had attempted to depose the vacationing President Gorbachev. After speaking with Canadian Prime Minister Brian Mulroney about the crisis (pictured here), the President returned to Washington. Within three days the attempted coup had collapsed and Gorbachev returned to Moscow. But within a week he had resigned as chairman of the Communist Party, disbanded its leadership, and acknowledged the independence of the Baltic States. The Union of Soviet Socialist Republics was no more.

The First Lady and her thirteen-year-old granddaughter Barbara play with Millie on the steps of the White House as they wait for the President to return from his checkup at Bethesda Naval Hospital on September 13. Doctors gave him a clean bill of health.

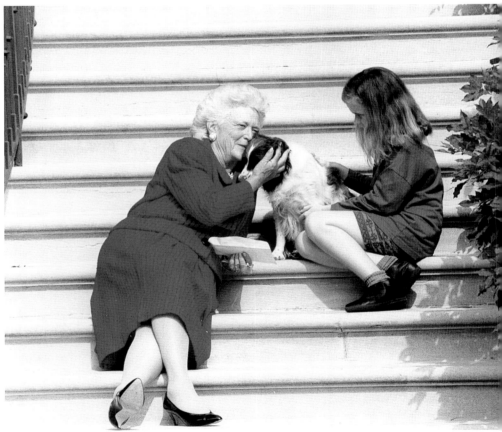

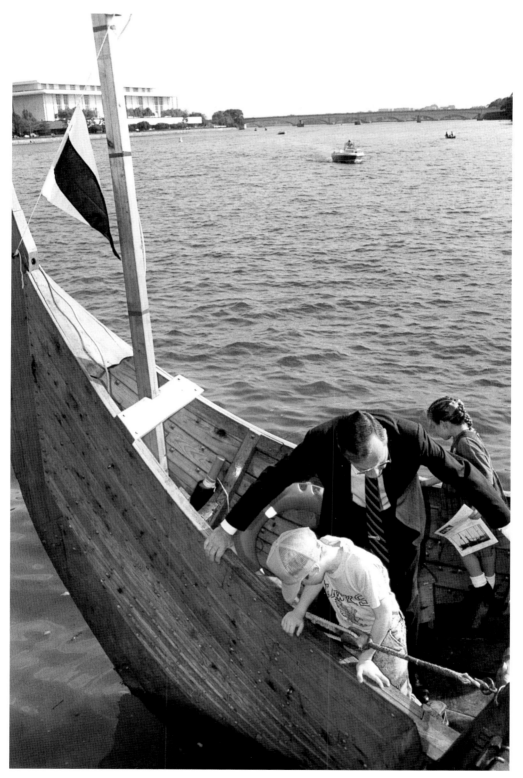

October 10: President Bush and Sam LeBlond peer over the side of one of three Viking ships that sailed into Washington Channel, horns blasting, to commemorate Leif Eriksson's voyage to the New World a millennium earlier.

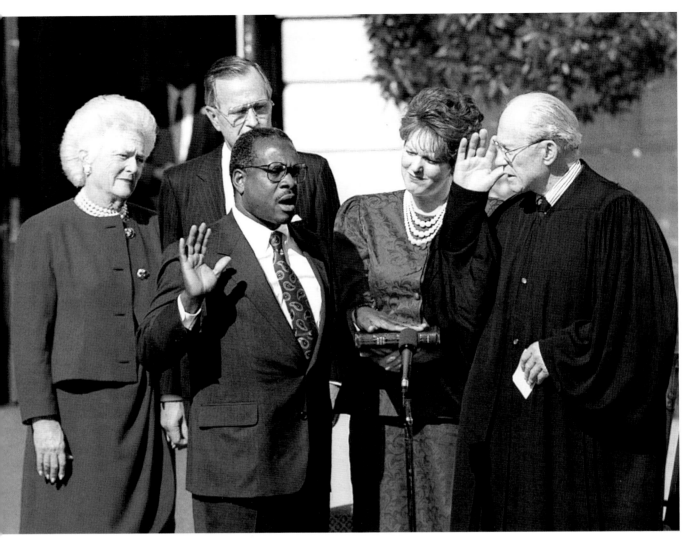

The Bushes and Virginia Thomas watch as Justice Byron White swears in Clarence Thomas as a Supreme Court justice on October 18. The Thomas confirmation hearings were among the most contentious in U.S. history. Many felt that the President's nomination of a conservative black man who opposed affirmative action and other programs that most African Americans favored represented a cynical attempt to seem to advance civil rights while actually hindering them. Despite the law professor Anita Hill's explosive charges at the hearings that Thomas had sexually harassed her ten years earlier, the Senate approved the nomination.

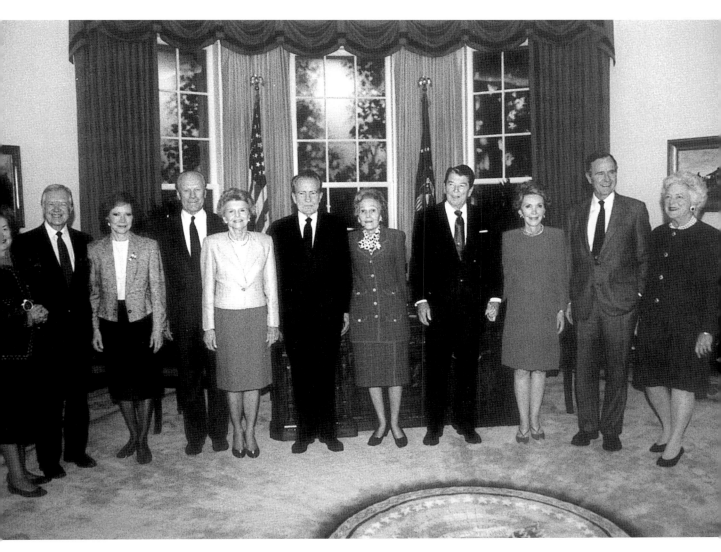

At the dedication of the Ronald Reagan Presidential Library in Simi Valley on November 4, four former Presidents and five former First Ladies join the Bushes. Left to right are Lady Bird Johnson, Jimmy and Rosalynn Carter, Gerald and Betty Ford, Richard and Pat Nixon, and Ronald and Nancy Reagan. "It was a nice reunion for us all," Barbara later wrote. "There was one sad thing. Pat Nixon did not look well at all." Mrs. Nixon passed away twenty months later, and Richard Nixon died ten months after that.

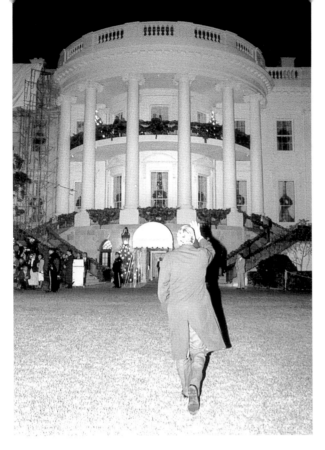

Returning from a trip on December 10, President Bush runs toward the South Portico of the White House and waves to several staff members on the Truman Balcony.

December 21: The President peers through opera glasses as he and Mrs. Bush wave to well-wishers at the National Theatre in Washington, where they have gone to catch a performance of *Crazy for You*.

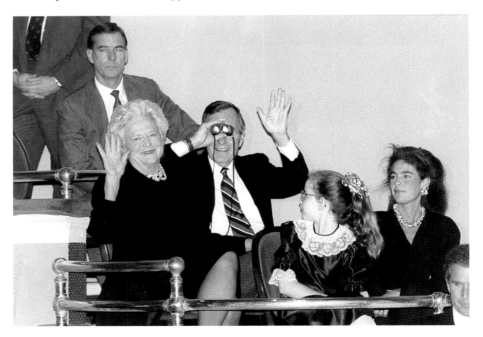

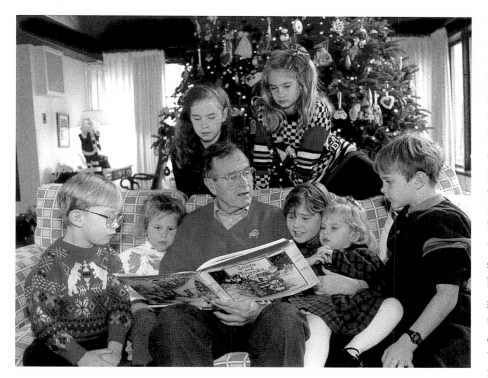

"Gampy" reads the story *Santa and Friends* to some of his grandchildren during the family's Christmas Eve at Camp David. A week earlier Barbara had flown to New Hampshire and filed the necessary papers for her husband to compete in the New Hampshire primary. Barbara and the President had wavered on whether he should run for re-election, but they decided to make a go of it despite the intention of archconservative commentator and former White House aide Pat Buchanan to challenge him for the nomination.

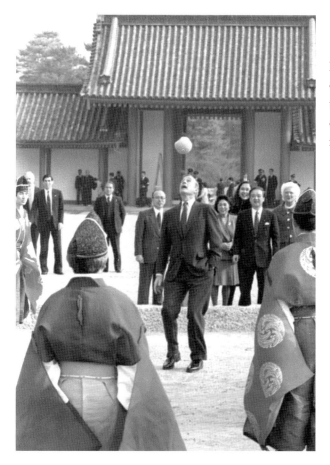

During a visit to the Imperial Palace in Kyoto, Japan, on January 7, 1992, the President takes a crack at the traditional Japanese ball game Kamari as costumed players and the First Lady look on. The four-day visit promoted trade between the United States and Japan.

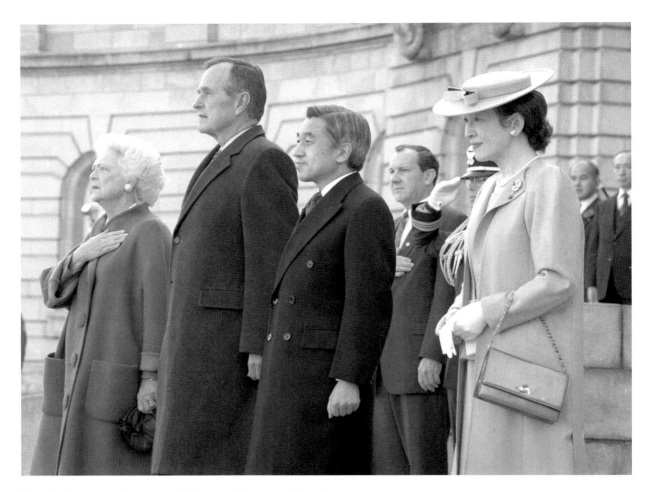

The Bushes join Emperor Akihito and Empress Michiko at a welcome ceremony at Tokyo's Guest House on January 8. The following evening, during a state banquet at the Imperial Palace, the President felt ill, vomited, and slid under the table. Security officials and Japanese Prime Minister Kiichi Miyazawa, who was sitting next to Bush, assisted him. Barbara said that afterward she "had nightmares about the fact that I hadn't moved to my precious husband's side. Several weeks later I was relieved to see a series of TV pictures that showed me wiping George's face and trying to help. . . . It reminds me that eyewitness accounts are not always true. I could have sworn that I had not touched George." The only photographs of the President's collapse were taken from video footage shot for by a Japanese television network. The network will no longer grant permission for those photographs to be published, a spokesman for the company said, because "there was trouble" over the airing of the footage in the United States. He did not elaborate.

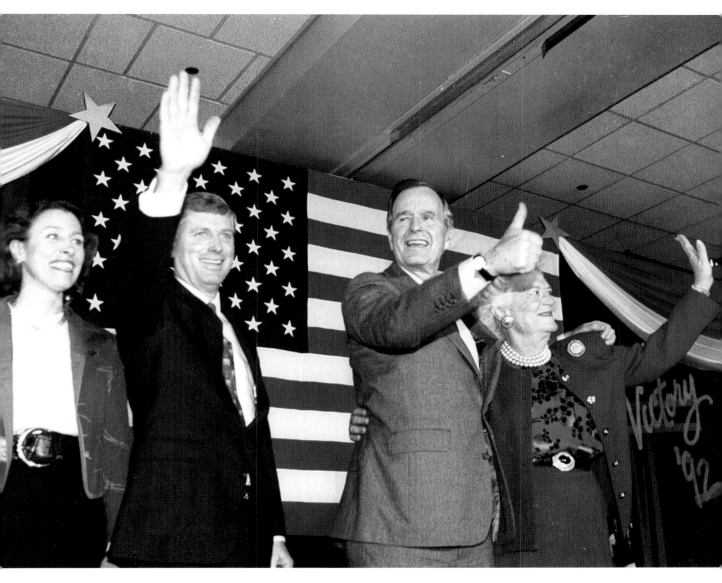

The Bushes and the Quayles wave to supporters as they kick off their re-election campaign in Washington on February 17. The President's approval ratings were down, to 56 percent, as memories of the Gulf War success faded and concern about the faltering economy grew. But at this point few doubted that he would win re-election.

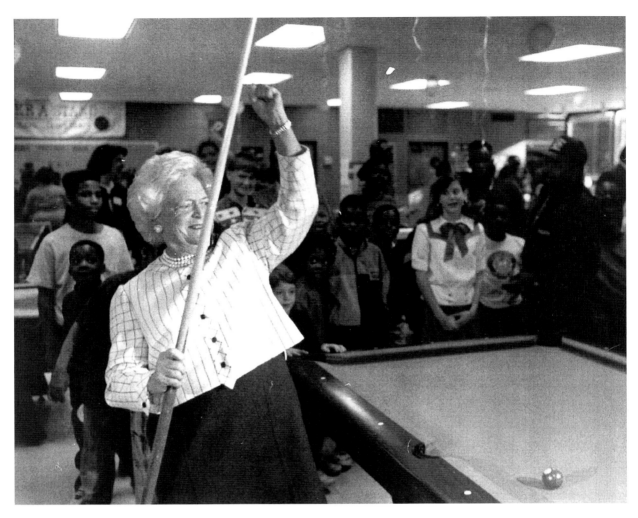

ABOVE: In San Antonio, Texas, on February 26 for a seven-nation drug summit hosted by her husband, Mrs. Bush reacts after making a pool shot during a tour of the Boys and Girls Club of San Antonio.

RIGHT: Mrs. Bush mimics a local television commercial during a campaign appearance in Metairie, Louisiana, on March 5. Although Pat Buchanan had garnered a stunning 40 percent of the primary vote in New Hampshire, George Bush's renomination by the Republicans was never in serious doubt.

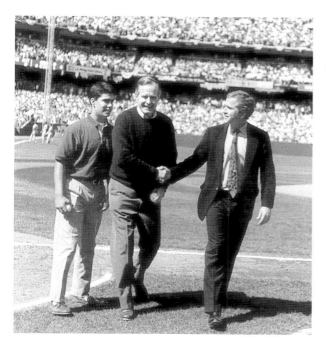

LEFT: George W. Bush shakes hands with his father as his sixteen-year-old nephew, George P. Bush, looks on just before the President threw out the first pitch at the opening of the Baltimore Orioles' new stadium in Camden Yards on April 6, 1992.

BELOW: An aide places a call from the President to Ross Perot during a trip to Boulder, Wyoming, on July 19. Perot, a self-made Texas billionaire, had just announced that he would abandon his third-party run for the presidency, which had garnered 27 percent support in polls. Bush later told reporters he had congratulated Perot for having "energized an awful lot of people" and added, "Now we will make it clear to all those Perot supporters that we share many of their same principles and that we want their support and that we welcome them warmly into our campaign."

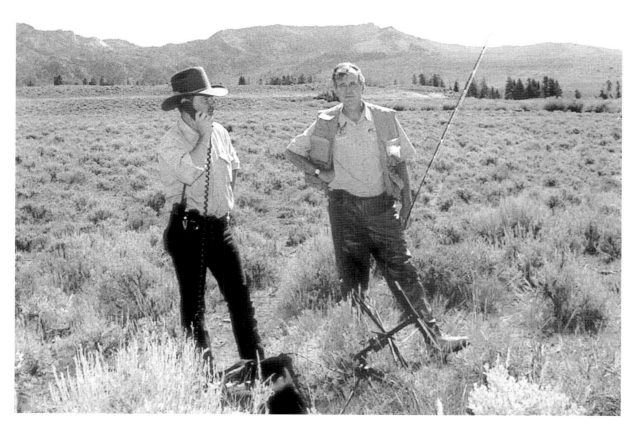

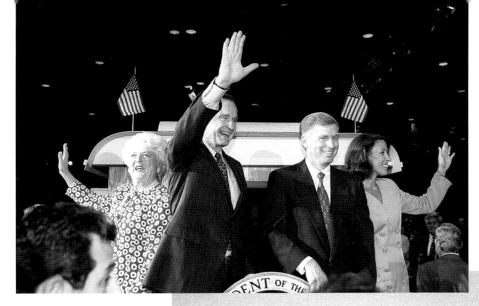

ABOVE: August 19: On the day they are to be renominated by the Republicans, George Bush and Dan Quayle accompany their wives on a train to a fund-raiser in Houston.

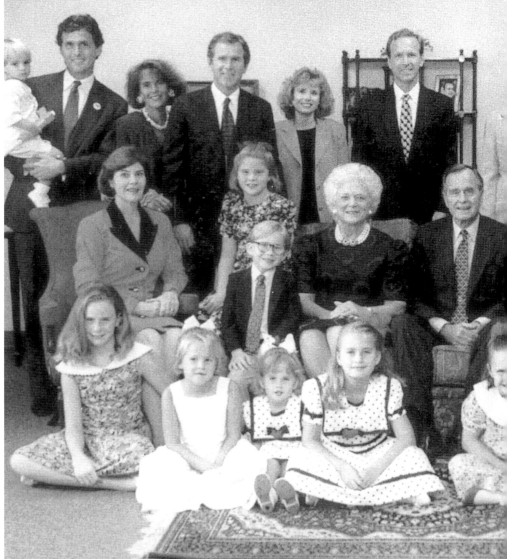

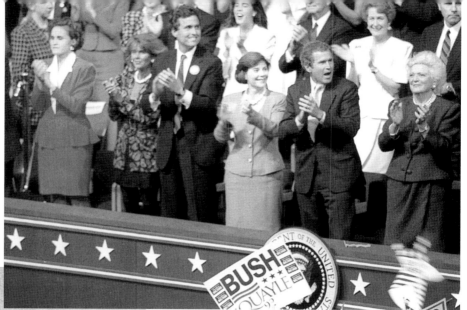

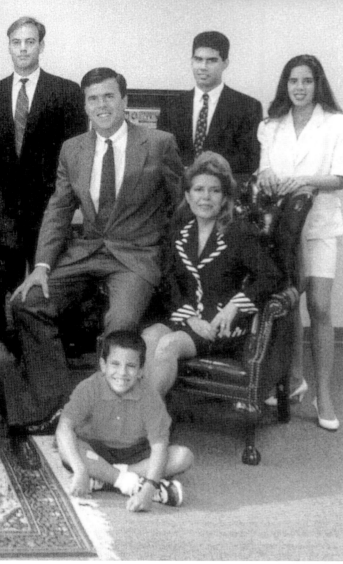

ABOVE: At the Republican National Convention on August 20, Bush family and cabinet members cheer as the President accepts his party's nomination.

LEFT: Just before the nomination, the extended Bush family pose for a portrait. Seated on the floor, left to right, are Barbara, Marshall, Ashley, Lauren, Ellie LeBlond, and Jebbie Bush. Seated in the second row are Laura, Jenna, Pierce, the First Lady, the President, Sam LeBlond, Jeb, and Columba. Standing in the back row are Marvin holding his son Walker, Margaret, George W., Sharon, Neil, Doro, her second husband, Bobby Koch, George P. Bush, and his sister, Noelle.

Barbara reacts to a very large balloon as the convention hall erupts in celebration after the President's acceptance speech.

At an Orange County rally in Anaheim, California, on September 13, Ronald Reagan joins his former Vice President for a round of campaigning.

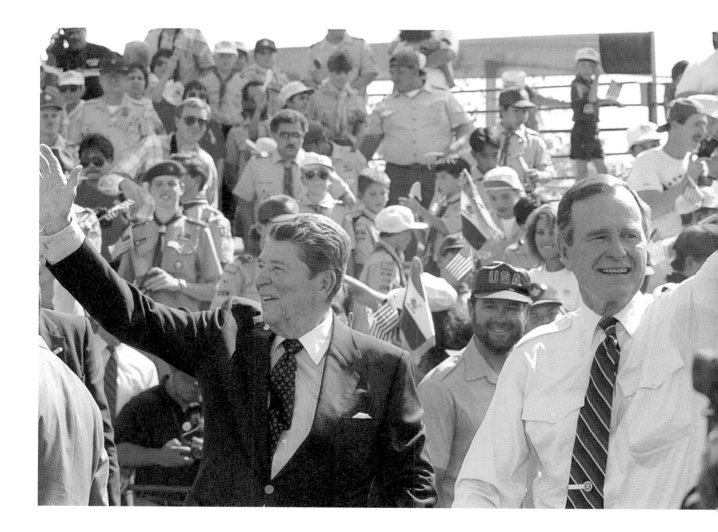

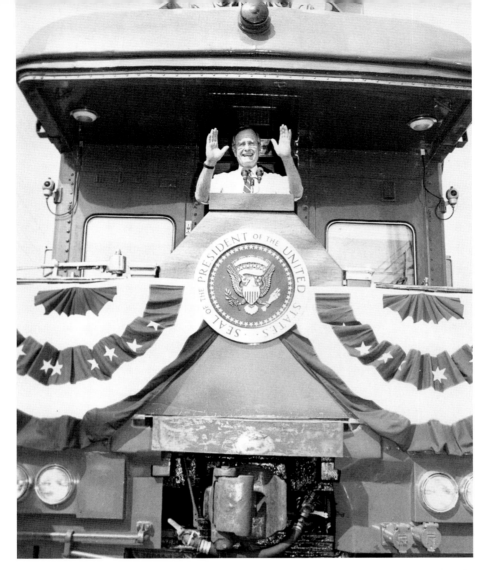

September 26: Taking a page out of Democrat Franklin D. Roosevelt's playbook, the President speaks to a crowd in Marysville, Ohio, during a whistle-stop train tour through Ohio and Michigan.

OPPOSITE: The President looks at his watch while his Democratic opponent, Arkansas Governor Bill Clinton, responds to a question during a debate on October 15. Two weeks earlier Ross Perot, seen here with Bush, had re-entered the presidential contest. Many viewers perceived Bush's glance at his watch as a sign of impatience with the debate itself, but he later explained that he felt Clinton's response had gone over the time limit.

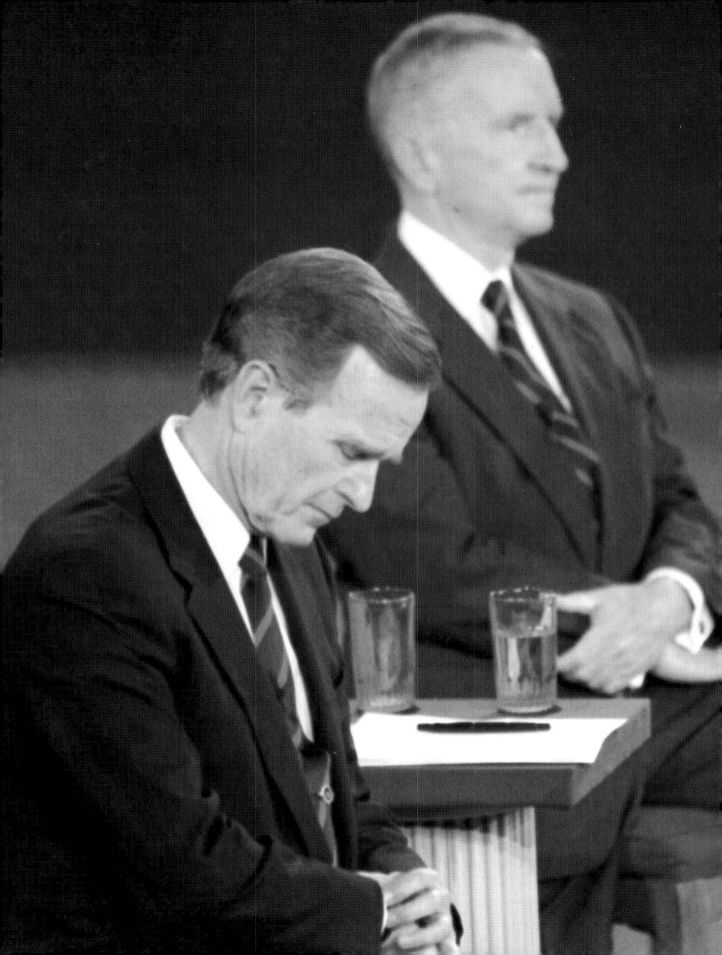

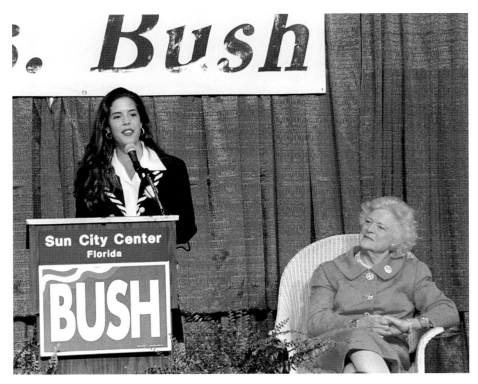

Mrs. Bush listens to Jeb's fifteen-year-old daughter, Noelle, as she urges a group of Sun City residents to vote for her grandfather in Tampa, Florida, on October 29.

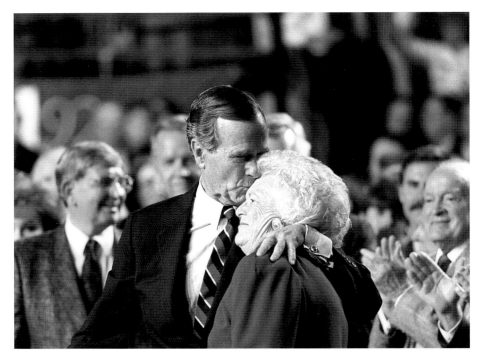

The President gives his wife a kiss as Bob Hope applauds approvingly at a pre-election rally in Houston, Texas, on November 2.

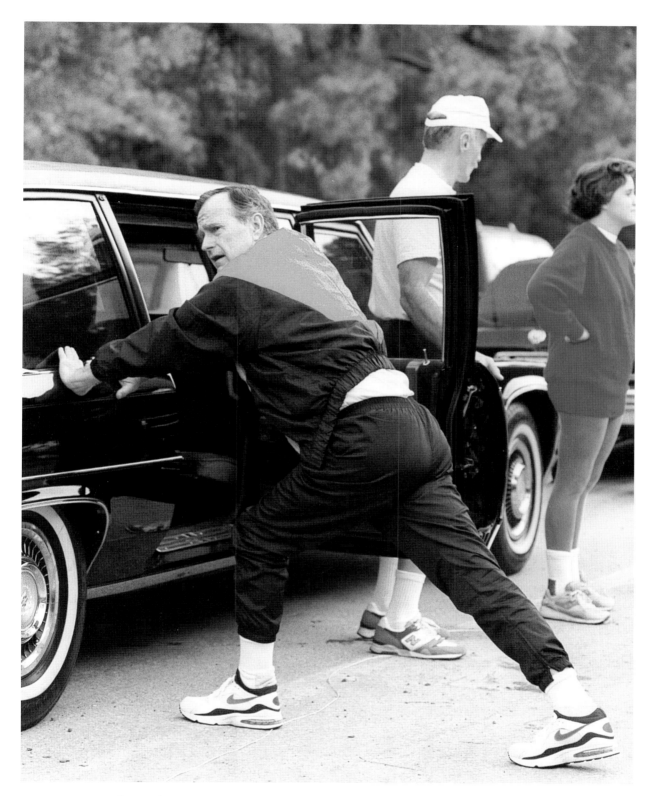

Bush stretches prior to an Election Day jog in Houston's Memorial Park on November 3. Polls indicated that Governor Clinton would likely defeat the President.

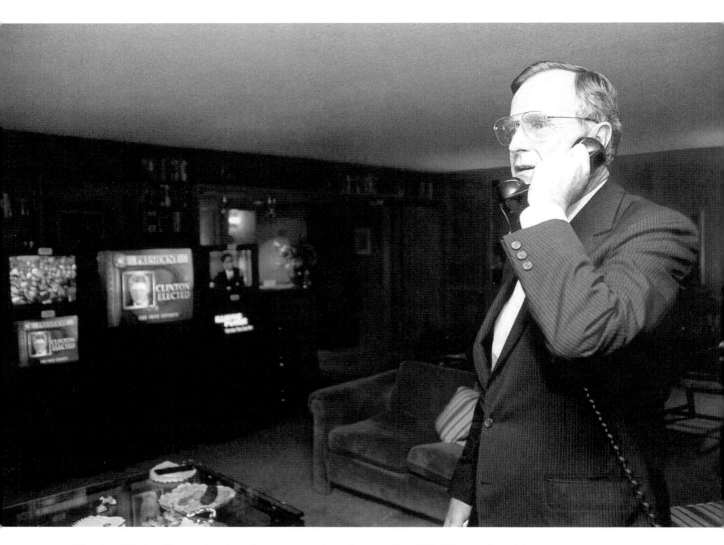

Election Night, George Bush makes a concession phone call to Bill Clinton from his Houston hotel room. Clinton and Al Gore received 43 percent of the popular vote, President Bush 37 percent, and Ross Perot 19 percent. Bush's defeat was blamed primarily on the sputtering economy and his broken pledge not to raise taxes, which alienated many in his conservative base. The drop from an approval rating in the high eighties to a 37 percent popular vote in less than two years was one of the most precipitous in American political history.

More bad news for the President: On November 18 Dorothy Walker Bush, ninety-one, suffered a stroke. Here, the President and his daughter, Dorothy Koch, return to Washington on November 19 after visiting the ailing matriarch in Greenwich, Connecticut. Shortly afterward, the President's mother died.

Millie helps the First Lady welcome her successor, Hillary Rodham Clinton, to the White House for a tour on November 19. "She was very easy to be with," Barbara recalled, "and we had a good visit. We talked about the office, the mail volume, and Chelsea. I suggested that she might want to bring a cousin or a best friend to spend the first year and go to school with Chelsea. It's a big lonely house for one little girl."

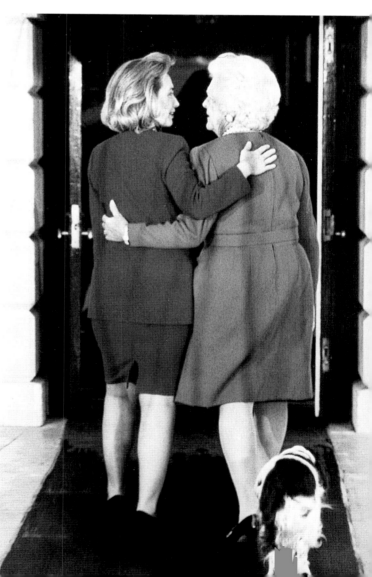

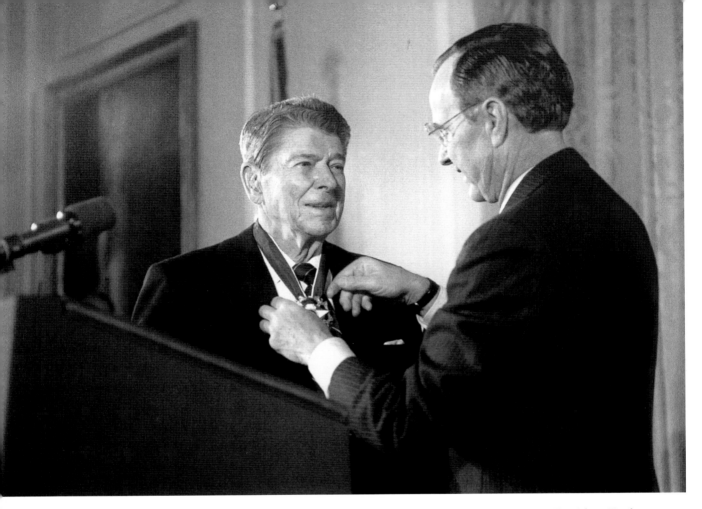

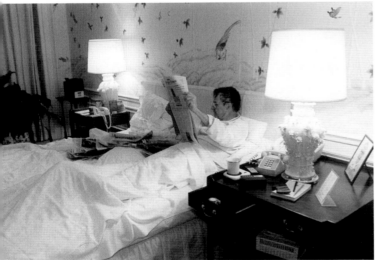

ABOVE: On January 13, 1993, President Bush presents the Presidential Medal of Freedom to former President Reagan in the East Room of the White House. According to Barbara, the President felt he had lost his re-election bid because he wasn't as good a communicator as Reagan—or, for that matter, Bill Clinton. Barbara disagreed: She felt the American people simply wanted a change after twelve years of Republican government.

LEFT: January 20: President Bush reads the newspaper in bed on his last day in office.

OPPOSITE: The present and future First Ladies leave the White House later that day to attend the swearing-in of William Jefferson Clinton as the forty-second President of the United States.

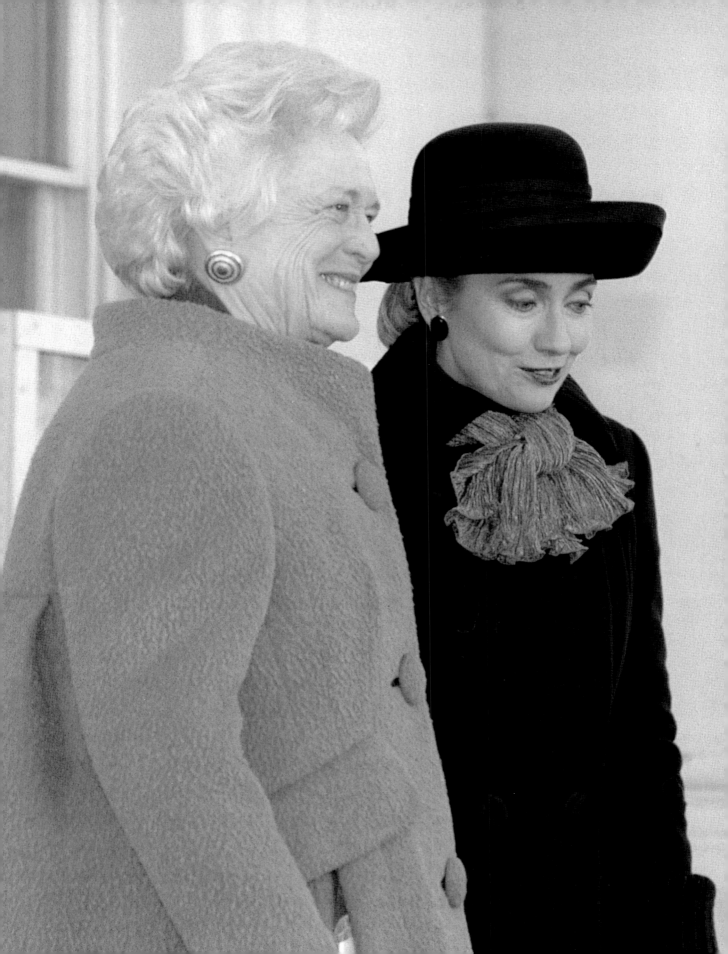

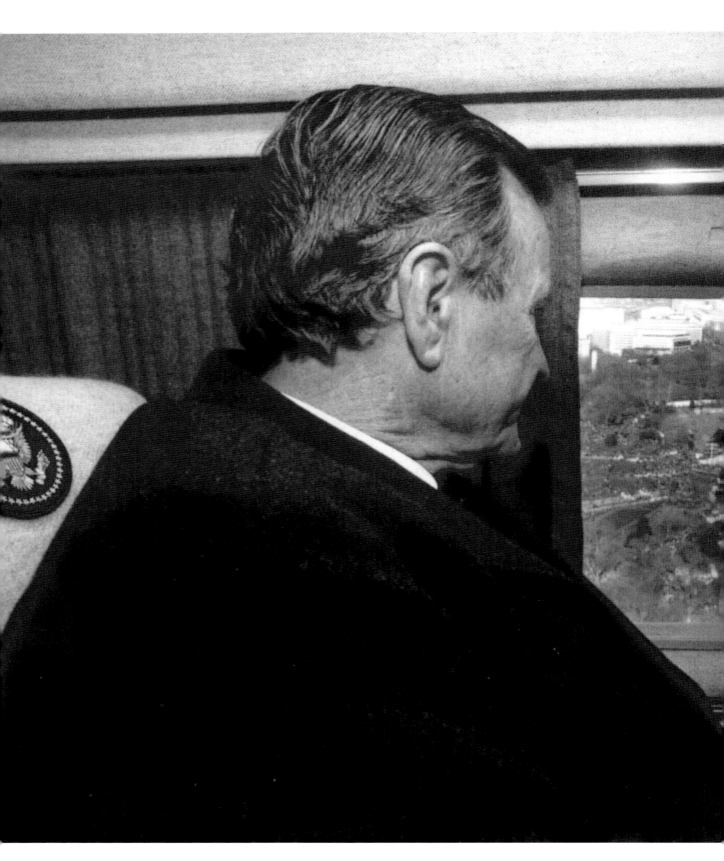

LEFT: After his successor's inauguration, the former President peers down at the Capitol as he leaves Washington for a rented house in Houston, Texas.

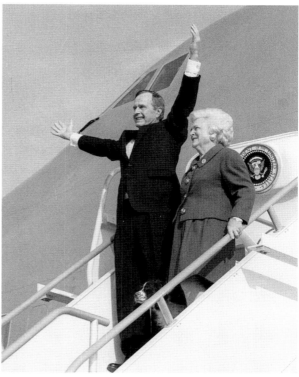

ABOVE: Bush reacts to well-wishers as he and Barbara arrive in Houston. "We were taken back into the community as if we had never left," Barbara wrote. Later, she recalled, "I was getting reacquainted with shopping, cooking, and driving after twelve years of living a grand life."

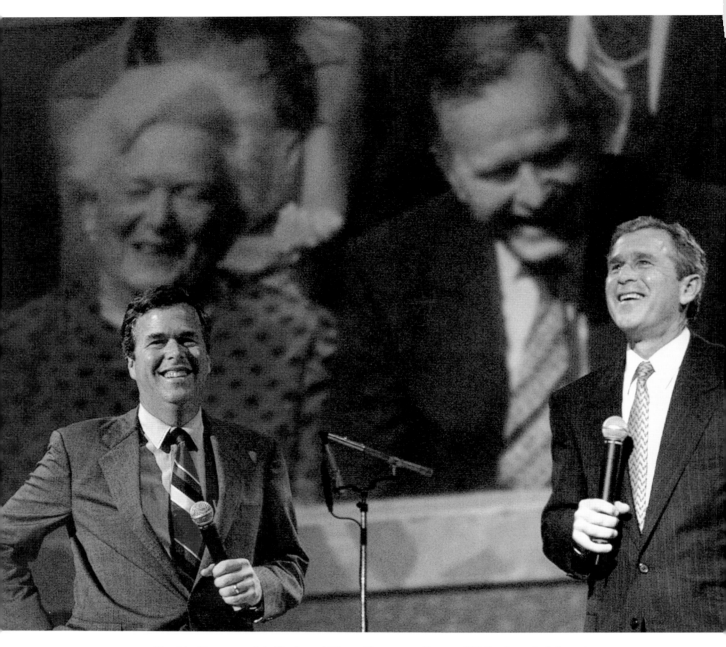

Florida Governor Jeb Bush and Texas Governor George W. Bush trade jokes about their parents as images of the elder Bushes flash on a screen above them at a charity birthday gala for George and Barbara in Houston, June 1999. The former President turned seventy-five on June 12; Mrs. Bush turned seventy-four on June 8.

SOUTHERN STRATEGY

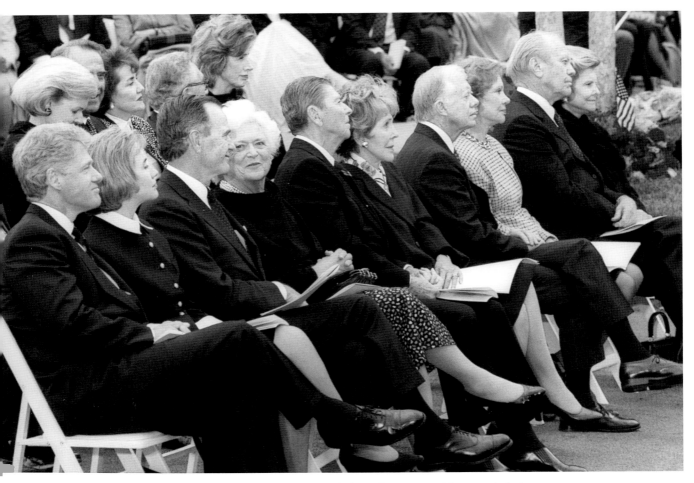

The Bushes join President and Mrs. Clinton and three former Presidents and their wives at the funeral of Richard Nixon in Yorba Linda, California, on April 27, 1994. Nixon was buried next to his wife, Pat, at the Nixon Library.

Running for governor of Texas, George W. Bush bears down on a dove as he participates in the opening of hunting season in Hockley, Texas, on September 1. Texas Waterfowl Outfitters guide Al Glos points out the unfortunate fowl. Earlier in the year Bush—despite his having lost his only run for public office and his lack of governmental experience—decided to challenge incumbent Ann Richards, the feisty gray-haired Democrat who had given a sensational speech at the 1992 convention in which she said of President Bush, "Poor George. He can't help it. He was born with a silver foot in his mouth."

Now his son would try to get even.

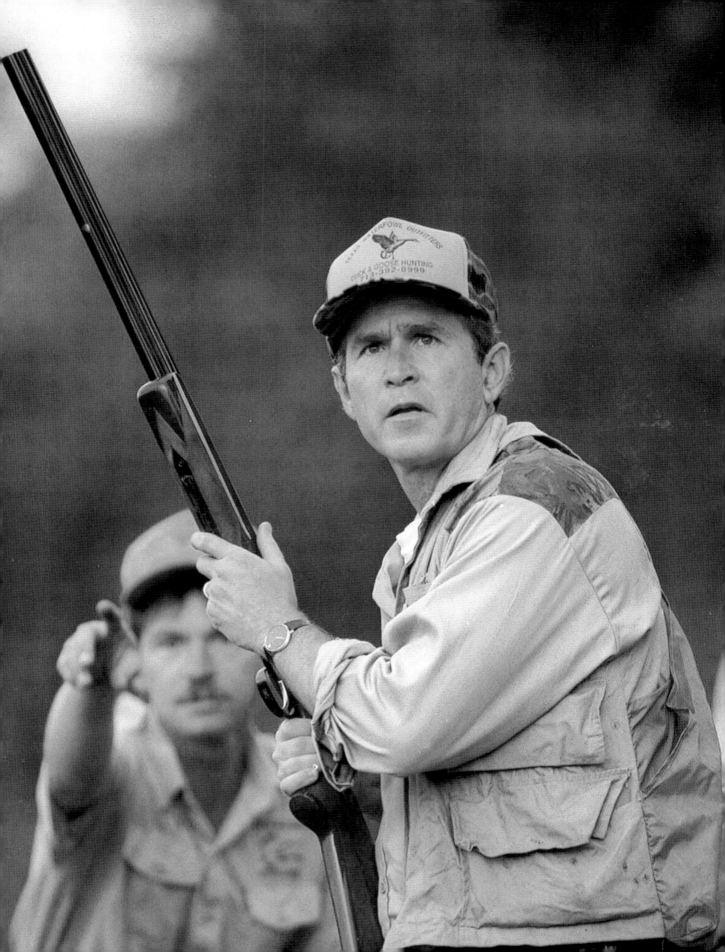

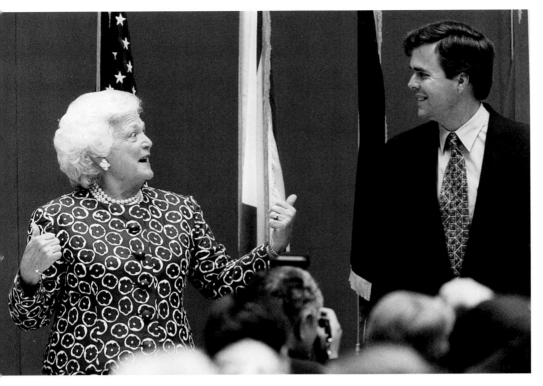

W. wasn't the only gubernatorial candidate among the Bushes that year. Jeb, seen here with his mother during a fund-raising luncheon in Fort Lauderdale on October 12, challenged incumbent Lawton Childs for Florida's top office. Like his brother, Jeb had never held elective office; after marrying and relocating to Florida, he helped start a real-estate development company that became one of the largest commercial real-estate companies in South Florida. From 1987 to 1988 he served as Florida's secretary of commerce and promoted doing business in Florida throughout the world.

October 27: Barbara shuttled between Texas and Florida to help her boys campaign. Here, she gestures as she talks to elementary-school students at an anti-drug rally at the Spring Branch Independent School District in Houston.

Governor-elect George W. Bush gives the thumbs-up after making his victory speech on November 8 in Austin. With him are Barbara, Jenna (partially obscured), and Laura. Bush's victory was attributed mainly to two factors: the increasing number of Republican voters in Texas and the star power of his name. Although the Texas Constitution gave him less power than the governors of most other states, his position as the head of one of the country's largest states put George W. Bush in the top tier of presidential possibilities. In Florida, a state more evenly divided between the parties, Jeb's surname didn't sufficiently help him. He lost his bid for governor.

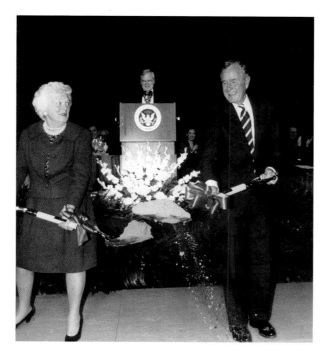

George and Barbara break ground for the George Bush Presidential Library at Texas A&M University in College Station, Texas, on November 30. The $82 million facility would house historical papers, tapes, photographs, and other memorabilia of the Bush presidency.

After addressing the 1996 Republican National Convention in San Diego on August 12, 1996, the former President is joined by his wife at the podium and responds to the cheers of the delegates. The convention nominated a former Bush rival, Kansas Senator Bob Dole, to run against President Clinton. Like Bush, Dole lost.

REPUBLICAN
NATIONAL
CONVENTION

RIGHT: George and Barbara walk through a phalanx of Texas A&M Ross Volunteers during a dedication ceremony for the George Bush School of Government and Public Service in College Station on September 10, 1997.

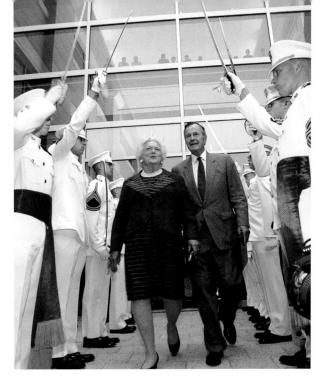

BELOW: Governor Bush chomps into a hot dog during the Texas Rangers' opening-day game against the Chicago White Sox in Arlington on March 31, 1998. Bush remained one of the team's owners; his share had been placed in a blind trust just before he became governor. Although running for re-election, Bush had traveled to thirteen states in the spring and summer to test the waters for a presidential bid in 2000 and had raised $10 million for the gubernatorial campaign. In September he sold his shares in the Rangers—which he had purchased in 1989 for $606,000—for $14.9 million.

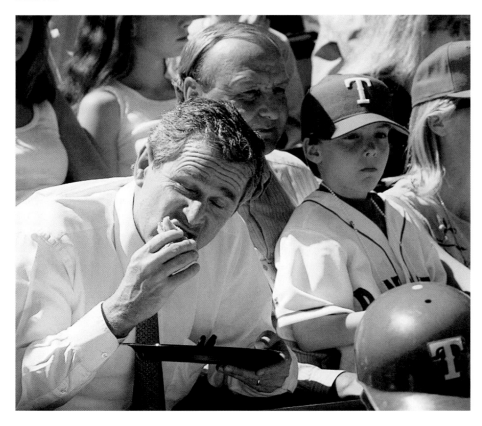

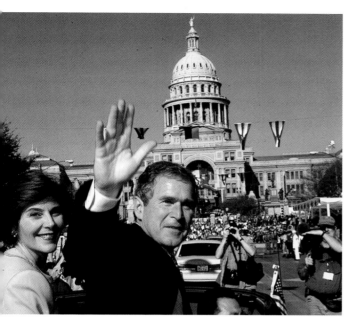

January 19, 1999: Governor Bush waves to the crowd as he and Laura ride to the state capitol in Austin for his second inauguration. His landslide victory (67 percent of the popular vote) put him atop the list of 2000 presidential prospects. In Florida, Jeb won the governorship with 55 percent of the vote against former representative Kenneth (Buddy) McKay. His brother's election was great news for W.: It wouldn't hurt his anticipated presidential campaign to have Jeb in charge of a pivotal state such as Florida. On March 7 Bush announced the formation of a presidential exploratory committee.

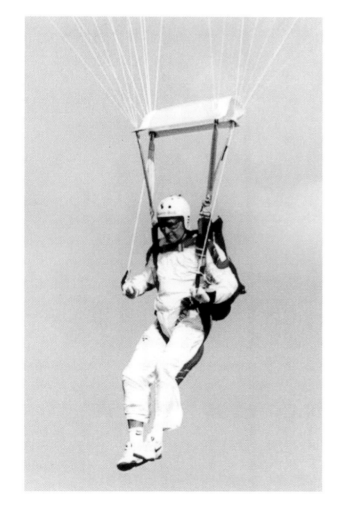

To celebrate his upcoming seventy-fifth birthday, former President Bush makes a parachute jump above College Station, Texas, on June 9. At the beginning of his dive, Bush failed to get in the correct position and began to spin out of control at 125 miles an hour. Two fellow jumpers struggled to right him, which they did at the last minute. He tumbled to the ground without incident. "It was really scary," Barbara recalled.

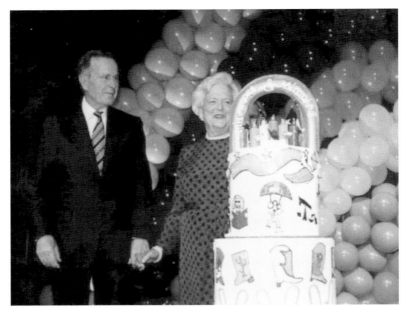

The following day George and Barbara celebrate both their birthdays (Barbara turned seventy-four) with balloons and a huge cake.

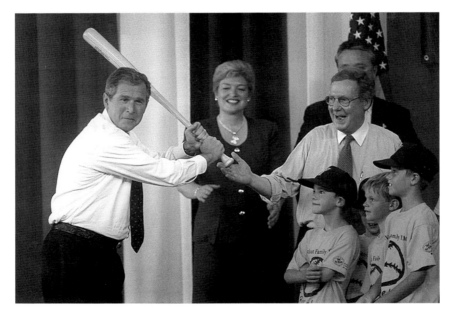

On his way to a $1,000-a-plate fund-raiser for his unannounced presidential campaign on June 23, W. swings a Louisville Slugger bat given him by a YMCA Little League team in Louisville, Kentucky. Despite doubts about Bush's lack of foreign policy experience and a perception that he was an intellectual lightweight, the nascent Bush candidacy gained steady momentum among Republicans throughout 1999.

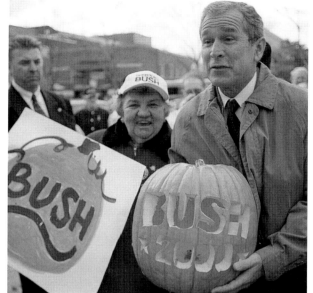

Now an announced candidate, Governor Bush poses with former child star and ambassador Shirley Temple Black at another fund-raiser in Redwood City, California, on September 30.

Keene, New Hampshire, October 22: In the state with the first presidential primary of 2000, Bush attends the Pumpkin Fest and adds a campaign advertisement to the thousands of jack-o'-lanterns on display.

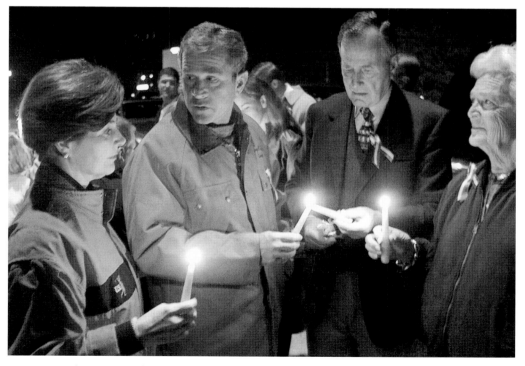

November 25: At the site of the tragic bonfire collapse at Texas A&M that killed twelve and injured two dozen a week earlier, George and Laura and George and Barbara hold candles during a vigil in College Station.

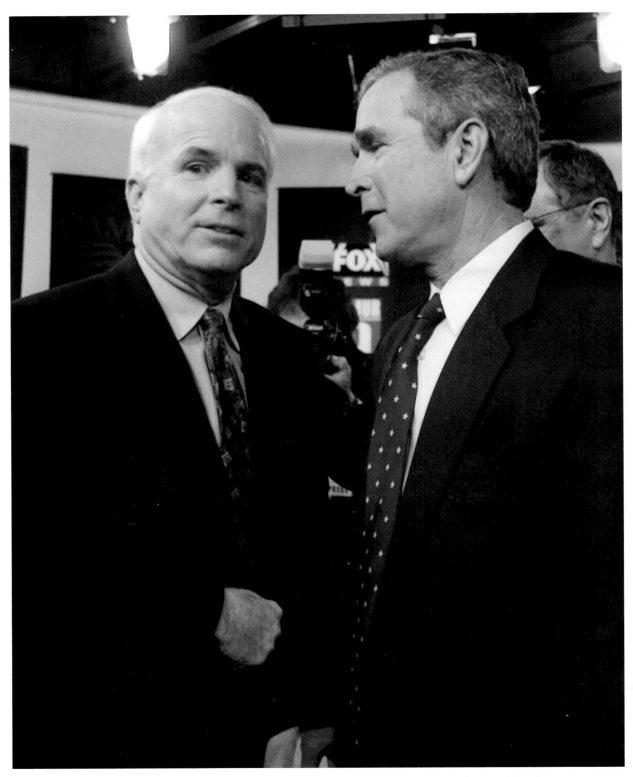

George W. Bush debated his primary challenger, Arizona Senator John McCain, in New Hampshire on December 2. Observers were surprised when the two contenders treated each other gently during the debate.

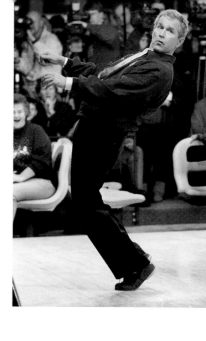

RIGHT: W. applies a little body language to his follow-through during a game of candlepin bowling in Nashua, New Hampshire, on January 31, 2000. The following day Bush lost the primary to McCain by a crushing 16 percentage points.

BELOW: The day after the New Hampshire loss, Bush, in an effort to shore up his conservative base in South Carolina, makes an appearance with his wife at Bob Jones University. His apparent sanctioning of the school's anti-Catholicism and segregationist policies created a firestorm of criticism, which prompted him to write a letter of apology to Cardinal John O'Connor, archbishop of New York. "I should have been more clear in disassociating myself from anti-Catholic sentiments and racial prejudice," the letter read. "It was a missed opportunity, causing needless offense, which I deeply regret."

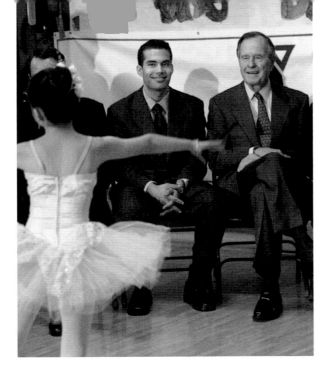

George P. Bush and his grandfather watch a ballet recital at the YMCA in San Francisco's Chinatown on February 13 as they campaign for W. in the California primary election.

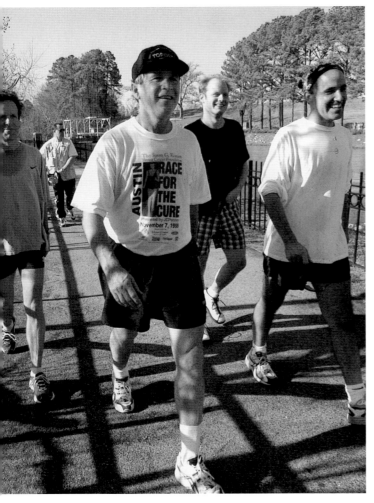

February 19: On primary day in South Carolina, W. walks along a running path in Riverfront Park in Columbia. After treating McCain "gently" in New Hampshire, the Bush campaign took off the gloves in the Palmetto State. A McCain supporter came forward to say her son had been upset by a phone call from a Bush supporter: "He was so upset when he came upstairs, and he said, 'Mom, someone told me that Senator McCain is a cheat and a liar and a fraud.' And he was almost in tears." Bush responded that a McCain ad accusing him of "lying like Clinton" went beyond the pale. Despite the Bob Jones controversy and the charges of dirty campaigning, Bush won the victory he needed, with 53 percent of the vote.

A man running for President needs all the support he can get: Bush holds up a tabloid newspaper given him by a staff member during a flight to Southern California on May 3. On March 7 Bush had won the California primary with 60 percent of the vote, as well as six other states out of the eleven voting on Super Tuesday, including New York, Georgia, and Ohio. The victories put him firmly on the path to the Republican nomination in August.

Caroline Kennedy presents former President Bush with a bust of her father at the John F. Kennedy Library in Boston on May 21. Bush was chosen to receive the Kennedy Foundation's Distinguished American Award.

Doro, Marvin, and Neil are interviewed about their brother on CNN's *Larry King Live* at the Republican convention in Philadelphia on August 3.

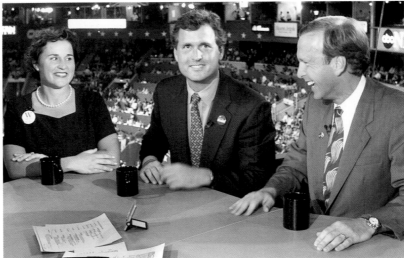

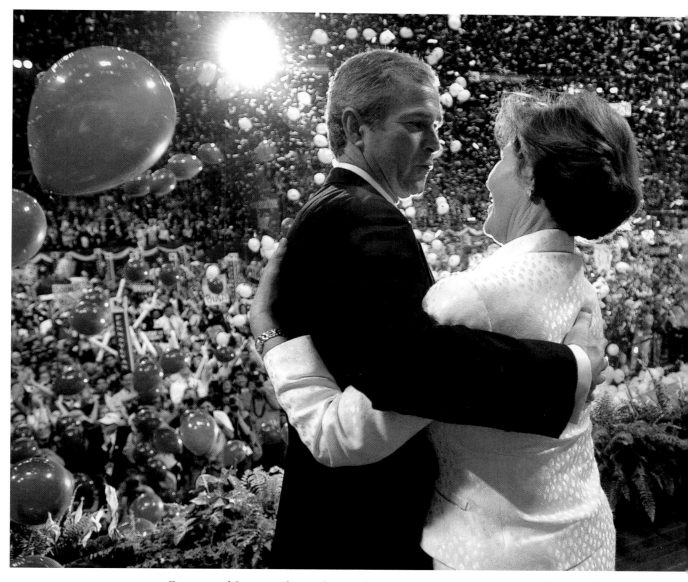

George and Laura embrace during the traditional dropping of the balloons follow-ing his acceptance speech on the evening of August 3. In the address, W. said, "I'm especially grateful tonight to my family. No matter what else I do in my life, asking Laura to marry me was the best decision I ever made. And to our daughters, Barbara and Jenna, we love you a lot. We're proud of you. And as you head off to college this fall, don't stay out too late. And e-mail your old dad once in a while, will you? And Mother, everybody loves you and so do I. Growing up, she gave me love and lots of advice. I gave her white hair. And I want to thank my dad, the most decent man I have ever known. All of my life I have been amazed that a gentle soul could be so strong. Dad, I am proud to be your son."

RIGHT: George Bush's secret weapon: George P. Bush campaigns for his uncle in Los Angeles on June 21. The handsome twenty-three-year-old drew responses from Latinos akin to those of a pop star, and the Bush campaign used him as much as possible in an attempt to win over young Latino voters, who usually skewed Democratic. The Bush campaign believed it had a shot at winning heavily Democratic California if it could wrest away enough minority votes.

BELOW: Bush and his running mate, Dick Cheney, onstage at a campaign rally at Naperville North High School in Naperville, Illinois, on September 4. In a *sotto voce* comment to Cheney, Bush called *New York Times* reporter Adam Clymer, who had written a series of articles critical of the candidate, an "asshole." Unfortunately, W.'s *voce* wasn't *sotto* enough. The comment was picked up by the microphone and broadcast across the country on the evening news.

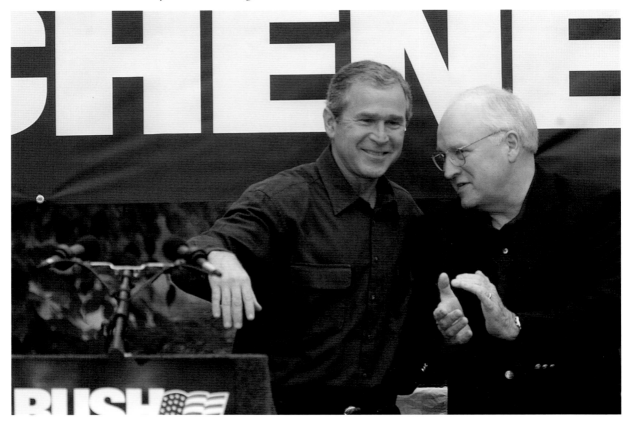

The candidate busses daytime talk show diva Oprah Winfrey during an appearance on her show, September 19. Winfrey asked the governor what he thought the biggest public misconception about him was. "That I'm running on my daddy's name," he replied. "I've lived with this all my life. I love my dad a lot. He gave me the great gift of unconditional love, which is a fabulous gift. It's allowed me to feel I can dare to fail and dare to succeed."

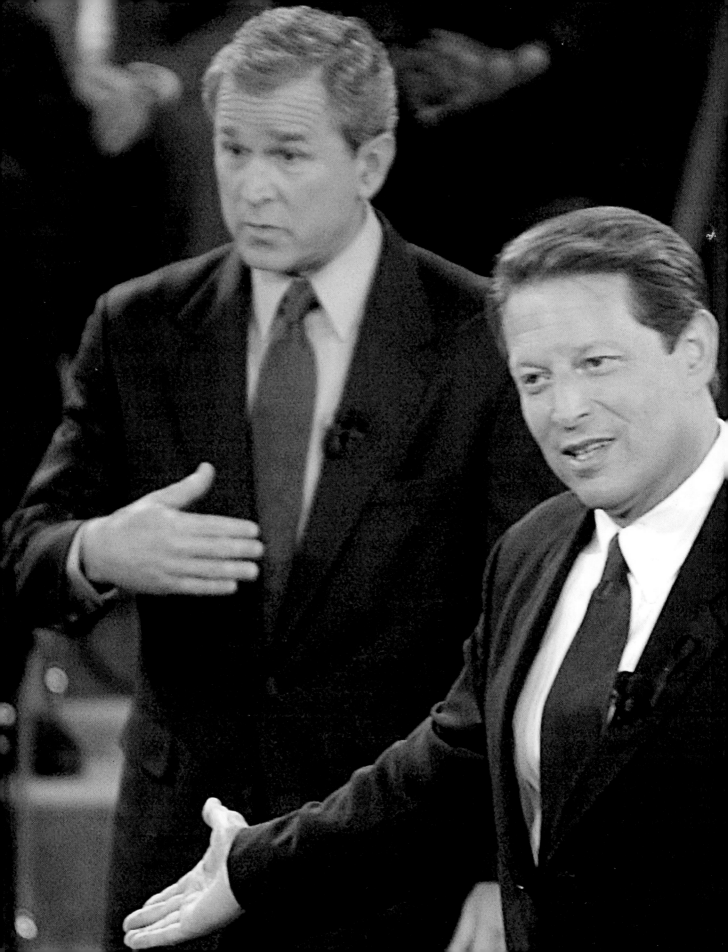

Barbara Bush appeals for the women's vote for her son during a campaign rally in Southfield, Michigan, on October 18. With her are Laura Bush and Lynn Cheney, wife of the vice presidential nominee.

Oops! A billboard in Charlotte, North Carolina, on October 21 seems a tad confused. Charlotte advertising executive David Oakley, whose firm created the billboard, blamed the blooper on "a mistake that slipped past the proofreader." Oh.

OPPOSITE: W. and his opponent, Vice President Al Gore, during a debate at Washington University in St. Louis on October 17. The Bush campaign had dragged its feet on accepting debates because of Gore's perceived superiority as a debater and W.'s tendency to twist syntax and make verbal gaffes. With expectations of his performance low, Bush was able to score points simply by holding his own against the Vice President. Observers felt that Bush also came across as a warmer, more personable man than the often wooden Gore.

W. wears a Gore mask and Jay Leno a Bush mask during a Bush appearance on the *Tonight Show,* October 30. Bush was in California for a last-ditch attempt to win the electoral-vote-rich Golden State. "I've got a record," Bush told more than two hundred Latino supporters in Anaheim Hills. "I am a uniter, not a divider. That is how I have led as the governor of a great and diverse state. That is how I will lead from the White House."

Thursday, November 2: Eager beavers George and Barbara Bush vote early for their son in Houston. The general election was scheduled for the following Tuesday.

On Sunday, November 5, the brothers Bush kid around as New York Mayor Rudolph Giuliani looks on during a bus ride to a rally at Florida International University in Miami. With W. trailing in California polls by 20 percentage points, winning Florida had become paramount: Without it, gaining an electoral-vote majority would be highly unlikely. Bush spent the last hours of the campaign in the Sunshine State.

An election that made history: In a roller coaster of an election night, November 7, Gore was projected the winner in Florida early in the evening, making his election virtually certain. A few hours later the networks pushed the state back into the "undecided" category, then projected Bush the winner, prompting headlines like this. (Although Al Gore won the national popular vote by a margin of 500,000, if Bush won Florida, he would eke out a 271–266 electoral college majority.) But the Florida vote, in fact, remained too close to call by the following morning and was put in question by Democratic charges of widespread voting irregularities, particularly the turning away of thousands of legitimate voters (primarily in heavily Democratic areas of the state) who were wrongly told they were ineligible to vote. The stage was set for a bruising recount battle.

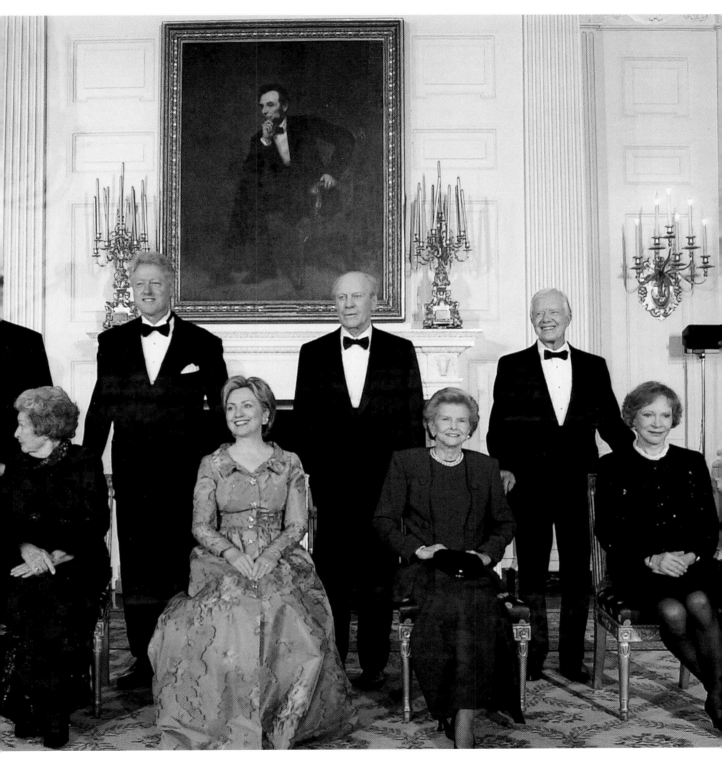

For a reception commemorating the two hundredth anniversary of the White House on November 9, President and Mrs. Clinton pose with, left to right, Barbara and George Bush, Lady Bird Johnson, Gerald and Betty Ford, and Jimmy and Rosalynn Carter.

Pictures like this one, taken outside the Governor's Mansion in Austin on December 4, were all the public saw of George W. Bush while he kept a low profile during the protracted legal battles over the Florida recount. For four agonizing weeks, the election results hung in doubt as both sides traded charges. They debated whether pregnant and hanging chads should be counted as votes and whether votes cast for third-party candidate Pat Buchanan in Palm Beach County were actually intended for Gore by voters addled by a confusing "butterfly ballot." On December 11 the U.S. Supreme Court ruled, 5–4, to overturn a Florida Supreme Court order for a recount and let stand a 537-vote victory for George W. Bush.

President Clinton welcomes President-elect Bush to the White House on December 19. Clinton showed Bush around the mansion and the two men discussed transition issues.

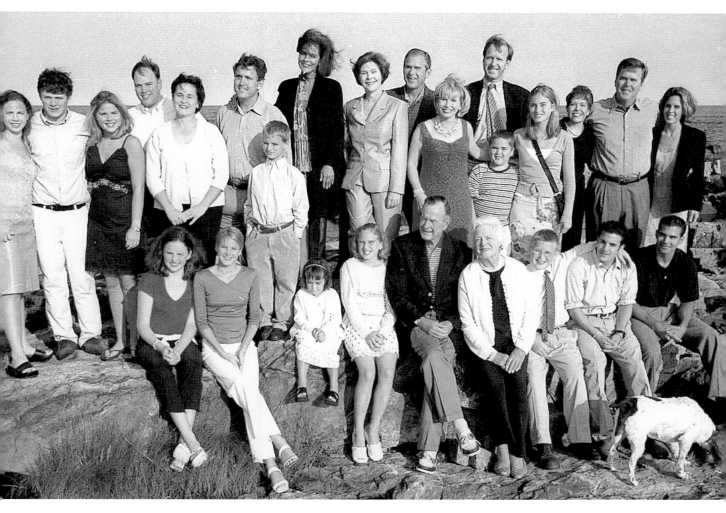

A former President, a President–elect, a governor, and lots of grandchildren:
The Bushes pose at Walker's Point for the family's 2000 Christmas card.

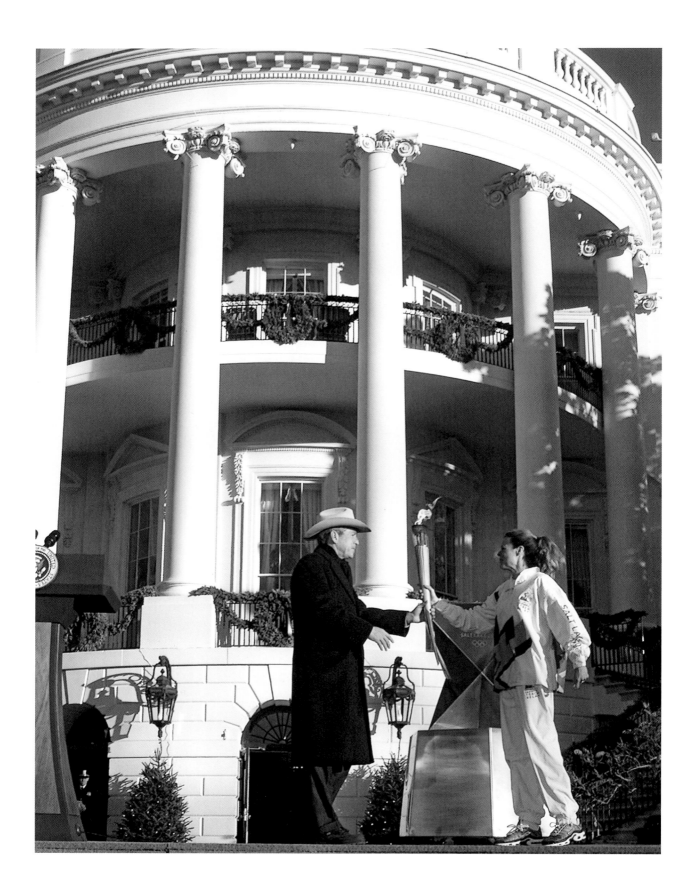

"43"

President George W. Bush receives the Olympic torch from torchbearer Elizabeth Howell on the South Portico of the White House; Saturday, December 22, 2001. Howell carried the flame to the White House in honor of her husband, Brady, who died in the September 11, 2001, terrorist attack on the Pentagon.

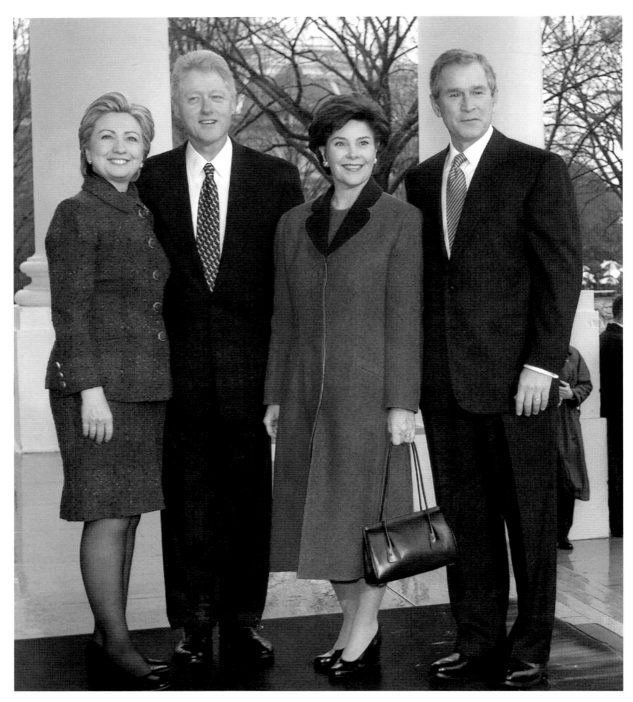

President Clinton and Senator Hillary Rodham Clinton of New York accompany
President-elect and Mrs. Bush from the White House to the inaugural platform on
Capitol Hill, January 20, 2001.

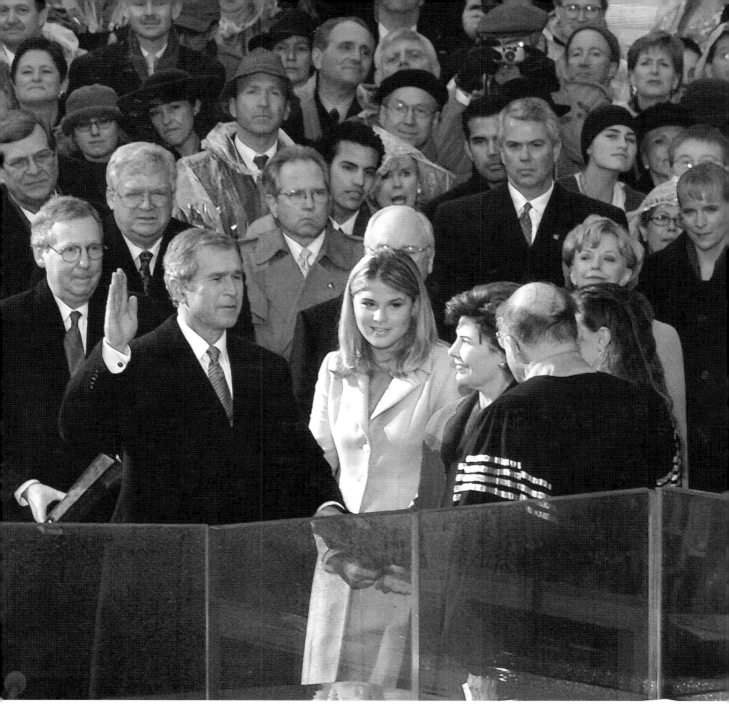

His wife and daughters look on as George W. Bush repeats the oath of office recited by Chief Justice William Rehnquist and is sworn in as the forty-third U.S. President on January 20. In his address, Bush said, "We will confront weapons of mass destruction so that a new century is spared new horrors. The enemies of liberty and our country should make no mistake: America remains engaged in the world by history and by choice, shaping a balance of power that favors freedom. We will defend our allies and our interests. We will show purpose without arrogance. We will meet aggression and bad faith with resolve and strength. And to all nations, we will speak for the values that gave our nation birth."

LEFT: "41" in the Oval Office with "43" after the inauguration. The elder Bush was taking a bath in the White House when his son called and asked him to come down. "I would say that this was typical of George W.," Barbara said. "He knew how much this would mean to his dad, and he wanted to share his first moments in this revered office with him. You can take a hot bath anytime, but just how often can you walk into the Oval Office and see your own son?"

ABOVE: That night the President and First Lady wave to supporters after sharing a dance at the Ohio inaugural ball.

Wasting little time, the President makes good on his campaign pledge to lower taxes as he unveils his plans in the Diplomatic Room of the White House on February 5. Bush said that all Americans would share in his tax cuts, but opponents charged that the vast majority of the cuts would be for the wealthy and that the reduced revenue would cause the budget deficit to balloon.

Laura Bush sheds a tear as she and the President attend an emotional ceremony dedicating a museum at the Oklahoma City National Memorial Center on February 19. The museum features artifacts—including personal effects and mangled concrete—salvaged from the wreckage of the Alfred P. Murrah Federal Building, which was destroyed when a truck bomb exploded in front of it the morning of April 19, 1995.

Sixteen-year-old Lauren Bush, the President's niece and a model, helps launch Tommy Hilfiger's spring 2001 collection in the designer's London store on March 1. Lauren is the daughter of Neil and Sharon Bush.

The First Couple enjoy the beauty of a late-winter snowfall in the Rose Garden on March 5.

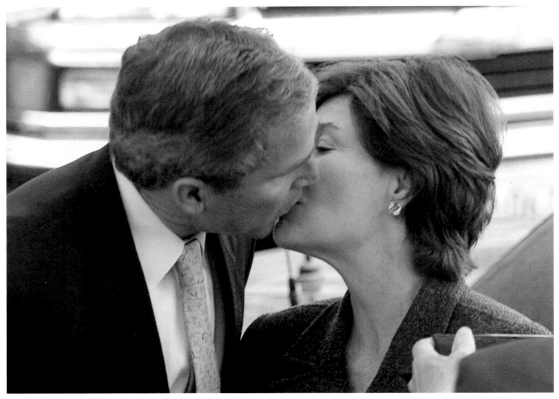

March 15: The President welcomes the First Lady back to the White House as she returns from a trip to their Crawford, Texas, ranch.

Jenna Bush, a student at the University of Texas, is seen through a window of the Austin Community Court on May 16. With her is her lawyer, William P. Allison. The nineteen-year-old college student pleaded no contest to a charge of possession of alcohol and was sentenced to pay $51.25 in court costs, serve eight hours of community service, and attend six hours of alcohol-awareness classes. Less than two weeks later, Jenna was charged with trying to use a third party's identification to purchase alcohol at a Mexican restaurant near the University of Texas campus. Her sister, Barbara, enrolled at Yale, was with Jenna that night and was charged with being a minor in possession of alcohol. They both pleaded no contest to all charges. On July 6, on the false identification charge, Jenna was ordered to pay one hundred dollars, perform thirty-six hours of community service, and attend a session with victims of alcohol-related crimes. On the underage drinking charge, Barbara was fined five hundred dollars and had her driver's license suspended for thirty days. The next time the girls saw their parents, a presidential aide reported, "it wasn't a Kodak moment."

On June 5 the President helps Habitat for Humanity volunteers build a house in Tampa, Florida. The faith-based program, dedicated to providing housing for low-income Americans, was observing its twenty-fifth anniversary.

Celebrating the Fourth of July in Philadelphia, the President poses with the city's baseball mascot, the Philly Phanatic, at a block party sponsored by the Greater Exodus Baptist Church. Bush was in Pennsylvania to promote his faith-based initiative to enable religious charities to provide governmental services.

New York's mayor Rudy Giuliani, Governor George Pataki, and Senator Hillary Rodham Clinton join the President on a ferry to Ellis Island to attend a naturalization ceremony on July 10 for twenty-nine brandnew New Yorkers. Bush led the new U.S. citizens in their first Pledge of Allegiance.

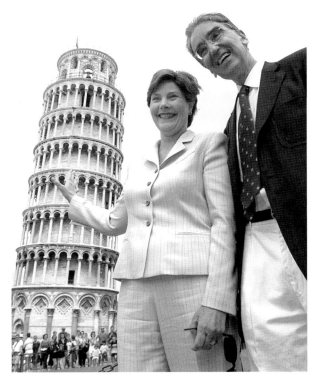

Laura gives symbolic support to the Leaning Tower of Pisa on July 20 during a visit to Italy with her husband, who was attending the G8 economic summit in Genoa. With the First Lady is Pier Francesco Pacini, head of the authority charged with preserving Pisa's historical monuments.

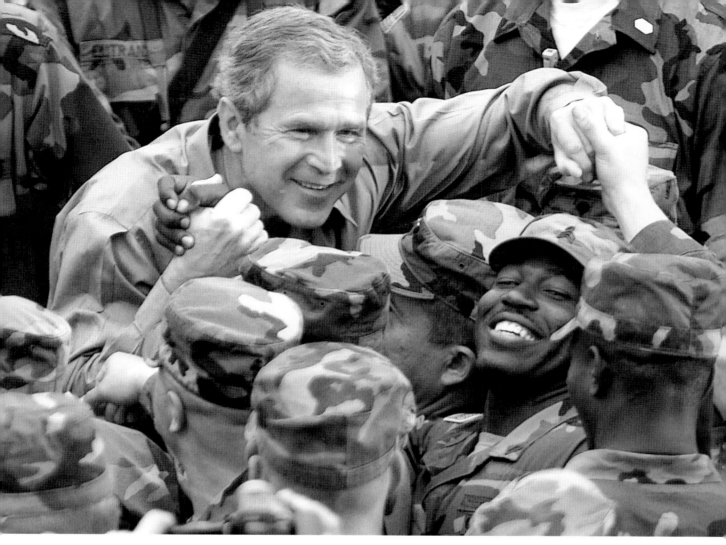

ABOVE: Bush grabs the outstretched hands of soldiers during a visit to the U.S. military base Camp Bonsteel in Kosovo on July 24. Bush had said during the campaign that he would speedily remove U.S. peace-keeping troops from the Balkans and press Europe to take up the slack—a position criticized by the allies. He now told troops that the U.S. military would stay until both the allies and the United States believed the job was finished.

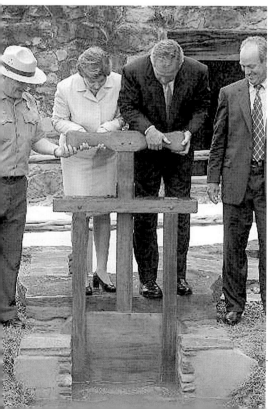

LEFT: The Bushes raise the gate for the San José Grist Mill at Mission San José during dedication ceremonies in San Antonio, Texas, on August 29. Mission San José is a Spanish Colonial mission founded in the eighteenth century.

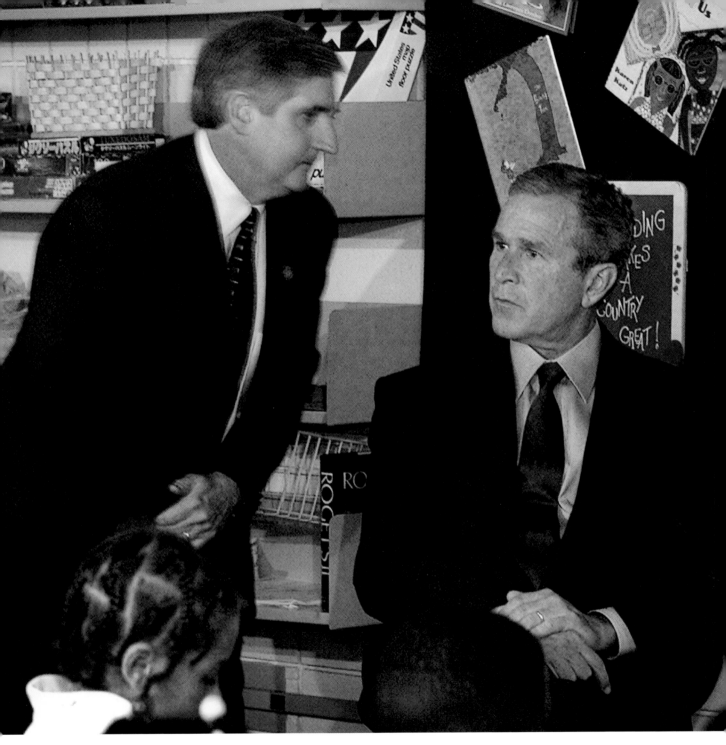

September 11: During a visit to the Emma T. Booker Elementary School in Sarasota, Florida, the President reacts to the news from his chief of staff, Andew Card, that a second jetliner has crashed into New York's World Trade Center towers. What had at first been thought to be a terrible accident had now clearly been revealed as a terrorist act. The events of this day would change America and much of the world—and help define George W. Bush's presidency.

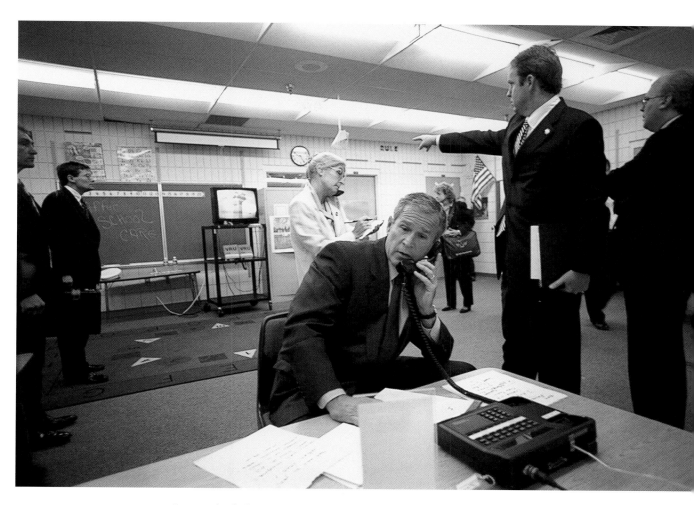

In a makeshift situation room at Booker Elementary, Bush gets updates on the attacks as Communications Director Dan Bartlett points to the shocking images of the Twin Towers burning on television. Behind the President is National Security Council member Deborah Loewer, and at far right is Bush's senior adviser Karl Rove. After another hijacked jetliner crashed into the Pentagon, the White House was evacuated and Vice President Cheney, who had been at work in his office, was taken to a "secure location."

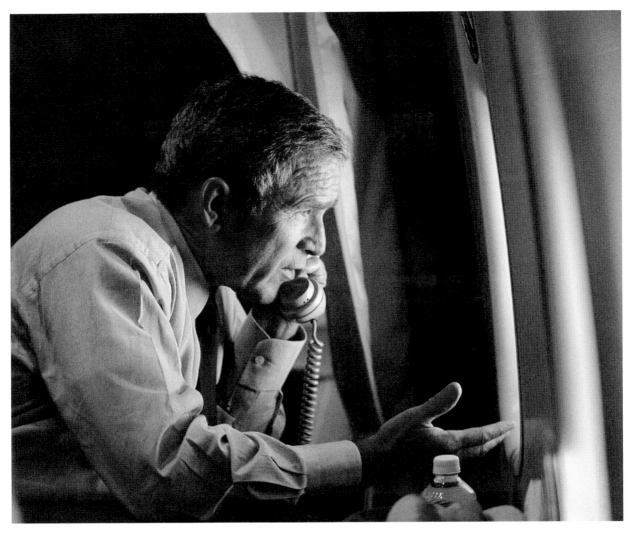

President Bush speaks to Dick Cheney from *Air Force One,* on its way back to Washington from Offutt Air Force Base in Nebraska. The Secret Service kept the President's whereabouts secret until the extent of the terror threat was known.

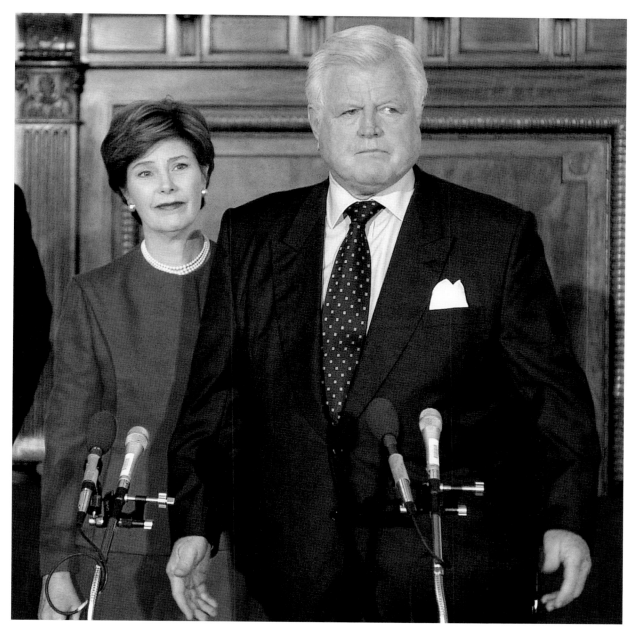

Fighting back tears, the First Lady listens as Massachusetts Senator Edward M. Kennedy expresses his horror and outrage at the terrorism. Mrs. Bush's testimony before Kennedy's Health, Education, Labor and Pensions Committee was postponed when news of the atrocity broke; a half hour later, the Russell Senate Office Building was evacuated.

The First Lady and Red Cross president Dr. Bernardine Healy smile as nurse Susanah Noralez draws blood from U.S. Trade Office attorney Bruce Overton on September 12. The blood drive at the Old Executive Office Building helped provide blood for the thousands of injured in New York and Washington.

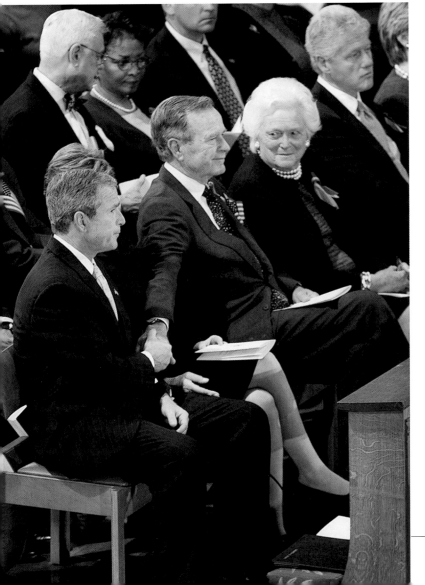

September 14: His father reaches over to the President in a "well done" gesture after his strong and emotional address at a National Day of Prayer and Remembrance service at the National Cathedral in Washington, D.C., for the three thousand victims of the attacks. "War has been waged against us by stealth and deceit and murder," Bush said. "This nation is peaceful, but fierce when stirred to anger. This conflict was begun on the timing and terms of others; it will end in a way and at an hour of our choosing."

OPPOSITE: Later that day the President visited Ground Zero in lower Manhattan to observe ongoing rescue efforts. He waved a flag and spoke to rescue workers through a bullhorn, promising to find and bring to justice "the people who brought down these buildings."

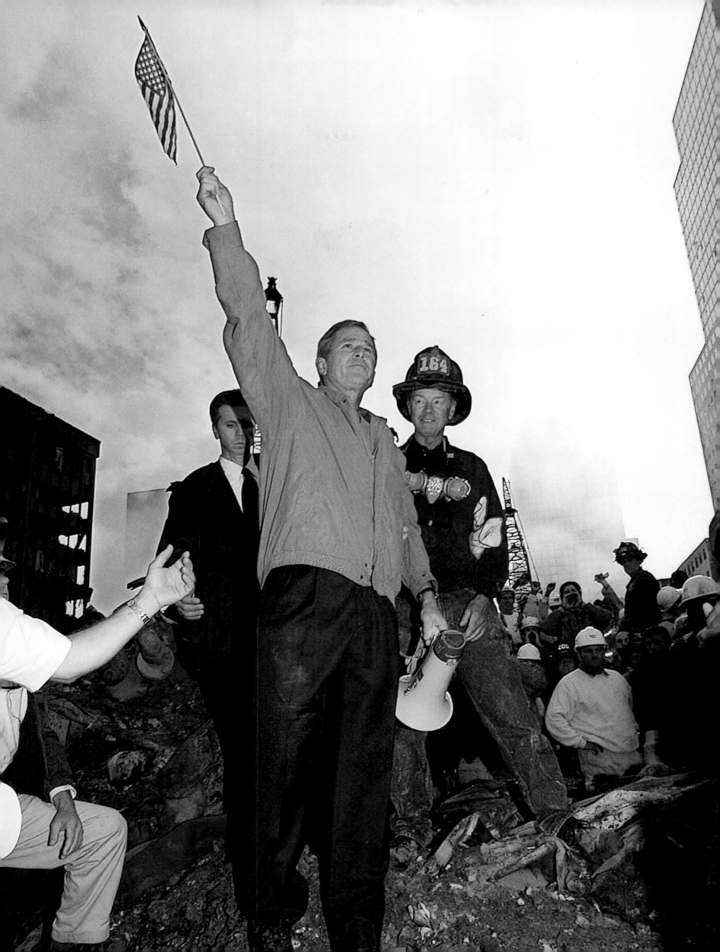

Hoping to stem a wave of anti-Muslim sentiment caused by Islamic fundamentalists' involvement in the attacks, the President stands with religious leaders at the Islamic Center in Washington on September 17.

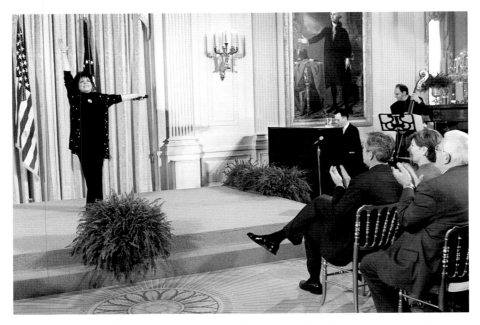

Entertainer Liza Minnelli belts out "New York, New York" at a Columbus Day ceremony in the East Room of the White House on October 8. The event also paid tribute to Arlington County, Virginia, firefighters who responded to the Pentagon disaster.

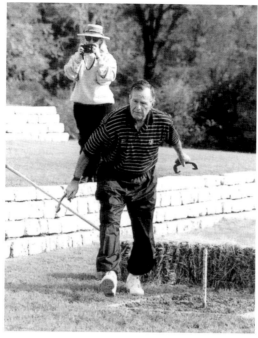

Former President Bush tosses horseshoes at a barbecue for the employees and students of the Bush Library, Bush School of Government, and Bush Foundation in College Station, Texas, on November 17.

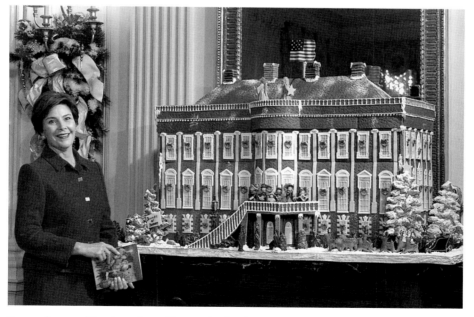

Laura shows off a gingerbread house in the State Dining Room during a media tour of the White House Christmas decorations on December 3. The cake is a replica of the Executive Mansion as it was in the 1800s. Because the White House remained closed to all but invited VIPs after September 11, Mrs. Bush taped a video tour of the holiday trimmings to be shown at the nearby White House Visitors Center.

RIGHT: December 11: With the First Lady at his side, President Bush addresses victims' family members, firefighters, and other rescuers during a White House ceremony to mark the three-month anniversary of the terrorist attacks. More than seventy countries that lost citizens in the attacks participated, playing their national anthems in tribute to the victims.

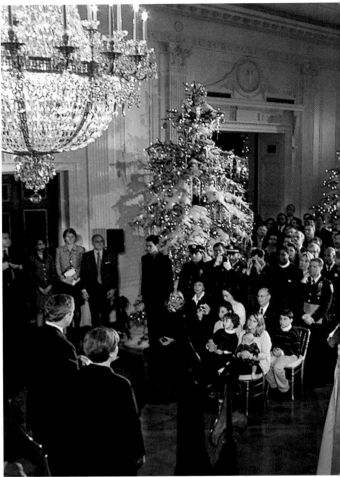

LEFT: Their English springer spaniel Spot enjoys the new rug in the Oval Office on December 21, as the President and First Lady meet with reporters. Bush said that while the United States did not know the whereabouts of al Qaeda leader Osama bin Laden, who had claimed "credit" for the 9/11 attacks, "we'll get him, dead or alive."

The President speaks with reporters on January 14, 2002, before leaving Washington on a two-day trip to the Midwest and New Orleans. The bruise on his face was the result of a fall when he fainted after choking on a pretzel in the White House residential quarters.

Senator Hillary Rodham Clinton welcomes the First Lady to Capitol Hill on January 24 prior to her testimony before the Senate Health, Education, Labor, and Pensions Committee, which had been postponed from September 11. Mrs. Bush told the committee about a White House summit on early-childhood cognitive development the prior summer and announced some education figures from the President's yet-to-be-unveiled budget.

OPPOSITE: February 6: In New York to bolster the city's depressed tourism after 9/11, Mrs. Bush walks past a wooden model of the Empire State Building during a tour of the American Folk Art Museum in Manhattan.

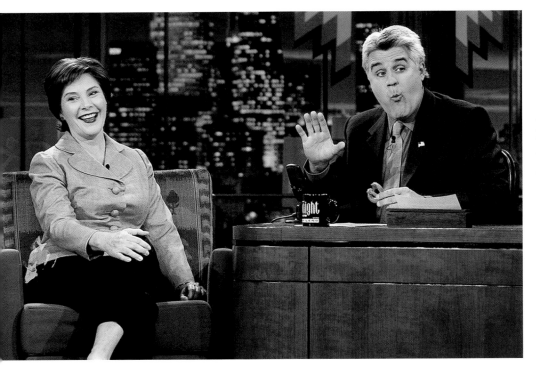

Mrs. Bush cracks up as Jay Leno pretends to choke on a pretzel she gave him during her appearance on the *Tonight Show* on February 11.

February 18: Barbara mugs as she stands between a twenty-foot bust of her husband and a life-size cardboard cutout of her son during an unveiling of forty-three busts to be installed at President's Park in the northern Black Hills, South Dakota. The former President looks on as the artist David Adickes discusses the likenesses.

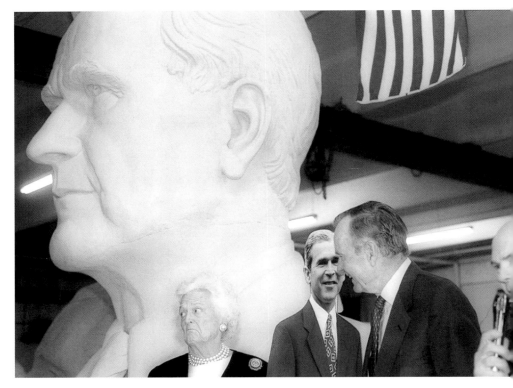

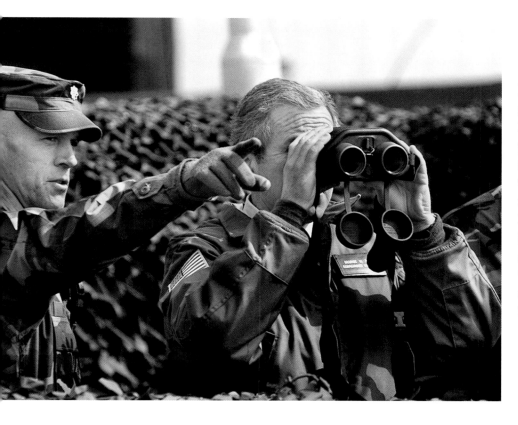

Lt. Col. William Miller gestures toward North Korea as the President peers through binoculars from Observation Point Ouelette in the demilitarized zone of South Korea on February 20. North Korea, the President said, was part of an "axis of evil" that threatened the security of the United States.

Laura tries her hand at making Chinese noodles while she tours the U.S. embassy in Beijing on February 21. The chefs are formerly unemployed workers being trained at the Shannxi Cuisine Training College. At left is the school's president, Li Jixian.

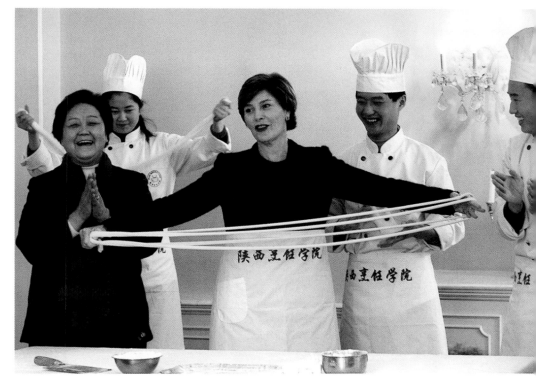

RIGHT: Neil Bush speaks to students at Northern Kentucky University about his company Ignite! Learning on March 5. Bush, who battled dyslexia as a child, started the Internet-based educational program, designed to help students with special learning needs.

BELOW: President Bush and Postmaster General Jack Potter, center, unveil the 9/11 commemorative stamp on March 11, the six-month anniversary of the tragedy. With them is Thomas E. Franklin, the photographer who took the photo used to illustrate the stamp.

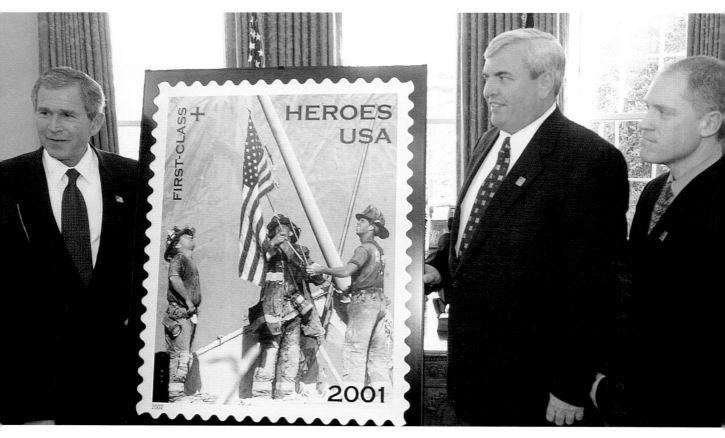

The First Lady joins the Easter Bunny in welcoming hundreds of children to the annual White House Easter Egg Roll on the South Lawn, April 1.

To mark Earth Day on April 22, the President helps volunteers work on a trail near the Ausable River in Wilmington, New York. Bush touted America's commitment to a purer environment, but by November critics were accusing him of attempting to gut the Clean Air Act at the behest of big-business polluters.

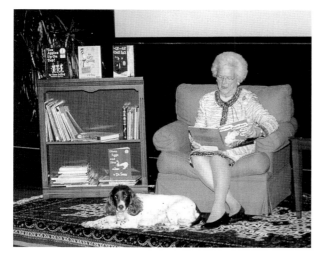

Barbara Bush reads Dr. Seuss's *Horton Hatches an Egg* to students at Rock Prairie Elementary School in College Station, Texas, on April 24.

The brothers Bush sing the National Anthem during a Cuban Independence Day event at the James L. Knight Center in Miami on May 20.

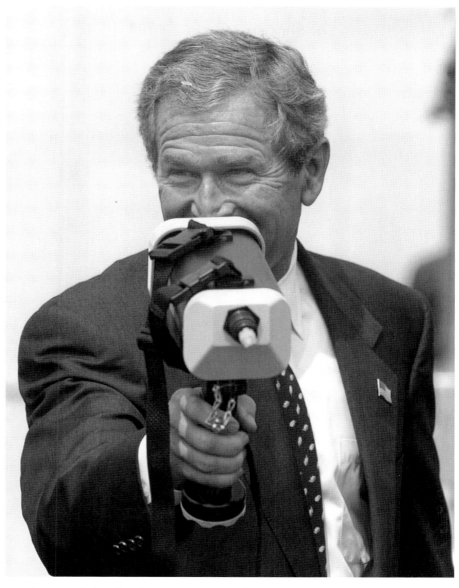

In order to push his plan for a Department of Homeland Security, the President tests a chemical-agent monitor during a tour of Port Elizabeth, New Jersey, on June 24. Bush at first opposed the Democrats' proposal for the new government department, then embraced the idea.

OPPOSITE: Russian President Vladimir Putin and his wife, Lyudmila, welcome the Bushes to Moscow on May 26 with a tour of the State Russian Museum in St. Petersburg. During this visit the two Presidents signed an agreement to slash their nuclear arsenals.

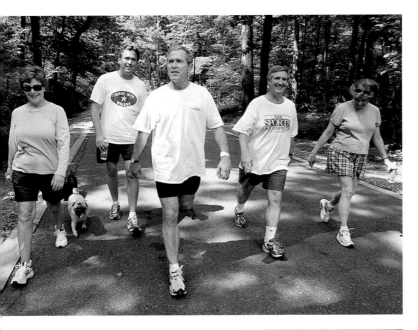

After undergoing a colorectal screening exam on June 29, the President jogs at Camp David with his wife, his brother Marvin, his chief of staff, Andrew Card, and Card's wife, Kathleene.

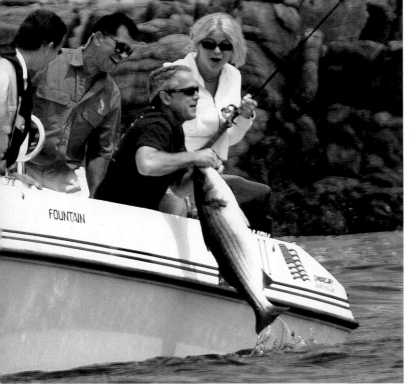

Jenna reacts as her father reels in a striped bass near Walker's Point on July 7. The Bushes spent the weekend with his parents at their summer home in Kennebunkport.

OPPOSITE: At his own retreat in Crawford, Texas, on August 9 the President clears non-native cedar from the oaks on the 1,600-acre ranch. The First Family were in the middle of a nearly monthlong vacation.

The Western White House
Crawford, Texas 2001

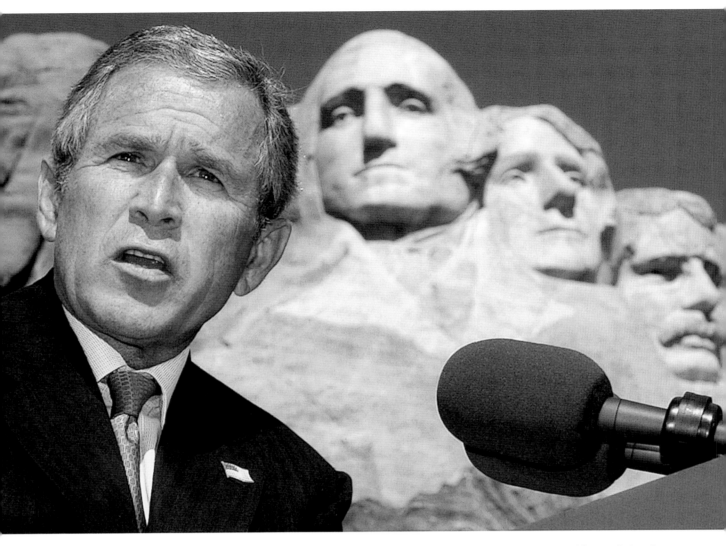

South Dakota Dreamin'? The President seems to fit right in amid his enshrined pre-
decessors at Mount Rushmore, South Dakota, on August 15, as he speaks about
homeland security and the national budget.

At the Parkview Arts and Science Magnet High School in Little Rock, Arkansas, on August 29, Bush trumpets his "No Child Left Behind" package of education reforms enacted by Congress. Eighteen months later, critics would charge that the President had not provided schools with the bulk of the money earmarked by the act.

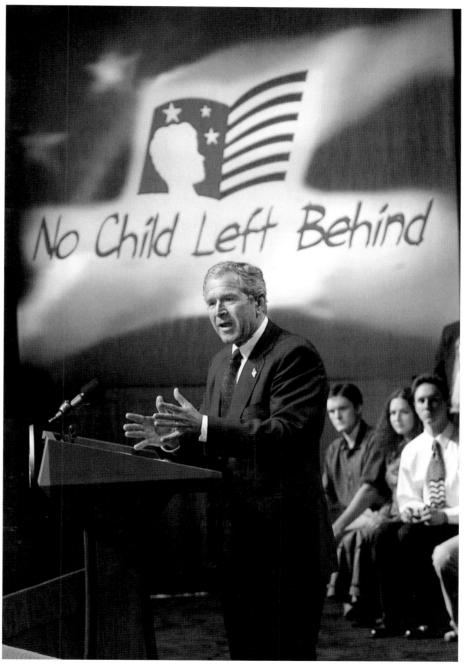

Lauren Bush, eighteen, walks hand in hand with fashion designer Jorge Galinanes as she models an elegant black gown at the end of a show of Galinanes's label, Toypes, in Barcelona, Spain, on September 5.

On the first anniversary of September 11, the Bushes walk down the entrance ramp to Ground Zero for a commemorative ceremony with the victims' families. Later, at Ellis Island, the President spoke. "I believe," he said, "there is a reason that history has matched this nation with this time. America strives to be tolerant and just. We respect the faith of Islam, even as we fight those whose actions defile that faith. We fight, not to impose our will, but to defend ourselves and extend the blessings of freedom."

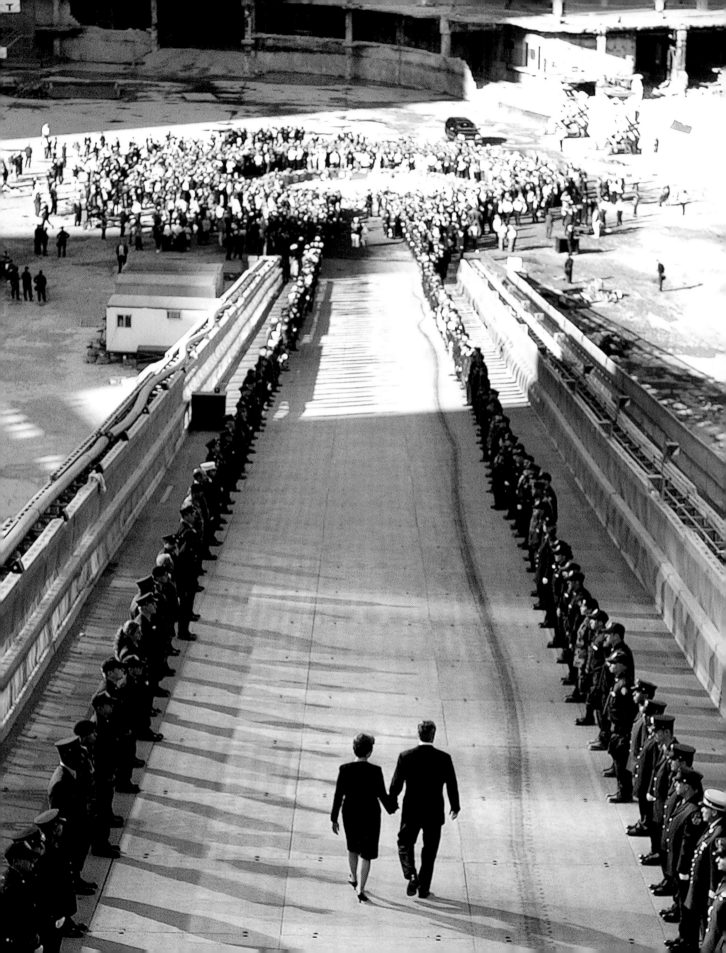

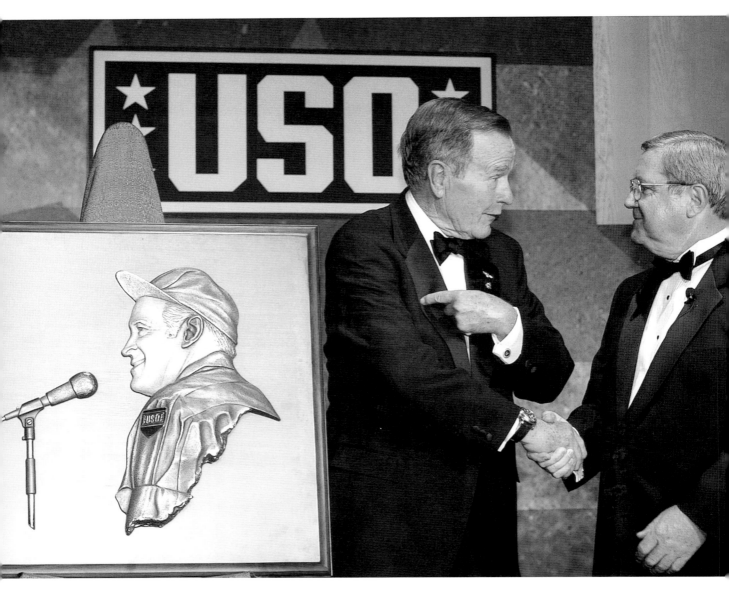

Former President Bush gestures toward a plaque honoring Bob Hope after receiving the USO Spirit of Hope Award on September 17. The award had previously been awarded only to Bob Hope, who entertained American troops as part of USO shows for decades, and his family. The award is given annually to individuals, organizations, or corporations demonstrating their support for the USO and their commitment to enhancing the quality of life of service members and their families. The former President's father, Prescott Bush, was involved in the formation of the USO in 1941.

During an appearance on *Sesame Street* on September 19, the First Lady reads a book with Elmo, Big Bird, and a few children as part of the show's Reading Is Fundamental program.

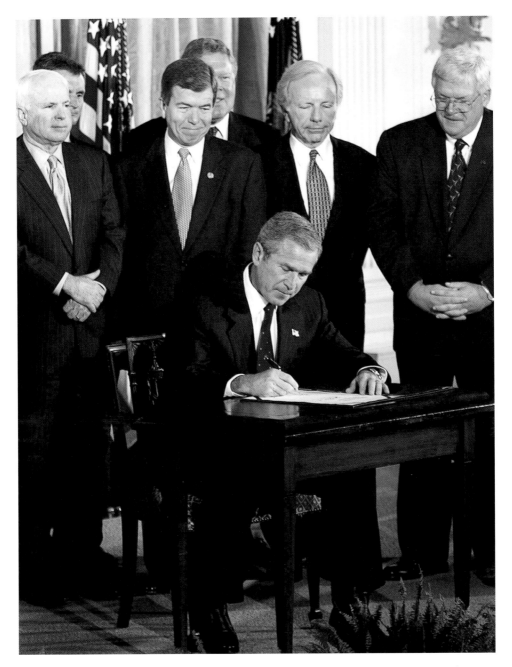

With senators, including Republican John McCain (left) and Democrat Joe Lieberman (second from right), looking on, President Bush signs a congressional resolution authorizing the use of force against Iraq on October 16 in the East Room of the White House. The administration held that Saddam Hussein's regime had stockpiled weapons of mass destruction and had attempted to buy materials to make a nuclear bomb, thereby posing an imminent danger to the United States and its interests. The administration pledged to seek as much international cooperation as possible with any military action before going to war, a promise that persuaded several wary Democrats to vote for the resolution.

Twenty-five-year-old Noelle Bush sits with her aunt Dorothy Koch in a courtroom in Orlando, Florida, on October 17. She was sentenced to ten days in jail for contempt of court after the staff of a drug-treatment center where she was being treated found rock cocaine in her shoe. She had been ordered into the treatment center after she was charged with attempting to use a forged prescription to buy the anti-anxiety drug Xanax at a drive-through pharmacy in January.

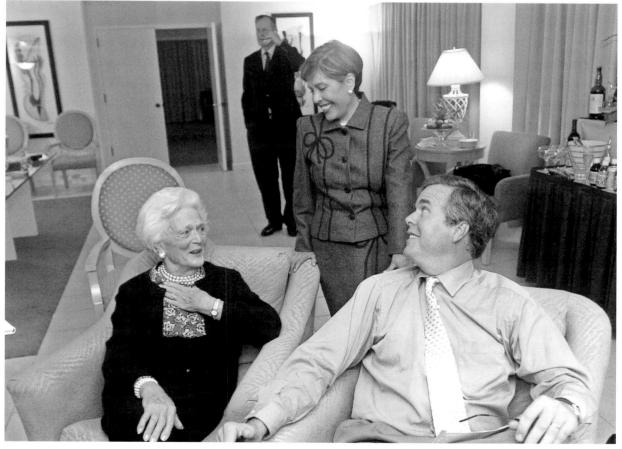

November 5: In a Miami hotel room, Jeb Bush, his wife, Columba, and his parents celebrate his re-election victory over challenger Bill McBride.

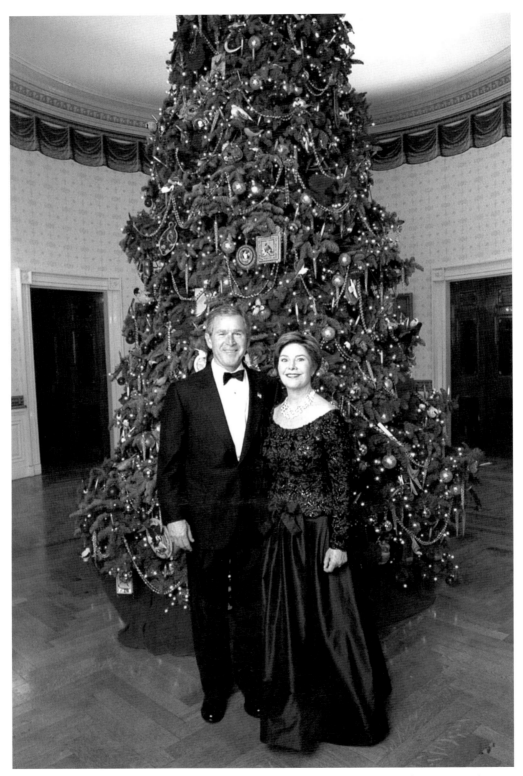

Prior to a reception for the Kennedy Center honorees on December 8, President and Mrs. Bush pose in front of the White House Christmas tree in the Blue Room. She is wearing a gown designed by Arnold Scaasi . . .

. . . and a week later, the elder Bushes posed in front of the Bush Library Christmas tree in College Station.

LEFT: Mrs. Bush and her terrier, Barney, join Santa Claus in a visit to Brittanie Morris at the Children's National Medical Center in Washington on December 12. Afterward the First Lady hosted a children's hour in the hospital atrium, where she showed a video tour of the White House as seen from Barney's perspective.

BELOW: On December 19 the First Couple pitched in to help volunteers Azalie Jewell, left, and Verona Canty, right, pack food at the Capital Area Foodbank in Washington, D.C. The food had been donated by employees of the White House and other federal offices.

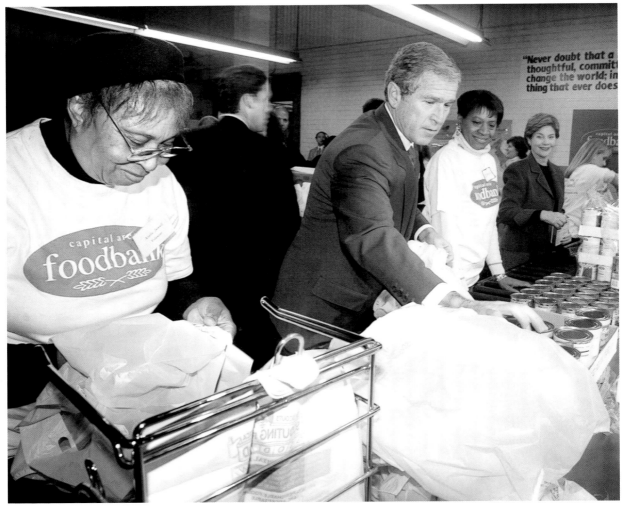

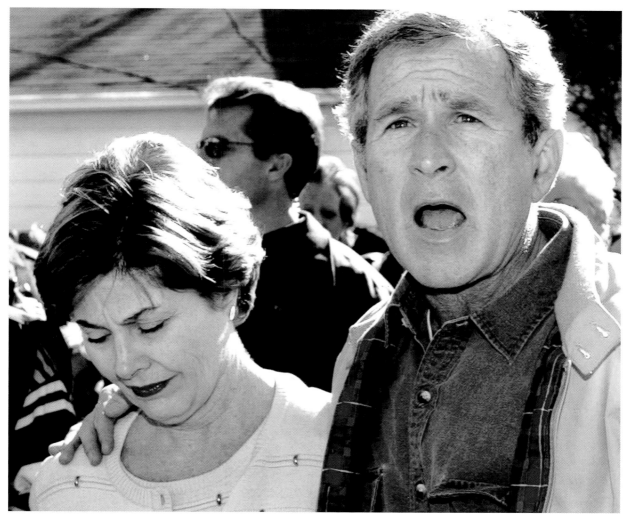

ABOVE: In Crawford for the holidays, the President speaks with reporters about the international threats posed by North Korea and Iraq. Bush said he was confident that North Korea's nuclear buildup could be stopped through diplomatic measures but warned that Iraq "has not heard the message" to disarm and risked igniting a war with the United States. Despite the opposition of what Secretary of Defense Donald Rumsfeld termed "Old Europe" powers such as France and Germany to armed conflict with Iraq, the Bush administration was now determined to take on Saddam Hussein.

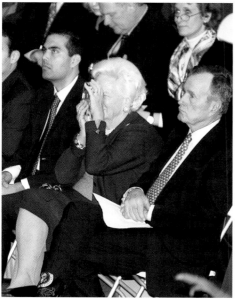

LEFT: Shutterbug Barbara Bush takes a snap as her son Jeb speaks at a 2003 Inaugural Prayer Service at Florida A&M University on January 7, prior to his inauguration for a second term as governor. To her right is Jeb's son, George P. Bush.

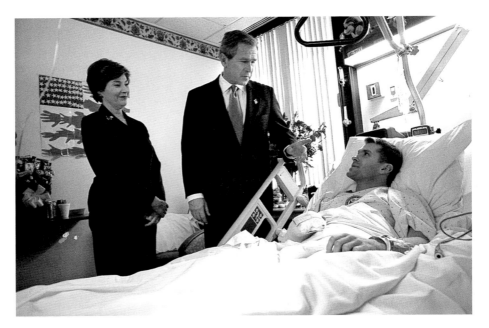

The Bushes visit Army Staff Sgt. Michael McNaughton at Walter Reed Army Medical Center in Washington on January 17. McNaughton was wounded in Afghanistan, where American troops had ousted the brutally repressive fundamentalist Taliban regime. The vanquished clerics had harbored al Qaeda terrorists, including Osama bin Laden, who remained at large.

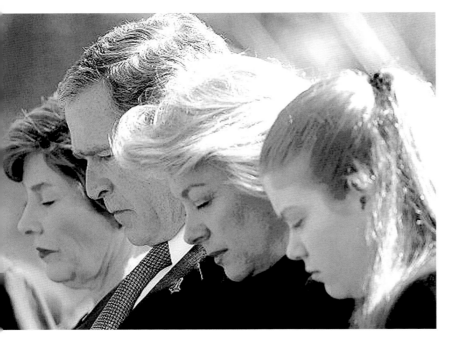

Houston, Texas, February 4: President and Mrs. Bush join Evelyn Husband and her daughter Laura at a memorial service for Rick Husband and six other astronauts killed in the explosion of the space shuttle *Columbia* as it reentered Earth's atmosphere on February 1.

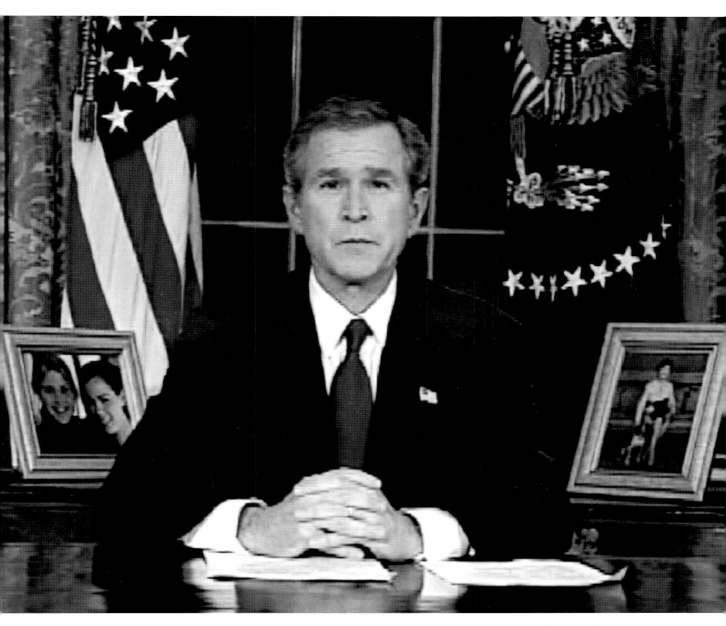

March 19: President Bush addresses the nation to announce that U.S. forces have launched air strikes against military targets in Iraq. Although the administration was unable to get support for the action from the United Nations, France, Germany, Russia, or any Muslim country except Kuwait, the President stressed that the action was required both to disarm Iraq and free its people from the tyranny of the Hussein regime.

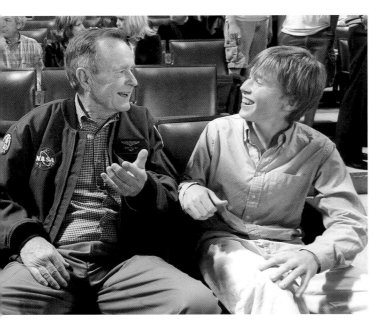

LEFT: George H. W. Bush jokes with his sixteen-year-old grandson, Pierce Bush, at the season-opening game of the Houston Astros in Texas on April 1.

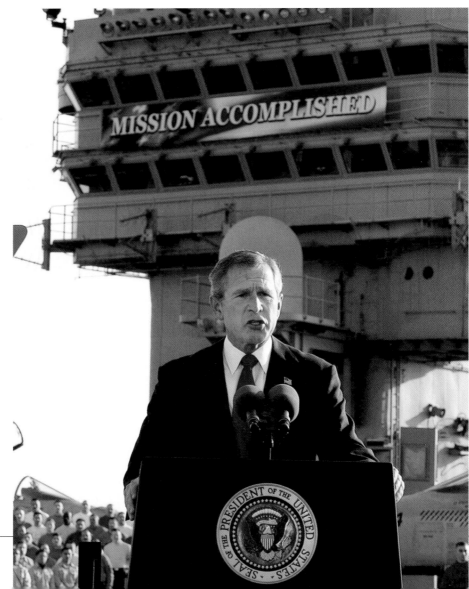

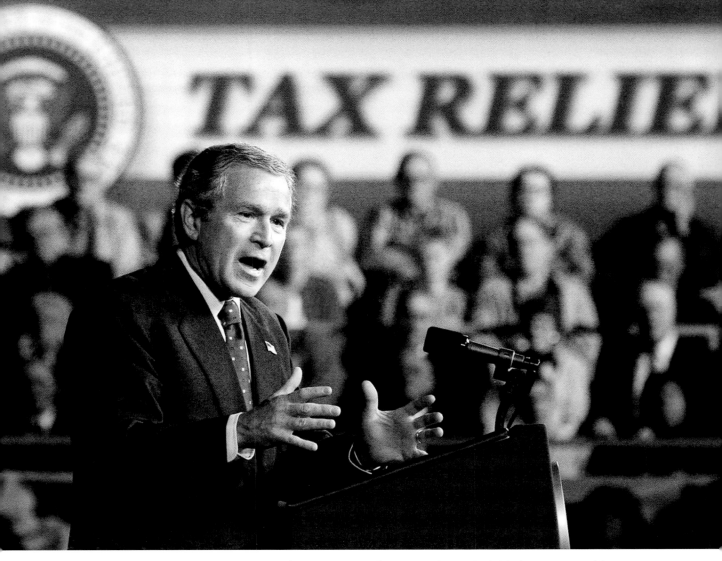

ABOVE: Turning his attention to his major domestic initiative—new and larger tax cuts—the President speaks to a crowd of seventy-five hundred in Indianapolis on May 13. He refuted the Democrats' charge that his tax cuts benefited mostly the wealthiest Americans and told recalcitrant members of Congress to "quit playing politics."

OPPOSITE: May 1: With banner unfurled, President Bush declares an end to major combat in Iraq as he speaks aboard the aircraft carrier USS *Abraham Lincoln* off the California coast. The President was whisked onto the carrier in a navy S-3B Viking jet, marked with the words GEORGE W. BUSH COMMANDER-IN-CHIEF below the cockpit window. Moments after leaving the plane, the President, dressed in a green flight suit and holding a white helmet, saluted servicemen on the flight deck and shook hands with them. Bush said he took a turn at piloting the craft. "Yes, I flew it. Yeah, of course, I liked it," he said. Critics lambasted the entire event as grandiose posturing and questioned whether the mission had in fact been accomplished, since American troops remained in Iraq and faced danger daily from violent insurgents.

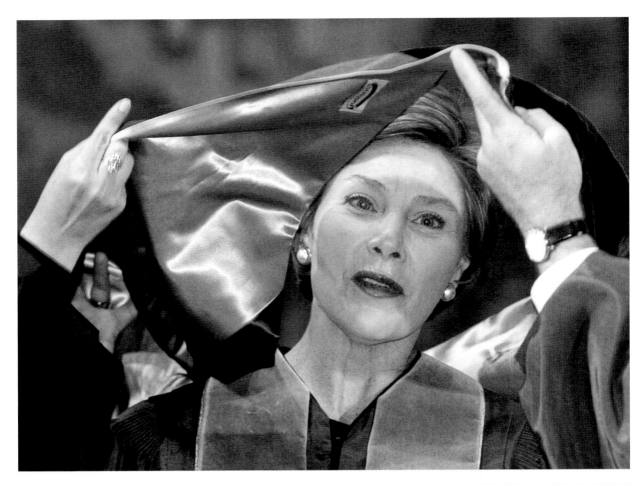

ABOVE: May 17: Mrs. Bush receives her hood as she is honored at Georgetown University in Washington, D.C., with the honorary degree of doctor of humane letters.

RIGHT: George P. Bush, twenty-six, throws out the first pitch at a game between the Texas Rangers and the Baltimore Orioles at the Ballpark in Arlington, Texas, on May 23.

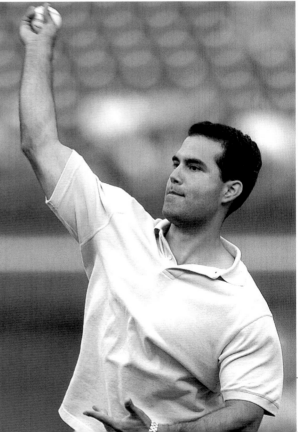

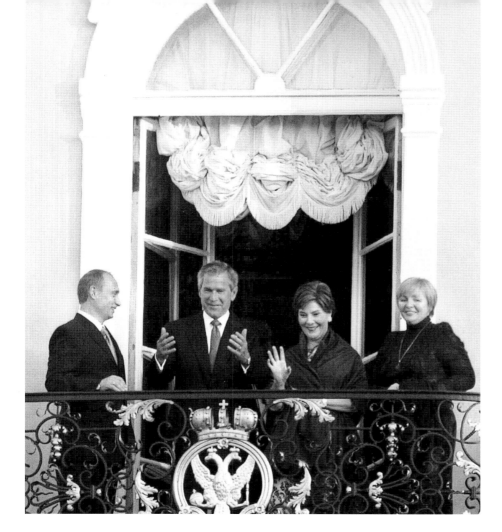

ABOVE: Russian President Vladimir Putin and his wife, Lyudmila, stand with the Bushes on a balcony of the Peterhof Palace near St. Petersburg on May 31. The President and First Lady visited St. Petersburg as part of that city's three hundredth anniversary celebration.

LEFT: Co-hosts Billy Bush and Daisy Fuentes run through a dress rehearsal for the 2003 Miss Universe competition on June 3, 2003. Bush, son of Jonathan Bush and the President's cousin, is a correspondent for the syndicated television show *Access Hollywood*.

Bush *père et fils* try their hands at riding a Segway on June 12 while Barbara sticks to a more traditional mode of transportation during a family holiday in Kennebunkport to celebrate the former President's seventy-ninth birthday. Mrs. Bush turned seventy-eight on June 8.

June 14: The current U.S. President prepares to cast a fishing line while the former President steers the boat off the coast of Kennebunkport.

ABOVE: More than two years before the 2004 elections, the President began a fund-raising drive that would see him raise over $100 million by early 2004. At a Bush-Cheney luncheon in Miami on June 30, Governor Bush introduces his brother to a cheering crowd of well-heeled Floridians.

RIGHT: During a five-day African trip in early July, the Bushes gaze at the ocean from the Door of No Return on Goree Island, Senegal, which slaves are said to have passed through to board ships destined for the Americas and the Caribbean in the nineteenth century.

Bush responds to reporters' questions as he joins National Park Service employees and student interns to shovel dirt onto a path threatened with erosion in the Santa Monica Mountains National Recreation Area in Newbury Park, California, on August 15.

Stopping for coffee on his way to play golf on August 18 during a vacation in Crawford, the President speaks with reporters about a deadly attack on U.N. headquarters in Baghdad. The President's critics pointed out that more U.S. soldiers had died in Iraq since he declared "Mission accomplished" than had died during combat.

The Bushes and members of the Waco Midway Little League Softball World Series championship team react with horror after the President accidentally dropped Barney at TSTC Airfield in Waco on August 30. Bush quickly scooped up the dog, who was uninjured.

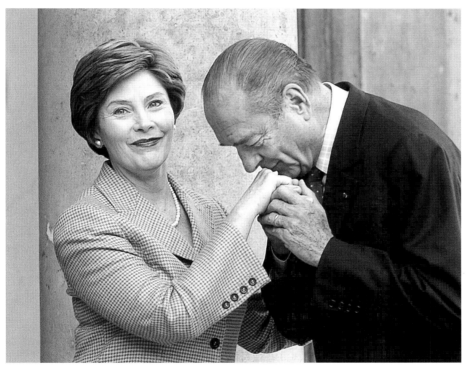

French President Jacques Chirac shows some Gallic gallantry as he kisses the First Lady's hand during her courtesy visit to the Elysée Palace in Paris on September 29. Mrs. Bush was in France to attend ceremonies marking America's re-entry into UNESCO, the United Nations Educational, Scientific and Cultural Organization. Mrs. Bush's meeting with Chirac was arranged in the hope of thawing relations between their two countries, which became so strained after France denounced the war in Iraq that the U.S. Congress renamed French fries "freedom fries."

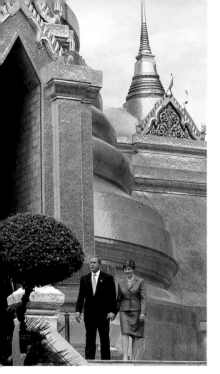

In Bangkok, Thailand, on October 19, the Bushes stroll along the base of the golden stupa, Phra Si Rattana Chedi, as they tour the Grand Palace and the Temple of the Emerald Buddha.

On the deck of the battleship USS *Missouri* in Pearl Harbor, Hawaii, on October 23, President and Mrs. Bush speak to veterans who survived the attack there on December 7, 1941, that forced America's entry into World War II.

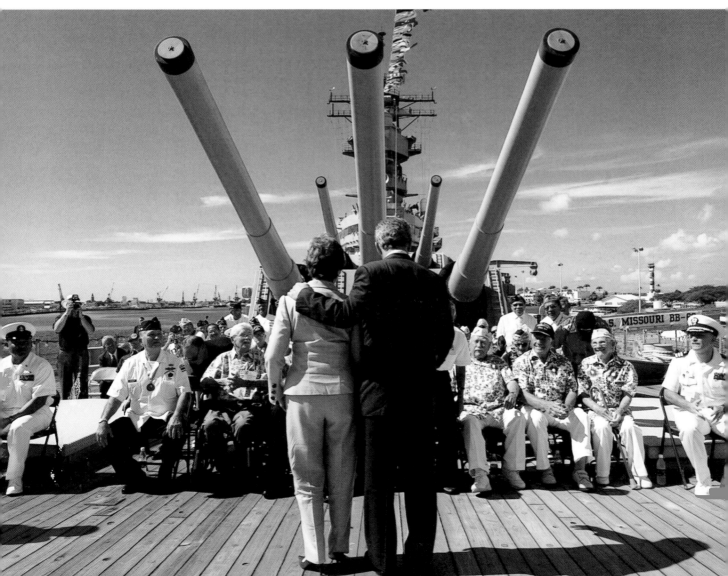

Barbara Bush kisses her son Jeb at a presentation of her second memoir, *Reflections,* at a Coral Gables, Florida, hotel on November 1. The book recounts Mrs. Bush's experiences since leaving the White House.

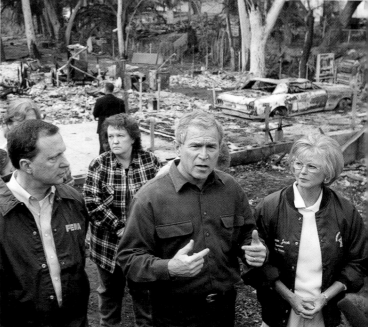

President Bush tours wildfire-ravaged areas of Southern California on November 4. With him are FEMA Chief Mike Brown, left, and San Diego County supervisor Dianne Jacob, right. Despite the President's promise of federal aid, critics charged that his administration was partially responsible for the tragedy because it had dragged its feet in combating the danger posed by dead trees in the area.

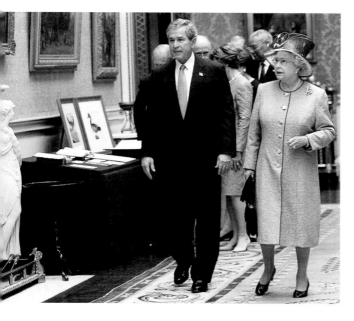

During a visit to Britain to thank Prime Minister Tony Blair for his unwavering support of the war in Iraq, the President tours the Queen's Gallery in Buckingham Palace with Queen Elizabeth II.

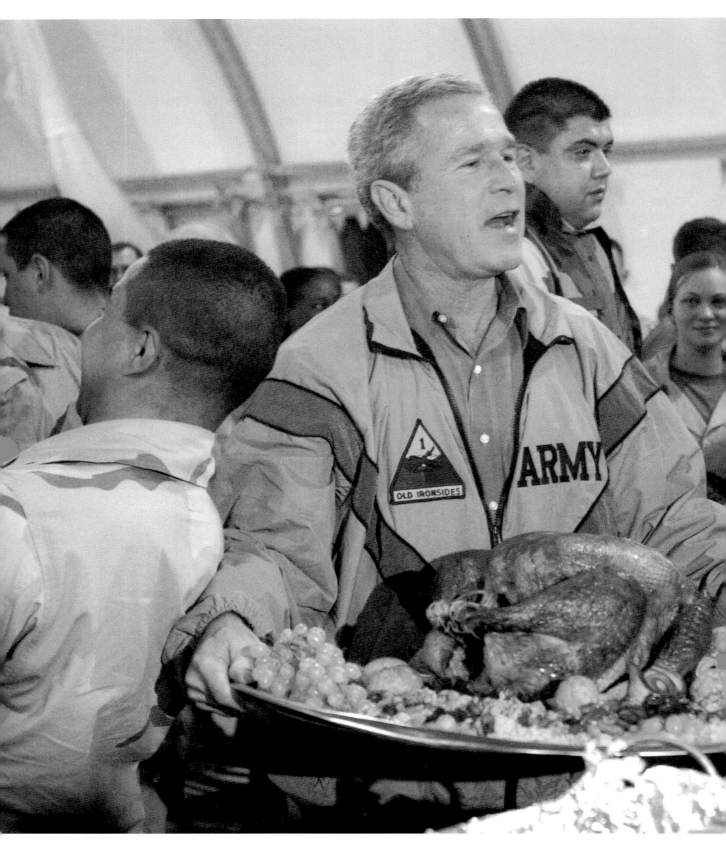

During a top-secret visit to U.S. troops in Baghdad that stunned the world when it was announced, President Bush appears to serve turkey to servicemen at a Thanksgiving celebration. Bush teared up as the soldiers cheered his startling appearance. The visit provided a much-needed boost to beleaguered servicemen and women and was hailed by many as the "political play of the year." Ever present critics, however, accused the President of grandstanding once again and pointed out that the turkey Bush is holding in this photo was part of a table display; he did not actually serve any turkey to the soldiers.

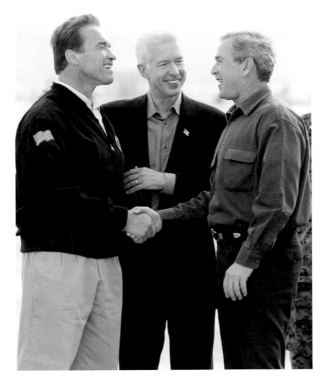

LEFT: Bush congratulates California's Governor-elect Arnold Schwarzenegger as he arrives at the Marine Corps air station in Miramar, California, on November 4. Between them is Governor Gray Davis, whose recall by the voters allowed Schwarzenegger to attain the office.

BELOW: At a media briefing in the Cabinet Room of the White House on December 14, the President announces the capture of Saddam Hussein, who was found hiding in a six-by-eight-foot hole on the outskirts of his hometown of Tikrit, Iraq.

OPPOSITE: Three days later George H. W. Bush displays his delight at the capture, by forces commanded by his son, of the man who plotted his assassination.

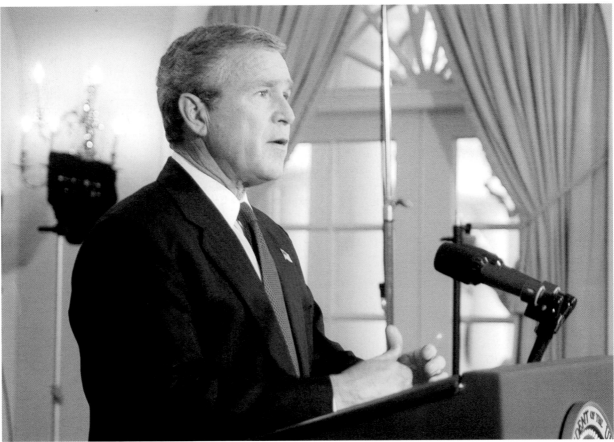

Anderson, Christopher. *George and Laura*. New York: William Morrow, 2002.

Bush, Barbara. *A Memoir*. New York: Scribner, 1994.

———. *Reflections*. New York: Scribner, 2003.

Bush, George. *A Charge to Keep*. New York: William Morrow, 2001.

Bush, George, with Victor Gold. *Looking Forward*. New York: Bantam, 1988.

Bush, George, with Doug Wead. *Man of Integrity*. Eugene, Ore.: Harvest House, 1988.

Ivins, Molly, and Lou Dubose. *Shrub*. New York: Random House, 2000.

Minutaglio, Bill. *First Son*. New York: Three Rivers Press, 1999.

Parmet, Herbert S. *George Bush*. New York: Scribner, 1997.

Radcliffe, Donnie. *Simply Barbara Bush*. New York: Warner Books, 1989.

Valdez, David. *George Herbert Walker Bush*. College Station, Tex.: A&M University Press, 1997.

ACKNOWLEDGMENTS

Jorge Jaramillo of AP/Wide World Photos is an enormously personable and efficient young man who has been of tremendous help to me on all my recent pictorial biographies, this one in particular. Mary Finch and Bonnie Burlbaw, audiovisual archivists at the George Bush Presidential Library in College Station, Texas, were extremely helpful and gracious as well. I also very much appreciate the assistance offered me by Danelle Moon, the reference manager of the Manuscripts and Archives Division of the Yale University Library, and Kennan Daniel, assistant director of design services of Phillips Academy.

I would also like to acknowledge the enthusiasm and insights provided to me by my editor, Elizabeth Beier, and my agent, Todd Shuster.

And, as always, I find indispensable the love and support I receive from my partner, Terry Brown, and my friends Richard Branson, Ned Keefe, Chris Nickens, Glen Sookiazian, Dan Conlon, Karen Swenson, Guy Vespoint, Chris Mossey, Jamie Smarr, Janet Smith, and Simone Rene.

AP/Wide World Photos: 3 (top), 4 (middle), 5, 7 (top), 9, 12, 18, 20 (top), 22 (top), 24 (top), 27, 30-31, 33, 35, 39, 41, 43, 44, 46, 47, 48 (top), 53, 61, 63, 67, 68, 79-81, 83 (bottom), 98, 99 (bottom), 102 (bottom), 105, 106 (top), 114, 117 (bottom), 118, 120, 124, 126, 138, 140 (top), 141 (top), 143, 145 (top), 146 (bottom), 147, 148, 150, 152, 154 (bottom), 157, 171 (top), 172 (bottom), 174 (bottom), 175 (bottom), 177, 178, 186, 188 (bottom), 189 (bottom), 190 (top), 196 (bottom), 200, 203, 205, 208 (top), 209 (bottom), 210 (bottom), 211, 214 (bottom), 215-217, 218 (bottom), 219, 221 (top), 221 (bottom), 224

Scott Applewhite/AP: 64 (bottom), 65, 72, 73 (bottom), 87 (bottom), 88 (top), 107, 166, 170 (bottom), 173 (bottom), 175 (top), 180 (bottom), 182 (bottom), 184 (bottom), 189 (top), 212 (bottom), 213

John Blecha/March of Dimes/AP: 100

Rick Bowner/AP: 164, 199, 202, 214 (top)

George Bush Presidential Library: iv, viii, 2, 3 (bottom), 4 (bottom), 6, 7 (bottom), 8, 10, 11, 13-17, 19, 20 (bottom), 22 (bottom), 23, 25 (top), 26, 28, 32, 34, 38, 40, 42, 48 (bottom), 49-52, 54-56, 57 (bottom), 58-60, 62, 64 (top), 70 (bottom), 74, 76, 77, 81, 82, 83 (top), 85, 86 (bottom), 87 (top), 89 (top), 90, 91, 93 (bottom), 95, 96 (bottom), 97, 100 (top), 101 (bottom), 102 (top), 103 (bottom), 108, 112 (top), 115, 116 (top), 117 (top), 121, 122 (bottom), 123, 125, 130, 132, 134, 135, 141 (bottom), 145 (bottom), 146 (top), 163, 183 (top), 191 (bottom), 207

Dennis Cook/AP: 86 (top), 92 (bottom), 113, 119

Bob Daugherty/AP: 104 (bottom)

Charles Dharapak/AP: 218 (top), 220, 221 (middle), 224 (top)

Eric Draper/AP: 149 (top), 150 (bottom), 151, 153, 154 (top), 160, 168, 196 (top), 197, 206, 210 (top)

John Duricka/AP: 159

Ron Edmonds/AP: 73 (top), 78 (top), 84 (top), 93 (top), 111 (top), 127, 128 (bottom), 129, 131, 156, 162 (right), 170 (top), 171 (bottom), 172 (top), 183 (top), 185, 191 (top), 191 (middle), 195, 204, 208 (bottom)

Michael Edrington/U.S. Army/AP: 100 (bottom)

Eric Gay/AP: 144 (bottom), 149 (bottom), 158

Greg Gibson/AP: 106 (bottom), 116 (top), 122 (top)

Kenneth Lambert/AP: 179, 190 (bottom), 198, 201

Wilfredo Lee/AP: 142, 156

Doug Mills/AP: 92 (top), 96 (top), 110, 133, 167, 173 (top), 176, 181, 182 (top), 184 (top), 192, 194

Pablo Monsivais/AP: 180 (top), 209 (top)

Anja Niedringhaus/AP: 222

Marcy Nighswander/AP: 89 (bottom), 104 (top), 111 (bottom), 127

David Phillip/AP: 136, 139, 140 (bottom), 144 (top), 159 (top), 212 (top), 225

Phillips Andover Academy: 24 (bottom)

Carol Powers/White House/AP: 78 (bottom)

Davis Sams/AP: 132

Amy Sancetta/AP: 57 (top), 169

Tom Seaton/AP: 164

Charles Tasnadi/AP: 66, 88 (bottom), 94 (top), 103 (top)

Mark J. Terrill/AP: 70 (top), 181 (top)

Barry Thumma/AP: 99 (top), 101 (top), 112 (bottom)

Kathy Willens/AP: 71, 187

Yale *Banner:* 29 (left)

Yale University Library: 3 (top), 21, 29 (right)

James Spada is a writer and photographer whose twenty books have included bestselling biographies of Julia Roberts, Barbra Streisand, Bette Davis, Peter Lawford, and Princess Grace of Monaco. He has also created pictorial biographies of John and Caroline Kennedy, Ronald Reagan, Jackie Onassis, and Marilyn Monroe, among others. He lives in Natick, Massachusetts.